RISING UP

Also by Julius V. Williams:

Make the Vision Plain
The Best Is Yet to Come

RISING UP

JUST WATCH ME COME STORMING BACK

JULIUS V. WILLIAMS

Copyright © 2023 Julius V. Williams.

All rights reserved. No part of this book may be used or reproduced by any means, graphic, electronic, or mechanical, including photocopying, recording, taping or by any information storage retrieval system without the written permission of the author except in the case of brief quotations embodied in critical articles and reviews.

This book is a work of non-fiction. Unless otherwise noted, the author and the publisher make no explicit guarantees as to the accuracy of the information contained in this book and in some cases, names of people and places have been altered to protect their privacy.

Archway Publishing books may be ordered through booksellers or by contacting:

Archway Publishing
1663 Liberty Drive
Bloomington, IN 47403
www.archwaypublishing.com
844-669-3957

Because of the dynamic nature of the Internet, any web addresses or links contained in this book may have changed since publication and may no longer be valid. The views expressed in this work are solely those of the author and do not necessarily reflect the views of the publisher, and the publisher hereby disclaims any responsibility for them.

Any people depicted in stock imagery provided by Getty Images are models, and such images are being used for illustrative purposes only.
Certain stock imagery © Getty Images.

Unless otherwise noted, scripture taken from the King James Version of the Bible.

Scripture marked (NIV) taken from the Holy Bible, NEW INTERNATIONAL VERSION®, NIV® Copyright © 1973, 1978, 1984, 2011 by Biblica, Inc.® Used by permission. All rights reserved worldwide.

Scripture quotations marked (NIrV) are taken from the Holy Bible, New International Reader's Version®, NIrV® Copyright © 1995, 1996, 1998, 2014 by Biblica, Inc.® Used by permission of Zondervan. All rights reserved worldwide. www.zondervan. com The "NIrV" and "New International Reader's Version" are trademarks registered in the United States Patent and Trademark Office by Biblica, Inc.®

ISBN: 978-1-6657-3604-6 (sc)
ISBN: 978-1-6657-3603-9 (hc)
ISBN: 978-1-6657-3605-3 (e)

Library of Congress Control Number: 2022923950

Print information available on the last page.

Archway Publishing rev. date: 12/23/2022

CONTENTS

Dedication .. vii
Introduction ... ix

Chapter 1 Where I Came From ... 1
Chapter 2 The Hoax. Yes, It's a Hoax ... 17
Chapter 3 This Is Real ... 33
Chapter 4 Stakeholders .. 47
Chapter 5 Blacks Are Rising Up for Trump 62
Chapter 6 B & B and H & F ... 77
Chapter 7 The Mind of the Spirit .. 92
Chapter 8 The Sick Are Rising Up ... 105
Chapter 9 My Last Word to Donald Trump and Joe Biden 124
Chapter 10 The Political Aspect of Rising Up 145
Chapter 11 I the Prisoner Rose Up Again 156
Chapter 12 Virginia Rising Up for Donald Trump 171
Chapter 13 Donald Trump's Threepeat ... 187
Chapter 14 Truck Drivers Are Rising Up 194
Chapter 15 Slamming ... 202
Chapter 16 The Enemy's Plan to Attack .. 215

Chapter 17 A Political Catastrophe ... 223
Chapter 18 You Can Have Your Death Sentence Overturned
 and Be Granted Eternal Life Instead.......................... 233
Chapter 19 The Risen Truth Showing God's Greatness................. 243
Chapter 20 The Truth about the City and the Mansions 252
Chapter 21 The End of All Things Is at Hand 260
Chapter 22 We Will Rise to Be like and Be Equal to Angels 273

About the Author .. 281

DEDICATION

This book is dedicated to the memory of my mother, Isabel Brown, who was instrumental in my life. Rising to the challenge, she did the very best she could for me. I am grateful to her for that.

To all the other loved ones who gave me words of encouragement, thank you. May you enjoy the blessings and the wealth this world possesses, along with the peace of God that passes all understanding, because you believe God's Word. To those who do not accept the Word, I am hoping that the King of kings and Lord of lords will be lenient with you in terms of your punishment. Peace!

INTRODUCTION

The American people were saddened at the outcome of the 2020 election. The night of the contest, Donald Trump was winning big. At eleven thirty, the counting had come to a standstill. After some hours had passed, at about four thirty in the morning, Donald Trump's big lead started to disappear. In Georgia, Fulton County's excuse was that they had to stop the counting because of a broken pipe that needed to be repaired.

In Detroit, Michigan, some people used cardboard boxes to block the windows in the building so that no one from outside could see what was being done inside. In Philadelphia, they were counting all the fake fraudulent votes and blocking their actions from the view of all those who were opposed to what they were doing.

In Arizona, Michigan, Nevada, North Carolina, and Wisconsin, there were a lot of shenanigans going on. The man Donald Trump, who had attracted thousands and thousands of loyal patriots and other people who had decided to vote for him, was now a laughingstock according to those who opposed him. "He is a loser. He failed to admit that he lost the election," they said.

So, it seems that all the shouts from Trump's patriots and supporters, saying, "We love you! We love you! We love you," were all in vain. After several challenges brought to the state courts, along with the "no standing" response from the Supreme Court, Trump was on his own. He decided to give himself and his followers one more shot, trying to see his win come through. January 6, 2021, was chosen. He asked his faithful followers to show up in Washington, DC, at a rally. A sea of people gathered on the Mall to hear Trump, hoping that Vice President Mike Pence would do the right thing.

After President Trump had spoken, he kindly asked his followers to march to the Capitol peacefully. Bold, boiling, and pumped up, and with their hearts beating and their patience running thin, supporters of both political parties took it upon themselves to commit an outlandish and foolish act: storming the Capitol Building. This is what is known as the famous "insurrection" of January 6. Yet only one person died, Ashli Babbitt, a thirty-three-year-old woman who was shot by the police. She was unarmed. She lost her life because of having been caught up in the heat and passion of the moment, with the prevailing sentiment being "Monkey see, monkey do." More than five hundred Republican supporters were arrested, most of whom are still behind bars.

American exceptionalism is nearly dead. Someone is responsible for this. Some say the culprit is Donald Trump. But what is currently taking place in the United States is bigger than the man Donald Trump. It's a movement of the people who have been standing in the gap, working hard to put the man Trump in office, seeing as he was chosen by God for such a time as this. Donald Trump is a man who made promises and kept his promises. So, let me thrust you into *Rising Up: Just Watch Me Come Storming Back*. This is a tantalizing, breath-stopping, eye-popping, heart-inflaming book. Why? I love to speak the wisdom of God in a mystery, even the hidden wisdom, which was ordained before the world unto our glory.

"But as it is written, eyes have not seen, for the people are blind, nor ear heard, because they are deaf, neither have the Word entered the heart of people, the things which God has prepared for them that love

Him" (1 Corinthians 2:9). But God revealed the Word of truth to us by His Spirit: "For the Spirit searcheth all things, yea, the deep things of God" (1 Corinthians 2:10). I did not receive "the Spirit of the world, but the Spirit which is of God; that [I] might know the things that are freely given to [me] of God" (1 Corinthians 2:12). And I know I have the mind of Christ.

> And at that time shall Michael stand up, that great prince which standeth for children of the people: and there shall be a time of trouble, such as never was since there was a nation even to that same time the people shall be delivered, every one that shall be found written in the book. And many of them that sleep in the dust of the earth shall awake, some to everlasting life, and some to shame and everlasting contempt. And they that be wise shall shine as the brightness of the firmament; and they that turn many to righteousness as the stars for ever and ever. … But go thou thy way till the end be: for thou shall rest and stand in thy lot at the end of the days. (Daniel 12:1–3, 13)

Rise up, as you are just here for a little while. Take this journey with me; I'm very sure you will be captivated by reading *Rising Up: Just Watch Me Come Storming Back*. Be wise! If you make the right preparation, then where you will be heading will be far better than where you are coming from.

CHAPTER 1
WHERE I CAME FROM

I was born in Jamaica—the most populous Anglophone country in the Americas (after the United States and Canada). Actually, it is the fourth-most-populous country in the Caribbean, with a population of about 2.9 million people. Jamaica is an island country that consists of fourteen parishes. The parish of Manchester, where I am from, has a population of about 190,812.

I vividly remember when my childhood home and family life as I knew it was upended. I was five years old at the time. To be so young to and have two siblings pass away was heartrending and hard to comprehend. Why did I lose them? Why did they have to die so soon? Will they be coming back anytime soon? Whose fault is it? Why are they dead? Should God be blamed for such a horrible act? If I blame God, will I die quickly also? These are some of the questions I asked my mother. She told me it was no one's fault but that it was something that had to happen sooner or later.

Up to that point in my life, it was the custom of some of my siblings and me to visit my other two brothers and sister from my father's side of the family on the way from school or after worship on Sunday morning. They lived in John's Hall, a middle-class community that I believed to be well-kept. They had a medium-sized yard where we ran around and played hide-and-seek and hopscotch, jumped rope, and shot marbles.

These playful and eventful moments ended very quickly. The mother of my three siblings would say to me, "Boy, stop the playing and go home to your mother. If you want to play, don't play here; you can do it over there." This she did many times to me; I was frustrated. I thought she was mean to me. Soon I had no more desire to play in that yard. Yet I was not mean or violent in any way toward those children or their mother. My mother taught me to be pleasant and speak kindly to everyone. She'd say, "If they answer you, fine. If not, don't you worry about it. You did your part."

Then there was my grandmother, who lived not too far away in a five-bedroom house. We would gather there together and linger because of what she had available, such as ackees, apples, breadfruit, guinep fruit, guavas, mangoes, oranges, and pears (what we called avocados). My grandmother and my aunt would say to me, "You can't just show up here and get things all the time without asking. Furthermore, you need to learn to work hard to attain the things you need in life." At the age of eleven, I went to live with my sister Luneth in Adams Valley. With her caring for Mr. Joseph, my help was very vital. I stayed with them for two years and attended the Nazareth School in Maidstone.

After two years, I returned to live with my mother. She taught me how to conserve. She would say, "Don't you allow people to control your life. Be your own man! Anything that you need, work hard for it, and you will have it. I am telling you this because you are special and you have ability to do things. You may not understand this now, but later you will. Listen to others, but you must have the final say in your decision."

At fourteen years old, when I was on my way home from a half day in school, Miss L. was going in the same direction as me. She greeted me, saying, "How are you doing today, boy?"

I joyfully replied, "I am doing fine. My father gave me this pair of shoes I am wearing, and he is supposed to be coming to see me soon."

"And who is your father?" she asked me.

"My father's name is Linford," I said.

"Little boy, hush your mouth. He is not your father; he's your brother," she said.

"He is my father," I repeated.

"Ha-ha. Who's turning you into a fool? Go home and ask your mother. She will tell you. And I hope she tells you the truth, the whole truth," she said.

These words hit like bricks. I ran away from Miss L. as fast as I could, hastily and breathless, and went to find my mama. I found her in the field.

"Hi, Mommy," I said.

"How are you doing, Son?" she asked.

"I am not doing too well today," I said.

"And what is wrong, or what seems to be the problem with you? Are you hurting? Are you feeling sick?" she asked.

"I am feeling sick, Mom, but not in the way you are thinking. I am not hurting like that. I am really hurting because I was talking to Miss L. about my father, Linford. She told me that he's not my father. He's my brother. She said to go home and ask you, Mother. Is this true, Mama, that he's my brother and not my father? Please don't hide it from me," I said to her.

Mama replied, "It's true! He's your brother. Your father, Frederick, died when you were just one month old."

"And how did that happen?" I asked.

"He went to the woods to get materials to make hampers to put on donkeys to take them to the market to sell. He got soaking wet from the rain. He came home, changed his clothes, and went to lie down. We had been having a conversation. I asked him a question, and he didn't respond to me. When I looked at him, I could see the whites of his eyes. I opened my mouth and called out his name. 'Frederick, Frederick, Frederick! O God, bring back Frederick to me! Bring back Frederick

to me, please, God.' Then Frederick opened his eyes and said, 'Isabell, what is it that you want? I was on my way, going up a hill to my home. I heard your voice calling me, and I returned to see what you need.' After he spoke these words to me, he closed his eyes and stopped breathing. He died," she said. "Again, you were only one month when he died. It took a toll on me and affected me very much. As you got older, you started calling your second-oldest brother your father. He went along with it. I didn't say anything each time you called him Dad. But that woman just couldn't keep her big mouth closed. She just had to disturb you this way. But I am glad it's all out in the open now. Don't be upset with me. From the day you were born, I knew you were not a normal child. We have a large family, but no one is willing to help me. This is the reason I must be working so hard to feed all of you." She continued, "Bob Marley, who is singing with the Wailers, is your cousin. He's my sister's son. That side of the family is doing very well, but I won't give up. No, I won't. But I will not get into that subject right now. So let me leave that subject alone. One more thing: we could be doing much better if the family was together. What can I say? It's true. When people don't want to be bothered, you leave them alone. With the help of God, I will make it. I will not steal. I don't care how hard it gets. If God wakes me up every morning and I can find a little food to give all of you and send you to school, it's all right with me."

My mother stopped talking and started singing—I assumed a song she made up.

"Sammy planted piece a corn down a gully. And it bore till it killed poor Sammy. Sammy's dead, Sammy's dead, Sammy's dead, oh."

Had my mother abruptly ended the conservation because she had told me too much and thought that I might ask more questions? That I will never know. Mama is dead. She lived for more than ninety years and is gone. But for sure I am convinced that that song had a meaning attached to it.

Mama had two bad habits. Number one was cussing when she was upset or engaged in a heated argument with the next-door neighbors. Number two was smoking her cigars. The house in which we lived was

small, and the smoke and odor from the cigars made my head hurt and caused me to lose my breath. I kindly said to her once, "Mama, please don't be upset with me. You are killing yourself with those cigars, and you are trying to kill me. I can't stand the smell. Why don't you come to worship with me? Come and let the Lord make a difference in your life."

Mama said, "I am very happy for you; I can see the change in you already. You just keep on going. I am not ready yet. When I am ready, I will come." Years later, Mama was baptized in the name of Jesus. One thing, though: she never confessed to receiving the Holy Ghost. Neither did I hear her speaking in tongues, as the Spirit gives the utterance. She made that step and was quick to give me the good news.

Living in Mama's house was challenging. I wanted to help her out by making my own money, so I asked her to give me a bit of the land where I could plant, beans, carrots, peas tomatoes, and yams. She gave me permission, and the Lord blessed me with abundance. At that age, having made some money, I bought my first two suits for worship. Mama made some money too. Farming was a way of life for us. We could choose to live by it or to die because of being too proud to get our hands dirty or just being downright lazy. The alternative was to go to school, study hard, advance to college, and hopefully make your life and your living situation better.

Mama wanted me to be a tailor, and she had the perfect person in mind from whom I should learn the trade from. I did not like tailoring at all. I hated it and bluntly told her so. I wanted to go to college if I could get a recommendation from the justice of the peace. I also wanted to be a mechanic. For this to happen, Mama would have to sign a loan for me.

Mama had me going to a Moravian Church to get me into the Boy Scouts so I would be exposed to certain facets of life. There were lots of thing I didn't like about the Moravian Church, and I didn't want to go back. Mama insisted, "You are going because I said so." I had noticed after morning and evening worship that some of the members would be out on the lot with their little bottles of white rum and whiskey, which they pulled out from under their coats. Some of them were drunk, saying crazy things, yet just coming from worship. There was a Shiloh Holiness

Church closer to us, where most of my family members whose lives had been changed were going. I ended up going to that little church, where something spectacular happened. I was fifteen years old when I gave my life to the Lord Jesus Christ. Back then, seeing that the lives of the people who were regularly going to worship service were changing for the better, I said to myself, *What a wonderful thing a changed life can be. God did it for them, so surely He can change my life too.*

Defining the Time from My Boyhood to My Manhood

Now fifteen years old, engulfed in the Boy Scouts, running marathons two evenings per week, I was very determined to make a difference. But every now and then, Mama would make me visit the Shiloh Holiness Church, which was totally different from the Moravian Church. I asked my mother if it would be OK if I were to visit that Sunday evening after attending my scout briefing, and she said yes. That Sunday night, my life changed for good. While I was sitting in the back of the building on a bench, the pastor, Kenneth Watson, who was preaching the Word, moved from the front of the podium to the edge of the pulpit. Looking steadfastly at me, he said, "Young man, the Lord Jesus is calling you." My four friends who were sitting to my left got up, bent their backs, raised their hands, and walked outside. I tried to follow them, but I was glued to my seat, unable to move. The pastor repeated the same words with an addition: "You, young man, the Lord is calling you. Will you come?" Remember, I was glued to my seat and could not move. Responding to his call, I had no trouble getting up this time. The glue having disappeared, I walked freely to the throne of grace, where I found help for my need after the pastor prayed for me. Thank You, Jesus. Somebody prayed for me, and You made the difference in my life. But still I had carnal things to contend with in my life as the years rolled by.

Here I was, now eighteen years old, hoping to get into college or to become the mechanic. I received a call from the justice of the peace to

come to his office to meet with him. I went and was given a card to enter the Farmworkers Program, destined for Belle Glade in Florida. But the program did not turn out the way I expected or hoped. After only two weeks cutting sugarcane, I was injured—a large wound to my leg where I had accidentally sliced into it with the machete I was using—and taken to the hospital. A man walked in and declared himself to be the doctor. He called two nurses, a man and a woman, who held me while the doctor, with a large needle in his hand, came and injected it directly into the wound. I was crying loudly and holding my right leg while the two nurses were holding me as the doctor stitched the wound. I was sweating profusely, my nerves jumping as I sat there after they left the room. The doctor came back and told me I could go.

That procedure was done in such a way to get me back to work as soon as possible. Three days later, I was back at work. The outer edges of the wound had healed, but the interior was very tender and painful. Later that evening, while standing in the mess line for dinner, I made it to the first step, but then I blacked out, fell, and caused further damage to my wound. I was taken back to the same hospital for treatment. My situation was not determined to be economically unfeasible by the company that had brought me to Belle Glade. One week later, I was placed on a plane headed back to Jamaica with a wound that took a long, long time to heal, a year and a half.

Being resolved, I pressed forward, doing everything I could to get well. I did! I went back to school and sat for the exams for my General Certificate of Education. Out of five subjects, I was successful in civics and religious knowledge. I knew I had a special gift. While I was on my way to class to finish working on the three subjects that I had failed, two of my classmates, my church sisters Cynthia and Judith, saw me from a distance. They ran and quickly caught up with me. I told them what the conversation they had been having was about. Surprised at what I said, they both yelled out, "How did you know that? You must have heard what we were saying, didn't you?"

I said, "No, I did not. How could I be this far away and hear what

you were saying softly? The Lord revealed to me what you all were saying."

They simultaneously said, "Oh my God! You are a prophet. You can read minds."

I said to them, "I will be going onto the police force soon."

One of them said, "And how will that happen? Aren't there certain things you must do after you sit the test—and then they call you for the interview?"

I said, "I have dreams. Just watch me." Shortly after I spoke this into existence, I went and sat the test for the police force, which I passed with flying colors. Now I had to wait to receive the call to begin the training. The call came. I was now on my way to Harman Barracks, Mobile Reserve, adjacent to the soldiers' camp. The training was really rough, but I was determined to see it through to the end. After six months of hard labor, I was successful. It was the year 1973.

Some time had passed. I was determined to prove my drive and my worth and to show I could succeed. There was construction going on for the new bypass road in May Pen, Clarendon. The May Pen police, overwhelmed with the crime in the city, called and summoned the help of the section of the force they called the "jump-out." Under the auspices of Inspector Hunt, a party of six uniformed officers and six plainclothes officers, of which I was one, went down to Clarendon on patrol.

We were told that men from Tivoli Gardens had descended on the city, causing havoc. Rising with much fanfare, they had gone about killing and breaking into houses, committing larceny. The community was on edge, panicking. Less than five minutes into our patrol, we twelve officers saw a group of four men running in different directions. Our two jeeps came to a complete stop. We jumped out as quickly as we could, leaving the two drivers in the vehicles, and went on foot patrol in pursuit of these men, hoping to find the culprits.

With my faith in God and my determination, hoping to make a difference, I had my eyes fixed on one of the four men. The chase was on! The drivers of the two jeeps were going around in circles, on the lookout. During the chase, one man of the community said to me, "Officer, he

has a gun and a machete. If you make a quick right, you will catch up with him."

The chase came to an end when the man scaled a fence with iron bars. The property had a big sign reading, "Realtors." He ran to one of the doors and tried to enter the building, but a young woman closed the door quickly. He ran to another door and tried to enter that one too, but found he was locked out again. I entered through the gate and walked onto the premises. The possessed young man came from the right side of the building, facing my left and coming at me full speed. He had a machete, sharpened on both sides and his right hand was raised in the air, hoping to do some damage to me.

I ordered him to drop the weapon. He refused and came within seven to ten feet from me. I fired one round from my shotgun. His weapon was now on the ground beside the building, and his right hand was dangling. By this time, my colleagues who were outside the gate shouted, "Kill the man! Kill the man!" I did not kill the man. So, I beckoned to my colleagues to come quickly. They did so. Before the jeeps came close, the young man said to me, "Officer, God will bless you for not killing me." This young man, who had risen up to terrorize the residents of May Pen, and who had come at me to maim, wound, or kill me, was wounded and now on his way to the May Pen General Hospital for treatment. On the way to the hospital, he kept on repeating, "Officer, God will bless you for not killing me. Thank you for not killing me." He was handed over to the May Pen police, who had wanted to capture him for a few years. My conservatism was on full display.

Willing to Make a Difference

I found myself striving to make a difference in the execution of my duties. It mattered not which side of the political spectrum you were aligned with, whether the Jamaica Labor Party (JLP) or the People's National Party (PNP), I was willing to execute my duties with the utmost dignity and respect. Transitioning into manhood, without fear

and with tenacity, I was making a name for myself and was also quickly making a difference. My superiors had called a meeting and made mention of the good work I was doing in the area where I lived without my having mentioned anything to them. On both sides of Jamaica's two-tier political party, there are goons, troublemakers, and killers. None of these traits has color attached to it. Men and women put into action the thoughts of their hearts and minds. By one's actions or the fruit one bears, one will be known.

Rebellion

The Jamaican rebellion, which consisted of around four hundred disgruntled men, occurred in 1865. That led to savage reprisals by Governor Eyre, who was recalled to London and subsequent tried, exposing the racist nature of the British Empire. A racist will do everything he or she possibly can to eliminate an individual who is a potential threat. Remember this: no one called Eyre a racist. But what he did showed his racism. That it was constantly reported in the papers and on the airwaves was the reason he was subsequently recalled to London.

The Hardening of a Radical Attitude and Desire

In 1865, in Morant Bay, Jamaica, there were a number of disorderly events that led to the death of eighteen people. The governor of the island, Edward Eyre, carried out his reprisals, which resulted in four hundred thirty-nine black people hanged, six hundred black people flogged, and between one hundred and seven hundred houses destroyed. Because of the barbaric scale of punishment, a Royal Commission was set up to investigate what was happening or had happened. A national debate about how native peoples should be treated was now being had.

There was also a national debate surrounding the trial of Governor Eyre. There were indications of the hardening of a radical attitude and

desire, and divisions about the possibility of native development. These things, once in motion, flare up like wildfire, which is very hard to control. In order not to make matters worse, one needs to plan carefully to come to a peaceful solution. For any successful accomplishment, one must work hard to achieve one's goal and claim the victory.

Radical Feelings

In Britain, John Bright believed that the country had been stained by the Jamaican episode. To Thomas Huxley, it was political murder. Mr. William Foster assumed the excesses happened because the British officers "were not free from radical feeling." Mr. Foster thought that the British in the colonies had contempt for black people, regarding them as inferior and with irrelevant viewpoints. "There is nothing new under the sun," the wise man Solomon said. All you need is a perpetrator or perpetrators to start something, then there will be followers, for better or for worse.

Charles Darwin's Book Debated

It was no surprise that Charles Darwin's *On the Origin of the Species* justified military aggression and the seizure of property. To many it seemed that Darwin's book suggested there were radical variations among the races. That said, for millions of years this was so, and the development of colonized people was not going to happen in the few years that Darwin's book's title, *On the Origin of Species*, was being debated.

Theories about pseudoscience were being developed. It was questioned whether it was feasible for native people to be suitable for development. This brought into account the idea of Britain's *Mission to Civilize*, written by Herbert Spencer, who also coined terms such as *man's fighting instinct* and *survival of the fittest*. You cannot blame a person for his or

her views. For as a person thinks in his or her heart, so is he or she. For from out of the heart, the mouth speaks.

George P. Gordon

George P. Gordon, born in 1820, was a wealthy mixed-race Jamaican businessman, magistrate, and politician. He was also one of the two representatives to the Assembly from Saint Thomas in the East. He constantly criticized the policies of the colonial government. Governor Eyre had declared martial law in the area and ordered troops to suppress the rebellion. George Gordon, who was in Kingston, was arrested and taken back to Morant Bay to stand trial. He was quickly convicted of conspiracy, with suspicion that he had planned the riot, and was executed.

His death was the result of the controversy in Britain. Those who opposed Eyre's action attempted to have him prosecuted for murder. The case never went to trial. Eyre was forced to resign. Legislation was passed by the British government to make Jamaica into a Crown colony, being directly governed by the British for years until 1962, when Jamaica gained its independence.

Marcus Garvey

Marcus Garvey was born on August 17, 1887, in Saint Ann's Bay, Jamaica, the youngest of eleven children born to Marcus Garvey Sr. and Sara J. Richards. Garvey was greatly influenced by his father, who said, "My son is bold, determined, firm, severe, and strong. He will not yield even to the superior forces if he believes he is right." During his time, his family was financially stable.

During his youth, Marcus Garvey attended elementary schools in Saint Ann's Bay. While a student there, he began to experience racism. When he was fourteen years old, he left school and worked as a printer's apprentice. He traveled to Kingston in 1903 and immediately became

involved in union activities. After four years, he took part in a printers' strike but was unable to gain any success. From this event, he kindled a love and passion for political activism.

Garvey traveled throughout Central and South America from 1910 to 1912. He made his first stop in Costa Rica, where his maternal uncle lived. There he lived for several months and worked as a helper on a banana plantation. Later, in 1911, he began to work as an editor for a small daily newspaper called *La Nationale*, where he wrote about the exploitation of immigrants on the plantation. That same year, he relocated to Colon, Panama, where he edited a biweekly newspaper. After several years of working in the Caribbean, Garvey went to London, where he attended Birkbeck College (University of London), taking classes in law and philosophy. He also worked for the *African Times* and *Orient Review*, which advocated Pan-African nationalism. He spoke very often at Hyde Park's Speakers Corner. He did all this within two years. Mr. Garvey made his return to Jamaica and founded the Universal Negro Improvement Association (UNIA) in 1914. This he did to unite the African diaspora to establish Jamaica as a country with an absolute government of its own.

Marcus Garvey moved to Harlem, New York, where he made great gains with UNIA, in 1916. As a seasoned public speaker, he crisscrossed the United States, making a name for himself. He had a separatist philosophy, political in nature, wherein he sought economic freedom for black people. He urged African Americans to be proud of their race and to return to their ancestral homeland, Africa. Thousands of people were attracted to him and provided him with support. He worked very hard developing programs to improve the plight of native Africans living all over the world. This he did by publishing his widely distributed newspaper, *Negro World*, to convey his message.

Marcus Garvey founded the Black Star Liner Company in 1919 to provide transportation to Africa in order to facilitate his avocation. He also founded the Factories Corporation to encourage black economic independence. He tried unsuccessfully to persuade the government of Liberia to grant land for people from the United States to settle. He

attracted a crowd of about twenty-five thousand people in Madison Square Gardens using the slogan "One Aim, One God, One Destiny." UNIA held its Second International Convention in 1921 at Madison Square Gardens. This time there were more than fifty thousand attendees at the event.

Mr. Garvey, along with three other UNIA officials, was arrested in the year 1922 for sale of stock in the Black Star Liner Company, which had now badly failed. The arrest of these three men had a lot to do with politics. Although there were irregularities connected to the business, the authorities accused Garvey of mail fraud. On June 23, 1923, Mr. Garvey was convicted and sentenced to prison for five years. He appealed the sentence, but he was denied. He was released from prison in 1927 and deported to Jamaica. Being a known leader and a political figure, he was willing to fight for the unity of African Americans, creating the Universal Negro Improvement Association and rallying his supporters together to fight.

Marcus Garvey spoke on communism as an active part of his career. He also spoke on the economy, education, and independence. His feeling was that most whites used communism to solve their economic and political problems, but in doing so, they further limited the success of blacks. Garvey believed the Communist Party needed only to use African Americans for their votes "to smash and overthrow" the capitalistic white majority to "put their group's majority or race in power, not only as Communist, but as 'white men'" (Amy Jacques Garvey, 1969).

Garvey discouraged blacks from joining the Communist Party, believing it had been created to control black people and nonwhites. He traveled to Geneva, Switzerland, in 1928, to present his "Petition of the Negro Race." In it, he outlined for the League of Nations the worldwide abuse of Africans. Having made a speech and criticized the corrupt judges, he was brought before the chief justice and was sent to prison again.

In 1935, Garvey left Jamaica for London. He just kept storming back. There he lived and worked until his death in 1940. Where there is a will, there is a way. Marcus Garvey never stopped trying to achieve

his dreams. He never stopped trying to achieve his goals. He used his God-given talents and never stopped trying until the day he breathed his last breath, the day God called for his life.

There is no man I have ever read about who has the power over his spirit to retain it. Nor does he have power on the day of his death. There's no way to be discharged in that war; neither will wickedness deliver those who are given to it. For there's a time to be born, and there's a time for all of us to die.

Jamaica's National Heroes

Paul Bogle, born about 1822, was a Baptist deacon in Stony Gut, a few miles north of Morant Bay, in the parish. He was eligible to vote at that time, when there were only 104 people living there. He was instrumental in the riots that took place at that time.

These men, Paul Bogle, George W. Gordon, and Marcus Garvey, were made national heroes in 1969, along with Alexander Bustamante. The other national heroes who rose to the challenge are Nanny of the Maroons, Samuel Sharpe, and Michael Manley. Rising to the occasion, these heroes played their part one way or another in rebuffing the racist acts of the past. This is how Jamaica came by the saying, "Out of many, one people." These people stood up for their rights, speaking about and criticizing what they believed was ultimately wrong.

You'd better speak now, or forever hold your peace.

What Have You Really Accomplished in Your Lifetime?

The blessed Word of God spoke to me thus:
"Young man, what shall be your profit if you shall gain the whole world and lose your own soul? Or what shall you give in exchange for your soul? You will take nothing when you leave. After you have done all

these great and wonderful things, what next? Only what you do for Jesus Christ will last. Everything that you do will be brought to judgment, good or bad. It will not get you into the kingdom of God. It will not get you into heaven. What will get you into the kingdom of God is to keep God's commandments, and His commandments are not grievous. His yoke is easy, and His burden is light. Only to those who love God and follow His Word will these words apply: Blessed are the dead who die in the Lord from henceforth. 'Yea, saith the Spirit, that they may rest from their labors; and your works do follow you' (Revelation 14:3)."

CHAPTER 2
THE HOAX. YES, ITS A HOAX

Yes, the investigation into Donald Trump's dealings with Russia was a hoax. The Steele dossier that led to the investigation was a hoax. The impeachment of the forty-fifth president was a hoax. What will the haters throw at Donald Trump next?

Throughout history people have always searched for and found scapegoats. Now, a scapegoat is not real. It is a figment of one's imagination. You can imagine something and then go ahead and make it up or find someone to go along with you and agree that what you have created in your mind is real. There is nothing new under the sun. People have taken matters into their own hands and have viciously attacked Mr. Trump. Even though people may say they have nothing against the president, that they have only love in their heart, their very words and actions prove them to be liars.

The secrets within their hearts either are spoken or are revealed by the almighty God, Jesus Christ. In the same way that conception begins

in the womb, conception begins in the heart and mind—and only the conceiver and Almighty God can do something about it. The heart is desperately wicked. A wise person who is endowed with knowledge will allow only allow words to proceed out of his or her mouth with the meekness of wisdom. Earthly wisdom is bitter, filled with envy and strife, and there is no truth in it. For it is written that a long, long time ago, God said, "I will destroy the wisdom of the wise, and will bring to nothing the understanding of the prudent" (Isaiah 29:14). So, because God's Word is settled in heaven, you must have spiritual eyes to see and spiritual ears to hear, then the Word will enter into your heart as it does to all concerning "the things which God has prepared for them that love him. But God has revealed them unto us by His Spirit. He does it through the Spirit, which does the work. For the Spirit searcheth all things, yea, the deep things of God" (1 Corinthians 2:9–10).

"For who knows a person's thoughts, except their own spirit within them? In the same way no one knows the thoughts of God except the Spirit of God" (1 Corinthians 2:11 NIV). "Now we have received not the Spirit of the world, but the Spirit, which is of God, that we might know the things that are freely given to us of God" (1 Corinthians 2:12 KJV).

> This is what we speak, not in the words taught us by human wisdom, but in words taught by the Spirit, explaining spiritual realities with Spirit-taught words. The person without the Spirit of God does not accept the things that come from the Spirit of God but considers them foolishness, and cannot understand them, because they are discerned only through the Spirit. The person with the Spirit makes judgments about all things, but such a person is not subject to merely human judgments. For, "Who has known the mind of the Lord so as to instruct Him?" But we have the mind of Christ. (1 Corinthians 2:13–16 NIV)

January 6, 2021, came about because of the fraudulent, stolen November 3 election, which Mr. Trump won. But those in the know thought they could find no one better than Trump to blame. So, they decided the best thing to do was to blame him anyway. This display was an effort to stop Donald Trump from regaining the White House. Donald Trump's rising up was God's idea. Just watch him come storming back. A thief who stole will return the loot only when he is caught red-handed. He will only do so when he is ordered to and is aggressively brought before an honest judge who neither will compromise nor is a respecter of persons. But then the judge will send out agents or his officers to confiscate the loot and recover the stolen property. In 2020, Donald Trump won the election for president of the United States. There is no doubt about it! Those who did the wrong thing will not get away with it. All may seem fine and dandy, but everyone will receive punishment for the wrong they have done. Though the winners are putting on a good show, trying to show unity to some degree, they are divided and are falling rapidly like the rain. It will not be long; you will see it with your own eyes: Trump won! Most of the Democrats know this for sure. All honest Republicans know for sure that the forty-fifth president was the real winner of the 2020 election.

I speak as a man, an honest man who is not afraid or ashamed to declare what he sees. I have no fear, for Jesus Christ walks beside me and is in me. "I will not fear. What can man do unto me?" (Psalm 118:6). For I am sheltered in the arms of God. Because of my love for God and the truth, I will not fear. Only God is good. He is the Truth. He has shown to me what the Truth is. Mr. Trump was robbed of the election win. We should not be deceived by vain words. We should seek after truth and pursue it. Only the truth will make us free. The god of this world has blinded the eyes of the people, causing them to be unable to see what God has shown and is showing and what He is doing.

The god of this world has allowed evildoers to live and reign a long time. Perhaps these people will allow God to find His place in their hearts, if they will repent of their evil deeds and turn to Him for their salvation. Otherwise they will live for eighty or one hundred years, die

as fools, and lift up their eyes in hell. God has set before every one of us good and evil. He has given us a choice. He has told us which one to choose, namely, good, and to refuse the evil. But we have set our minds to doing evil rather than good. As I walk this pilgrim journey, attaining new heights every day, I ask the Lord to open my eyes to all His truth. The only truth-teller we have is God Himself, who cannot lie. "That by two immutable things, in which it was impossible for God to lie, we might have a strong consolation, who have fled for refuge to lay hold upon the hope set before us" (Hebrews 6:18 KJV).

"The great dragon was cast out of heaven, that old serpent called the devil and Satan" (Revelation 12:9 KJV). Satan fills human hearts with lies from the time they are in the womb. To rid yourself of telling lies, you must put on the new man, Jesus Christ. You will be renewed in the knowledge of God, who created Jesus Christ as the Truth. "All liars shall have their part in the lake which burneth with fire and brimstone, which is the second death" (Revelation 21:8 KJV). The January 6 House panel, marching to unearth Donald Trump's "secrets" as they call them, is an attempt to stop Trump from continuing in his winning ways. For Trump has said, "We are going to win, win, win until you say, 'We are tired of winning.'"

When you have done everything unfairly to stop a winner and it seems that you have succeeded, you must keep up the pretense and keep the show going. But just remember this: for everything, there is a season and a reason. What my eyes have seen and what my ears have heard, about eighty million people also believe. The reason those people voted for Trump was not that he was righteous and holier-than-thou, as some seem to be, but simply because he has good ideas.

In many things, we all fail. Sometimes we seem to think we know it all, yet when we are put to the test, we realize how little we really know. Every good and perfect gift cometh from God above.

Now watch this! We read the following in Exodus 31:1–6:

> And the Lord spake unto Moses, saying, "See, I have chosen Bezalel son of Uri, the son of Hur, of the tribe of Judah, and I have filled him with the Spirit of God,

in wisdom, and in understanding, and in knowledge, and in all manner of workmanship, to make artistic designs for work in gold, silver, and bronze; to cut and to set stones, to work in wood, to engage in all kinds of crafts. Moreover, I have appointed Aholiab son of Ahisamak, of the tribe of Dan, to help him. Also, I have given ability to all skilled workers to make everything I have commanded you." (NIV)

So, as you can see, my friends, my people, God chooses people He created and made, and then fills them with His wisdom to do the work. As humans, we sometimes tend to be selfish, not wanting to give credit where and when credit is due. You probably will give credit to someone else if the person you are giving the credit to is in a league with you. God has filled Donald Trump with lots of wisdom to do the work he has been assigned. Can't you see why such an effort has been made all around to stop Trump? It has been said, "I will do everything in my power to prevent Trump from returning to the White House." Not once, not twice, but many, many times they have tried to stop him, and they failed every time.

In my first book, published in June 2021, I pointed out what the Lord showed me about the coronavirus pandemic. "It was created to hurt President Donald Trump in the upcoming election." In the conclusion to *Make the Vision Plain*, you will find these words written: "The winner will be announced, and it will not be Donald Trump, but ... Joe Biden, because of the fix. This will be vigorously challenged from every angle. This is a sore evil to be seen under the sun. That which was to be has already been, but God will require this at Joe Biden's hand."

Mr. Biden may think he is getting away scot-free, along with all those who were involved in the draconian-style fix. They are all guilty to the max. The coronavirus came from China, and China is in on the fix for Mr. Biden. Sarcastically, you may ask me, "Why do you believe God would allow such a thing like this to take place?" I will give you a

long but simple answer. Let's take a good look at the conspiracy headed by King David's son Absalom's. Here we go:

Second Samuel 15:1–3 tells the beautiful story of how, in the course of time, Absalom provided himself with a chariot and horses and with fifty men to run ahead of him. He got up early and stood by the side of the way leading to the city gate. Whenever anyone came with a complaint to be voiced before the king for a decision, Absalom would call out to him, "What town are you from?"

The individual would answer, "Your servant is from one of the tribes of Israel."

Then Absalom would say to him, "Look, your claims are valid and proper, but there is no representative of the king to hear you." He was being slick and blatantly lying to them.

Absalom would then add, "If only I were appointed judge in the land, then everyone who has a complaint or case could come to me, and I would see that they receive justice" (2 Samuel 15:4 NIV). Also, whenever anyone approached Absalom to bow down before him, Absalom would reach out his hand, take hold of the person, and kiss him. "Absalom behaved in this way toward the Israelites who came to the king asking him for justice; and so, he stole the hearts of the people of Israel" (2 Samuel 15:5–6 NIV). At the end of four years, Absalom went to the king and asked him for permission to go to Hebron and fulfill a vow that he claimed he had made to the Lord. He told his father, "While your servant was living in Geshur in Aram, I made this vow: 'If the Lord takes me back to Jerusalem, I will worship the Lord in Hebron'" (2 Samuel 15:8 NIV).

> King David, not knowing the deception of his son and evil intent of his heart, said to him, "Go in peace." Then Absalom sent secret messengers throughout the tribes of Israel to say, "As soon as you hear the sound of the trumpets, then say, 'Absalom is king in Hebron.'" Two hundred men from Jerusalem had accompanied Absalom. They had been invited as guests and

went quite innocently, not knowing about the matter. While Absalom was offering sacrifices, he also sent for Ahithophel, the Gilonite, David's counselor, to come from Giloh, his hometown. And so, the conspiracy gained strength, and Absalom's following kept on increasing. (2 Samuel 15:9–12 NIV)

Someone came and told King David that his son had stolen the heart of the people of Israel and also that Absalom had Ahithophel as his counselor. The king's official told David, "Your servants are ready to do whatever our lord the king chooses" (2 Samuel 15:15 NIV). Then David said to all his officials who were with him in Jerusalem, "Come! We must flee, or none of us will escape from Absalom. We must leave immediately, or he will move quickly to overtake us and bring ruin on us and put the city to the sword" (2 Samuel 15:16 NIV).

DAVID FLEES TO REGROUP

The whole countryside wept aloud as all the people passed by. The king also crossed the Kidron Valley, and all the people moved on toward the wilderness. Zadok was there, too, and all the Levites who were with him were carrying the ark of the covenant of God. They set down the ark of God, and Abiathar offered sacrifices until all the people had finished leaving the city. Then the king said to Zadok, "Take the ark of God back into the city. If I find favor in the Lord's eyes, He will bring me back and let me see it and His dwelling place again. But if He says, 'I am not pleased with you,' then I'm ready. Let Him do to me whatsoever seems good to Him." The king also told Zadok the priest, "Do you understand? Go back to the city with my blessings. Take your son Ahimaaz with you, and also Abiatha's son Jonathan.

You and Abiathar return with your two sons. I will wait at the fords in the wilderness until word comes from you to inform me." So Zadok and Abiathar took the ark of God back to Jerusalem and stayed there.

But David continued up to Mount of Olives, weeping as he went; his head was covered, and he was barefoot. All the people with him covered their heads too and were weeping as they went up. Now David had been told, "Ahithophel is among the conspirators with Absalom." So, David prayed, "Lord, turn Ahithophel's counsel into foolishness."

When David arrived at the summit, where people used to worship God, Hushai the Arkite was there to meet him, his robe torn and dust on his head. David said to him, "If you go with me, you will be a burden to me. But if you return to the city and say to Absalom, 'Your Majesty, I will be your servant. I was your father's servant in the past, but now I will be your servant,' then you can help me by frustrating Ahithophel's advice. Won't the priests Zadok and Abiathar be there with you? Tell them anything you hear in the king's palace. Their two sons, Ahimaz, son of Zadok, and Jonathan, son of Aithar, are there with them. Send them to me with anything you hear." (2 Samuel 15:23–36 NIV)

I will be very grateful for your help, David mused in his heart. King David did not use anybody to lie about anything in order to orchestrate a cover-up. He knew he did not have to trick his son or scam him, as God had already made him king.

THE DECEPTION OF ABSALOM EXPOSED

Absalom's deception was brought to light. A lot of the people were with him, but not all. Some got caught up in his deception because of the fix he orchestrated. Now, you have two kings, Absalom and David. At no time did David ever concede his kingship to Absalom his son, for God had made him king. Absalom became king because of his slick and sly ways. His defeat was about to take place, but not at the hands of David, his father. His demise would come from a tree, with the help of one of David's servants (military commanders).

Remember this: when King David realized what his own son did to him, although it was very disturbing and out of touch, he didn't want to hurt Absalom or kill him. He sought God's help. Second Samuel 15:31 tells us, "And David told the Lord to turn the counsel of Ahithophel into foolishness." Ahithophel was the man who gave advice and counsel to Absalom in his deception. The Lord God responded to his servant David's request.

Absalom was riding his mule, and as the mule went under the thick branches of a large oak, Absalom's hair got caught in the tree. He was left hanging in midair, while the mule he was riding kept on going (2 Samuel 18:9). A certain man saw King Absalom hanging from the tree and told Joab, the captain of David's army. Joab said to the man who had told him this, "What? You saw him? Why didn't you strike him to the ground right there? Then I would have had to give you ten shekels of silver and a warrior's belt" (2 Samuel 18:11 NIV). The man made it plain: "Although you would have done good by me, even if a thousand shekels were weighed out into my hands, I would not lay a hand on the king's son" (2 Samuel 18:12 NIV). But Joab and ten of his young armor-bearers went and saw Absalom hanging from the tree. Without the knowledge of the king, they struck him with spears and killed him.

> Ahimaaz, the son of Zadok, ran with the news about the death of the king's son. Then Ahimaaz called out to the king, "Everything's all right!" He bowed down in

> front of the king with his face toward the ground. He said, "You are my king and master. Praise be to the Lord your God! He has handed over to you those who lifted up their hands to kill you."
>
> The king asked, "Is the young man Absalom safe?" … Soon after David asked the question, the man from Cush arrived and said, "My lord the king, hear the good news! The Lord has vindicated you today by delivering you from the hand of all who rose up against you." The king asked the Cushite, "Is the young man Absalom safe?" (2 Samuel 18:28–29, 31–32 NIV)

The Cushite kept talking and told the king he hoped the enemies of his lord the king, and all who revolted against him in order to do him harm, would be as that young man. He did not just want to come out and tell the king that his son was dead.

You don't have to fight your own battles. Let the Lord do the fighting for you. But no, you won't, because you are stout-hearted and self-willed. "But evil men and seducers will wax worse and worse, deceiving, and being deceived" (2 Timothy 3:13). Such individuals will stick around for a while because my God allows them to. But the Lord God granted David his request. Ahithophel's advice was defeated. In 2 Samuel 18, you will find out that although Absalom was king, David was the real king and was very loved and still popular.

Let me say this: Donald Trump, the real president, is still popular. They call him the forty-fifth ex-president, but he is more popular than the current president, who was placed in power because of the fix. Just as David was popular with the people, so is Trump. He won the 2020 election by receiving eighty million votes. Now you can understand why there is so much ado about the January 6 episode. It is pure theatrics! For you to remain behind the curtain, behind the radar, is to make it seem as if all that happened on January 6 is Mr. Trump's fault. You may say you have nothing against him, as many say about Trump, but then

you do everything in your power to frustrate and hurt him. Copies of Mr. Trump's State of the Union material were destroyed in clear view. To some, this was offensive. To others, it was no harm, no foul. All true patriots and people who are disciplined will tell you it was egregious and disrespectful. Your foes are those in your own house. "And a man's foes shall be they of his own household" (Matthew 10:36) and of his own party—foes without and within.

Theatrics

Using riots, calling for defunding the police, protesting police killings, and paying lip service to all the other made-up grievances, the corrupt politicians of the United States and the organized parties ignored the behaviors of rioters and ignored the destruction of businesses, including looting and vandalism; they were only concentrated on political positioning and theatrics. Some officers at the Capitol Building opened the doors and allowed the people to pour into the offices. There were imposters who blended in with the Trump supporters on January 6. They pushed over barriers, assaulted police officers, and desecrated the place. There were outspoken renegades on camera talking about their vicious acts and how they got away with them.

Yet for all of this, only Trump supporters were arrested. Six hundred or more of these people are still subject to political persecution. Whom do you blame for the things that happened on January 6? All of this, they say, is Trump's fault. "He is delusional! He must be nailed! He is a psychopath!" King David never blamed his son Absalom for all the disrespect he showed him. He loved him to the end. If you intend to blame someone, please make sure you are aware of those who are involved, whether they are on the left or on the right side of politics. Let everyone receive their fair or just reward. You must be honest in everything you do, or your injustice will surely come back to bite you where it really hurts. All the evil that human beings do lives on after them.

Your work follows you wherever you go, even to death. You will

never be allowed to repent in the grave for all the ungodly deeds that you have committed, for all your fair and hard speech, even when you have surreptitiously spoken in blasphemy. Every idle word that you speak is recorded in His books. Our great God has many books. He keeps good records. He makes no mistakes at all. He will reward all for the evil and the good that they have done in their lives. No one will escape His judgment. Let us strive to do good.

Repent and turn to the Lord. He will have mercy upon you. He will abundantly pardon you for all your transgressions. You had better do it today, before it is too late. We are told to do whatsoever our hands find to do, heartily unto the Lord; there are no activities or planning in hell. God's justice is real because "the law of the Lord is perfect, converting the soul" (Psalms 19:7).

There are those who refuse to hear God. There are those who refuse to listen to God. There are those who refuse to obey God. For their behavior, my God responds by sending them a strong delusion, that they should believe a lie. Absalom became king over Israel, a great nation, because of his evil deeds. My friends, Joe Biden was deceptively and fraudulently given the presidency or made president. Mr. Biden, whom I had voted for before because I thought I was just doing my civic duty, of which voting is but one of those duties, is now the president. We can be overcome with passion for people and not consider the things they stand for, and when we do so, we find out we are well entrapped.

But Biden's rising up was not God's choice. This was the doing of lots of corrupt people determined to prove their point. The Lord allowed this to happen in order to enable Mr. Biden to see and understand who he really is. God allowed this to happen to show the people and let them understand how blind they are when they call evil good. "Every way of a man is right in his own eyes: but the Lord pondereth the hearts" (Provers 21:2). You cannot deny that many people love Joe Biden and voted for him. Some people voted for him because they say Mr. Trump was too brash and Mr. Biden was the next-best man there to fill the gap.

Some people voted for Joe Biden because they are party loyalists and will not change. Then there are those who crossed party lines, saying,

"We are going to teach Trump a lesson." All these facts put together amount in the phrase "You reap what you sow." They who teach others, do they not teach themselves? They should! "For from within, out of the heart of men, proceed evil thoughts, adulteries, fornications, murders, thefts, covetousness, wickedness, deceit, lasciviousness, an evil eye, blasphemy, pride, and foolishness. These are all the evil things which comes from within and defile the man" (Mark 7:21). Who among us can truly say, "Without God, my heart is pure"? None of us. Therefore, it's imperative that we make every effort to guard our words very carefully. Mr. Biden is truly a good man, but he is not right.

When you have opened your mouth and you say, "I have one of the greatest fraudulent organizations in the country," should we not believe you? I do! I never hear this from a stranger. I didn't hear it from another friend. I heard it from the mouth of Joe Biden that he has set up a fraudulent system in this country. Oh, please, don't make me into a liar and a hypocrite. I will accept it if I am proven to be wrong in my assessment of what was said.

Please don't try to get me to fall for any of the cynical ideas that are currently making the rounds. It has been said that Joe Biden received eighty million votes. Most of those who said so are now silent and will not move their little fingers to help prove it to the people, crying out that both they and Trump were robbed and that the Democrats are wrong. Try to help and prove why the people are wrong to believe what they believe. Did you know a good and faithful witness will always speak the truth without swearing? But a false witness will utter lies in the blink of an eye.

Lots of false witnesses said Joe Biden fairly won the 2020 election, including his running mate, Kamala Harris, who is now vice president. Whom would you rather believe, God or humankind? People lie all the time. This they do just as the liar the devil, their father, does. "That by two immutable things, in which it was impossible for God to lie" (Hebrews 6:18 KJV). So then, let God be true. God said, "Donald Trump is the winner." How is it, then, that Mr. Biden was declared the winner before the certification of the election? Lo and behold, Mr. Joe

Biden was indeed certified as the winner. There are some things about God I may not know. There are some things about God I may not understand. But one thing that I am sure of is that my God is real. He's a man with a plan. He's not a man that He should lie. He will cause us to think that we are losing our minds. Why is this so? Because He deals with us differently or oddly. God uses the foolish things of the world to confound those with wisdom gained in colleges and universities. I give glory to God, the only One who is wise, through Jesus Christ, forever. "For the Lord giveth wisdom. Out of His mouth cometh knowledge and understanding" (Proverbs 2:6 KJV).

"You have spoken out of your mouth blasphemy and evil, and your tongue is filled with lying and it frames deceit. When thou sawest a thief, and then you consent with him, and has been partaker with adulterers. … These things have thou done, and I kept silence; thou thoughtest that I, was altogether such an one as thyself" (Psalms 50:18, 21 KJV). The Lord God spoke to my spirit, saying, "Tell them that I will reprove them and set them in order before thine own eyes."

In the process of writing my first book, *Make the Vision Plain: The Lord Showed Me Donald Trump—Others*, while I was musing, God showed His awesomeness. He changed my narrative. I wrote what He said about Donald Trump, and He made me write this: "Joe Biden will win." When I queried God about this, I was shocked. How God could have me write in the same book that Joe Biden will win and Donald Trump will win? God blew my mind when it was revealed to me that Mr. Biden would be declared the winner because of the organized fixing of the election.

I said, "God, what will I say to all those people whom I have told about Trump being the winner? Will I not be made out to be a false prophet and a liar?"

But the Lord said unto me, "Have I not told thee to write? Write!" My God said, "Joe Biden will be given the presidency and made president because of the fix. Donald Trump is the winner. More people will be voting for him than in 2016—Asians, blacks, Hispanics, Natives, and whites, people of all nations." President Donald Trump is the rightful

winner. He, not Joe Biden, got eighty million votes. I thank God for my mind. The thoughts keep coming. In athletics, two people can cross the finish line at the same time. In horse racing, two horses can make it to the winner's circle if they both come to the line at the same time (dead heat). God speaks once. He speaks twice, yet no one listens or takes notice. I get the answers when I learn to pray.

Mr. Biden has been on the rise for a very long time, for forty-seven years up to the 2020 election. When you rewind the tape of history to analyze what he did and what he said, you will be blown away. Mr. Biden was working hand in hand with the Ku Klux Klan. He framed laws to have black men and other people of color be cast into prison. He also said, "If you have a problem figuring out whether you're for me or Trump, then you ain't black."

Since the early nineties, when I received the privilege to vote, I have always voted for Democrats. You must try to listen and respond to the voice of God. We all have a civic duty to support those who are running for office. You should do your analysis on those seeking office and, with it, power. You may not agree with everything they stand for, but you should choose the one with the best ideas, voting your conscience with the fear of God. The fear of God is the beginning of wisdom. Best of all, if what the candidates have said and are now saying violates God's Word, then you must strongly object to it and reject it. You must stand up for what you believe and know is right without the adoration of humankind. God's law is holy. He spoke the Word, and it stood fast.

"We speak that we do know and testify that we have seen; and ye receive not our witness" (John 3:11). Joe Biden is a man of charm; although he is elderly now, he's still charming. He is also a bully and is filled with sarcasm. Bear with me for a while as I speak of my observations of the man, not what the Lord revealed in this case.

> What do I have to gain if I begin to commend myself again? Or do I need, like some people, letters of recommendation to you or from you? When you preach the Word and a person turns to God, you yourself are our

> letter written on your heart, known and read by everyone. When you tell the truth, it makes our faces shine on you. You show that you are a letter from Christ, the result of our ministry, written not with ink, but with the Spirit of the living God, not on tablets of stone, but on the tablets of the human heart. (2 Corinthians 3:3 NIV)

What I am basically saying is, as we go from day to day, we are all being read by everyone.

I have read many things about Joe Biden. Out in the open, he writes one thing, then the next moment he says, "I didn't write that. That's not what I said." I noticed Mr. Biden during one of his speaking engagements saying, "This is what I will do." The very next day, or the next week, or the next month, someone asked him the same question, and he looked the person dead in his eyes and said, "I didn't say that.'"

Mr. Biden rose up to prominence and has been sitting in a high seat for a very long time. He has had more setbacks than givebacks. When the Lord Jesus walked the earth doing good, He carried in His body the nature of the eternal God. They called Him a deceiver to His face; the man who came to save us by His grace, they rejected Him. But as many people as received Him to them, He gave power to become the sons of God, even to those who believe in His name for the saving of their souls.

Again, I ask, do you not expect me to take Mr. Biden at his own word? For by his words he is justified, and by his words he is condemned. If you are not able to take people at their word, then there's something wrong with you, and you cannot be trusted to make good on your word either.

CHAPTER 3
THIS IS REAL

Here on God's green earth, you cheat, invest, lie, purchase life insurance policies, scheme, and do all you can to attain power and prosperity. After you have done and attained all that, what comes next? It is certain that you will take nothing with you when you leave, yet most people are not securing the right life insurance or making the right investment. So, why worry about tomorrow? Why worry when things go wrong? All you must do is make up your mind and just do the right thing. Seek for eternal life; it is free. You had better seek the Lord today. All the other things you have sought for and gained, and all the things that you are now seeking after, are temporary. I sought the Lord, and He heard me; there is no need for me to be worried.

Many worried parents in our nation today are standing up against the controversial critical race theory. This issue has affected the Virginia gubernatorial race, which the Republicans will win. People are fed up with hypocrisy. When your eyes have seen and your ears have heard

things that you have the power to change, go ahead and make those changes. You have the right to train your children and your household in the way they should go. Instead, you are quick to blame others and point the finger.

What would happen if your children were being taught critical race theory? Would you suck it up and accept the change, or would you pretend as if nothing were happening? "Every way of a man is right in his own eyes: but the Lord pondereth the hearts" (Proverbs 21:2). Often we hide things that will expose our poor behavior and our bad deeds. We do not mind exposing others and telling their stories on the mountaintops and in the busy streets. Everywhere you go, you realize that others' stories are out there. You should realize that as you do to others, so shall it be done unto you.

Real Time with Bill Maher

Even Bill Maher is speaking up about critical race theory. When he was on MSNBC, he touched on the Hunter Biden debacle, which the news media avoided to benefit one political party but which now is dominating the news. Most likely Bill Maher's conscience was troubled by what he heard and saw in terms of the Biden administration's treatment of the teachers and parents who are worried about critical race theory being taught in schools and are fighting back. Here, Bill Maher was rising up and speaking about his party, being neither afraid nor ashamed to do so. He spoke from the heart. Never underestimate the power of change. That change begins with you and in you.

Miranda Rights

The purpose of Miranda rights is to ensure that individuals who are arrested are made aware of their right to refrain from making any statements that may incriminate them and their right to have an attorney.

To explore this concept, let me ask a hypothetical question: Say that I have just told you of my fraudulent organization that operates all over the country. Should you not check it out and investigate me? You should! What is it the problem then? Some things that you call fraud are not fraud at all. Some things are indeed fraudulent, but you turn and look the other way because of whom is alleged to have committed the fraud. Or you have some connection, so you turn and look the other way.

No one is holding Mr. Biden to his word, which he has given time and time again. Yet people are trying to skin Donald Trump and everyone who is connected to him. This is evil at its best! Every person who has had control of or power over the people must give an account to God for what he or she has done. Those who hold this power, rulers, should not be a terror to the people. They are supposed to be ministers of God, serving the people for good. The government rests upon God's shoulders. You can do nothing without Him. You live in Him and move in Him; you were created by Him.

The Word

Every day, "the Lord's voice crieth unto the city, and the man of wisdom shall see thy name. Hear ye the rod, and who has appointed it" (Hosea 6:9). The Lord God is demanding an answer, asking, "Should I still forget your ill-gotten treasures, you wicked nation, the United States, and the short, haphazard prayers that you prayed, which are accursed? Should I acquit someone with dishonest scales, with a bag of false weights?" God said that rich people are violent and are liars. Their tongues speak deceitfully. They have blasphemed the worthy name of Jesus Christ the great God. Although they pretend to love poor people, they actually despise the poor. The rich power grabbers drag others before the courts. They call it good business. "I, therefore, have begun to destroy you, to ruin you because of your dishonesty," God says.

"Are there yet not treasures of wickedness in the house of the wicked and the scant measure that is abominable? Shall I count them pure with

the wicked balances, and with the bag of deceitful weights? For the rich men thereof are full of violence, and the inhabitants thereof have spoken lies, and their tongue is deceitful in their mouth" (Micah 6:10–12 KJV). Just imagine how King David felt! He was the king, and then he was told his own son had been made king.

There are consequences for our actions. "Evil men and seducers will wax worse and worse, deceiving and being deceived" (2 Timothy 3:13 KJV). "Woe unto them that call evil good, and good they call evil" (Isaiah 5:20). Because of a person's dishonesty, all the things that he or she does are right in his or her own eyes. What a wretched, dishonest person such an individual is! Who shall deliver him or her? Only Jesus Christ can change a wicked heart as He did mine. He will not force anyone. He will never force Himself on you. You must get out of yourself and your religion and turn toward salvation in Jesus Christ. No other person can give you salvation. Someone might be shining like the sun and, whenever he comes by you, have bells ringing from his hips and thighs, having decked himself all over with gold. Still, he will not be able to save you, because of his tainted blood and his sin-filled nature, which is going to die soon. It might have already died.

THE BIG LIE

Mr. Biden has labored hard to get to where he now is. After seven months in office, things were not looking good for him. What seemed to be the problem? There must have been something he was not doing right. Had he placed all his staff in their rightful places, and had he manned the departments with the right people to get things done appropriately? Somebody must have an answer for all the things that are happening or not happening at all. Yet the Democrats all have an answer, called "the Big Lie." If you use the phrase *stolen election* or say that fraud was committed in the 2020 election, people in power will go out of their way to try to stop you head-on. If you say the election was rigged, then to them you are engaged in the Big Lie. And everything to

other names along with "white supremacist." To end this story, the jurors acquitted the young man.

After Mr. Biden was sworn into office, he immediately went to work and completely stopped the building of the border wall between the United States and Mexico. Bye-bye, baby! Then he canceled the Keystone XL Pipeline project. Bye-bye! Then he rescinded the "remain in Mexico" agreement. Wear the masks as we have ordered you to do, or bye-bye, baby. Take the vaccine, or bye-bye, baby. You'd better do what I say, or else you'll lose your job. These are some of the Build Back Better positions taken by Mr. Biden, his vice president, and his regime. It is amazing how the narrative has changed and the pendulum has swung since Mr. Biden took the reins of power.

BAD NEWS FOR JOE BIDEN

Mr. Biden's poll numbers are dropping bit by bit like water slowly dripping from a faucet or from a downspout hanging from a rooftop. His poll numbers are expected to go even lower as time progresses. It is a fact that neither Mr. Biden nor his team will be happy upon seeing these numbers. This is the man who touted the alleged fact that he received eighty million votes in the 2020 election. There is one thing that I know and am certain of: "God is not a man that he should lie" (Numbers 23:19). The coronavirus pandemic was created to hurt President Donald Trump in the 2020 election. Who can deny this? The coronavirus was used as a ploy and a means to create thousands and thousands of fake votes to gain the advantage. I believe God all the time, compared to anything I am told by humans a thousand times. "Surely the Lord God will do nothing, but He revealeth His secret unto His servants the prophets" (Amos 3:7). Be it known unto you that a faithful witness will not lie, not once.

Everything the current president has touched has resulted in a problem. The US-Mexico border is a crisis issue and a hot mess. It is hard to believe all the drugs pouring into the United States from Mexico. I say

do with Donald Trump and the 2020 election is a big lie according to them. The warp speed advocated by Mr. Trump was called a Big Lie. What is the reason for saying these things? For everything we do under the sun, there is a reason. Trump should not be credited with anything, people believe, and his push for election integrity across the country is called the Big Lie. It has been said that this kind of information is what has disenfranchised voters.

But the truth is, Mr. Biden won the election because of the fix. In all honesty, Mr. Biden did not receive eighty million votes. Just as King David's son Absalom was wheeled into power by trickery, so it is currently with Mr. Biden, who was certified as the winner. Now, you cannot deny that he lost. In my book *Make the Vision Plain* are these words: "All you people better turn to Donald Trump or suffer the consequences." Mr. Biden has been in the White House for a good while; the cries and complaints of the people are mounting.

Even though stimulus money has been appropriately given to millions of people across the country, still the people are not satisfied. Mr. Biden said, "America is back. We are going to build back better." But when I listen to the things that come from the mouth of the president, it makes me wonder: *Is this the man who is claimed to have received eighty million votes?* Look, my friends, my people, I love Mr. Biden with the love of the Lord. I would never disparage or belittle the president. I know better than that. I am just pointing out what I see as the facts. If I cannot speak the truth because I am worried about someone hurting me, then I should not be a servant of the almighty God.

Jesus, "who when He was reviled, He reviled not again" (1 Peter 2:23 KJV), was a man of dignity and discipline and one acquainted with grief. He has given us a sure word of faith. He reminded us, saying, "Remember the words that I said unto you: 'If they have persecuted Me, they will also persecute you; if they have kept my sayings, they will keep yours also'" (John 15:20). These days, fact-checkers are all over the place, yet they are unable to get the facts straight. Many things have been said about Kyle Rittenhouse, the young man who, in Kenosha, Wisconsin, on a night of looting, defended himself against attackers. He was called

to myself, *What I am looking on, is it real or not?* People from all over the world are pouring in at the southern border like bees from a hive and are given free passes to enter other US cities. Afghanistan is a hot mess and chaotic. It is hard to believe what has taken place in that country. Walking away, leaving behind eighty-three billion dollars' worth of property, was the president's doing. At the time of the rising up and pulling out of the country, thirteen US service members died and about eighteen were reported injured. I would say to Mr. Biden, "If you are willing to take the credit, you should be willing to accept the responsibility."

I voted for Mr. Biden and some members of the Democratic Party several times before. Then the Lord gave me exceptionally clever ideas. Why would you stand with and embrace someone who stands for same-sex love relationships? Why would you stand with those who embrace critical race theory? Why would you stand with those nincompoops and perverts who are teaching the children in some schools about lesbianism, homosexuality, and the gay lifestyle? Because they have perverted minds, and because wickedness resides in the high places of their hearts and minds, these people are doing the things they do.

People previously tried to hide their teaching of these things until the ideas stuck and took root. But how can you hide your sins before God? He knows your intentions and what you are thinking. He is the faithful and true Judge and knows your wicked heart. His Word gives you assurance. He will come through for you if and when you ask Him. When you break your promises, as you often do, only the faithful God keeps His promise to you. He will allow you to hear the truth and know the truth. It is a fact that under the current Biden administration, people are being persecuted for speaking up.

It is a fact that if you criticize the government or speak up for one reason or another and the socialist Democrats disagree with you, you are canceled right away. They are behaving like gorgons and duppy (ghost) conquerors. It has been said that Donald Trump is the biggest threat to our democracy and the Constitution. Everything that goes awry is the fault of Donald Trump. The mindset is to blame everyone else except oneself. "Do not blame the government, and do not blame the side that

I represent, as I will not appreciate that," they have said in effect. My desire, therefore, is that Joe Biden perform and make good on the vow that proceeded out of his own mouth.

Conceit and Deception

Those in power are taking away people's God-given rights, such as the right to birth your child. Teachers are teaching your children conspiracy theories in the schools and are doing many other things that they are hiding them from you, the parent. They are teaching students that it is OK for a boy to be called a girl and a girl be called a boy. I speak by the power of the almighty God. For God I live, and for God I die. I will stand and always speak the truth. "But the wicked shall do wickedly: and none of the wicked shall understand. But the wise shall understand" (Daniel 12:10). The wicked shall proceed no farther; their own folly shall be manifested unto all. An old Jamaican proverb says: "The cow cannot go farther than the length of its rope." I do hope you get my point. If you do not wish for people to know what is in your heart, just keep the door of your mouth closed. "For by thy words, thou shall be justified, and by thy words, thou shall be condemned" (Matthew 12:37). That is a fact!

If one is truthful and honest, then why would one hide all these things that should be public knowledge? All this mess is dysfunctional. The current administration have agreed that health insurance policies should pay for gender reassignment surgery. Men who have undergone a sex change operation are permitted to be placed in the women's section of a prison. It has now been reported that some women inmates have become pregnant by such men. How can this be if the prison is all female? Is there a wild male dog among the population manipulating the process? Or is it just the warden behaving as the bad boy? Whatever the situation is, what the Biden administration is doing is not working at all. You can change body parts, but you cannot change the truth of God that He has placed in the human body.

If you have risen to prominence and are well schooled but cannot

give the definition of a woman, then you are a blatant fool. You could be beaten in the mortar and still come out a fool, not knowing what you are or who you are. Look at yourself and tell me what you see. You are foolish; you will die unless you repent and change your ways and ask God to change your thought process. "And He will have mercy upon him; and to our God, He will abundantly pardon you" (Isaiah 55:7). I know He will.

Rising Up to Be the Light

A Fulbright scholar who holds four degrees from MIT, including his PhD in biological engineering, Dr. Shiva Ayyadurai started seven successful high-tech companies, providing thousands of jobs in Massachusetts. In his rising, he has dedicated his life to solving tough problems by identifying the root cause and bringing people together to innovate real solutions. The doctor has risen, exposing blatant and nefarious election fraud, including destruction of ballots. In his research, he found more votes than voters. He found that many votes were tabulated as decimal fractions, not as whole numbers. He has been very instrumental in the voter integrity investigation in Arizona and other states.

Dr. Ayyadurai has been remarkably busy, showing a pattern of behavior among both political parties who, knowing the truth about the fraud, the real fraud that took place, refused to act. The Democrats say there was no voter fraud; some Republicans say the same thing. President Trump cried foul. Some other Republicans did too. With all the evidence that has been exposed, still the legislators and Republicans who have control in several states are content to remain silent. There is something ultimately wrong with their behavior. Only a few Republicans have risen up, showing their willingness to pursue the truth about this vicious crime of the century.

Why is everyone so silent, not wishing to be transparent? Those who were elected to serve the people are doing so in disguise. Now that the voters are asking questions, those in power say, "There is nothing here

for you to see. In fact, we do not have to show you anything. Just leave us alone! We do not need nosy folks snooping around, trying to show us up. We will have none of that." But the citizens are not sitting idly by. They are rising up, speaking up, and taking action. Dr. Shiva is a true patriot. He has spoken up on many other topics and is willing to be effective. Many other patriots are following in his footsteps.

Speak Evil of No Person

It would be totally insane of me to speak about that of which I have no knowledge. I would be out of my mind to accuse someone of things of which he or she is not guilty. I speak that which I am told. "We speak what we know and testify that we have seen" (John 3:11). I will speak evil of no person. I will not be a brawler. I will be gentle, showing the meekness that God has given me to show to all humankind. There was a time in my life when I was foolish, as were you at one point in your life. "For we ourselves were also sometimes foolish, disobedient, deceived, serving lusts and pleasures, living in malice and envy, hateful, and hating one another" (Titus 3:3 KJV). Some got involved in different and diverse pleasures, men having sex with men, women having sex with women. We were filled with envy and kept malice within our hearts. We were all filled with hate and were hating each other for petty reasons, which often leads to hurtful feelings that cause death.

Jesus, the Christ, the Mediator in whose body God manifested Himself, is whom we preach unto the world. He came on our pathway and was effective at showing us the pattern for how to behave, live, and serve each other. Therefore, I will speak evil of no person. I speak the truth, which sets people free. There is such a thing as constructive criticism. I do not criticize to denigrate or to pull someone down unfairly. For God said I should "cry loud spare not, lift up [my] voice like a trumpet, and show [His] people their transgression, and the house of Jacob their sins" (Isaiah 58:1 KJV). I am commanded to show the people their

wrongs and to take heed of what I am saying. It's not easy, but I must do as I am commanded in order to be saved.

I am commanded, "Therefore judge nothing before the time, until the Lord come" (1 Corinthians 4:5). "But he that is spiritual judges all things" (1 Corinthians 2:15). "Yea, I judge not mine own self. But He that judgeth me, is Lord" (1 Corinthians 4:3–4). I know when I am right, and I know when I am wrong. All I must do is be honest to God, myself, and other people. I judge neither Joe Biden nor Donald Trump. They are both public servants serving the people. The current president and those behind the curtain are behaving like Pharaoh and his officials in Egypt. Pharaoh did not last! The honorable Joe Biden will not last.

Just look at the states that are run by Democratic governors. They are allowing the children to be taught pornographic ideas, such as men having sex with young boys, and girls having sex with girls. They are teaching children to hate the police. Giving the go-ahead, they are not afraid to instruct the children with these woke ideas. They are teaching the children to be racist. Do you not know that children are the future? They must be taught well, and then they will lead the way. We are no more than that which we are taught. The true preachers are rising, saying that there are only two genders, male and female. Just watch as we come storming back, refusing to be silent and speaking the truth in love, striving to keep the peace and holding to the truth. People with depraved minds are narcissistic.

God has allowed me to live, and, "I have seen a wicked and ruthless man flourishing like a luxuriant native tree, but he soon passed away and was no more" (Psalms 37:35–36 NIV). Such people will only be memory. We will keep looking for them but will be unable to find them, for death will have taken them away. How can we allow people to teach other people's children these crazy, indecent "woke" things? There are those who have set themselves to do evil. Can any good thing come out of their mouths?

God has given us the power to change our situation. Let us rise and do it wisely.

Elections Have Consequences

Look at what is happening today in our country. Just look at the consequences we are facing because of a stolen election. Mr. Biden's rise may not have been God's idea, but nothing was done without God's approval. He allowed it to happen to teach the people a lesson. Brother Achan stole the Babylonish garment and hid it in his tent under his stuff. Israel went to war and was completely humiliated. Joshua cried to God about the problem. God told Joshua that the people had sinned and had transgressed the covenant that He had commanded them, for they had taken of the accursed thing and hidden it among their own stuff.

The loot has been hidden. There are many individuals involved in the conspiracy. Because of this, we see these draconian-style behaviors and policies. For a long time, the Democrats and their allies have been trying to take control of your children. They are of the opinion that big government should be in control of your children. Now that they have the power they need, they can place whatever they want in libraries, schools, and even college textbooks and curriculums without your having a say in, or any input into, the matter. In order to carry out their ideas and policies, they use force or steal, and then claim that they are the true winners. Now you can see the real reason why many are seeking power, gaining power, and holding on to power. "Now that I have what I need, I will do whatsoever it takes to accomplish my goal and my ideals. If you are foolish enough to keep voting for us and letting us rule over you, don't blame us. Blame yourselves."

Our Request

Two of Jesus's followers, James and John, the sons of Zebedee, came unto Jesus and asked Him if they could have whatsoever they desired. "And He said unto them, 'What would ye that I should do for you?' They said unto Him, 'Grant unto us that we may sit, one on Thy right hand, and the other on Thy left hand, in Thy glory'" (Mark 10:36–37). Jesus

reprimanded them for being foolish and for having no understanding of what they were really asking. Jesus immediately set the record straight. He told them they could have that opportunity, but it was incumbent upon what they did.

> And when the ten heard it, they began to be much displeased with James and John. But Jesus called them to Him and saith unto them, "Ye know that they which are accounted to rule over the Gentiles exercise lordship over them; and their great one's exercise authority upon them. But so shall it not be among you: but whosoever will be great among you, shall be your minister: and whosoever of you will be the chiefest, shall be the servant of all. For even the Son of man came not to be ministered unto, but to minister, and to give His life a ransom for many." (Mark 10:41–45)

Let those seeking power strive for excellence in the making and doing of good. Fulfill the performance whereof with your mouth you vowed to the great King (Jesus Christ our God) of heaven, saying what you intended to do. So, whatever proceeds out of your mouth, do it. Be not overwise in your saying and in you doing.

When you have sinned against your own soul, who will honor and justify you? Evidently, you will not be able to justify yourself before the great king Jesus, our God. He will bring you very, very low and will hide Himself from your face when you call out His name. Let your words be sincere, and in no way speak against the truth. When you see a need and you have the occasion to do good, do not refrain to speak, and do. You, Joe Biden, were very eager and wanted to be not just vice president but president. And God said, "I saw what you did and how it was done. I allow the fraudulent organization you have set in place to exist. Nothing that you did will ever escape My eyes.

When a man as you, Mr. Biden, cunningly and secretly does such a thing, saying thus in your heart, "Who will see and know what I did?

What need I to fear? God will not remember this little thing. I have all my bases covered; I am well organized," you cleverly conceal your actions. For, "Such a man only fears the eyes of men and knows not the eyes of the Lord are ten thousand times brighter than the sun, beholding all the ways of men, and considering the most secret parts. He knew all thing ere ever they were created; so also, after they were perfected, He looked upon them all" (Ecclesiastes 23:19–20).

CHAPTER 4
STAKEHOLDERS

Dr. Miguel Cardona, secretary of education, said when testifying before Congress, "Parents should not be the only stakeholders in the children." He was asked to explain what he meant by that. He continued, "I believe the government should be stakeholders in what [the children] learn."

I am a little voice crying out, rising and declaring God's truth. Hear the Word of the Lord since you are clever and wise. The voice spoke to me, and in my spirit, He declared,

> And Joseph died, and all his brethren, and all that generation. And the children of Israel were fruitful, and increased abundantly, and multiplied, and waxed exceedingly mighty, and the land was filled with them. Immediately there arose a new king over Egypt which knew not Joseph. And he explained unto the people how

> the Israelites have become too numerous for us. "Look," he said to his people, "the Israelites have become far too numerous for us. Come, we must deal shrewdly with them, or they will become even more numerous and, if war breaks out, will join our enemies, and fight against us and leave the country." (Exodus 1:7–10 NIV)

It is amazing how God can deal with the human mind and show us things to come, or confuse us to accomplish His will.

> So, they put slave masters over them to oppress them with forced labor, and they built Pithom and Rameses as store cities for Pharaoh. But the more they were oppressed, the more they multiplied and spread. So, the Egyptians came to dread the Israelites and work them ruthlessly. They made their lives bitter in harsh labor in bricks and mortar and with all kinds of work in the fields. In all their harsh labor the Egyptians worked them ruthlessly. The king of Egypt said to the Hebrew midwives whose names were Shiphrah, and Puah, "When you are helping the Hebrew women in childbirth on the delivery stool, if you see that the baby is a boy, kill him; but if it's a girl let her live.' The midwives, however, feared God and did not do what the king of Egypt had told them to do; they let the boys live. … The king of Egypt summoned the midwives and asked them why they did not do what he had asked of them. He asked them why they allowed the boys to live. The midwives explained to Pharaoh, because the Hebrew women are not like Egyptian women; they are vigorous and give birth before the midwives arrive. For every action there's a reaction. So, God was kind to the midwives, and the people increased and became even more numerous. And because the midwives feared God, He

gave them families of their own. Then Pharaoh gave this order to all his people: "Every Hebrew boy that is born you must throw into the Nile, but let every girl live." (Exodus 1:11–17, 20–22 NIV)

In Exodus 2:1–10, you will find written that a man of the tribe of Levi went and married a Levite woman, and she became pregnant and gave birth to a son. When she saw that he was a fine child, she hid him for three months. But when she could hide him no longer, she got a papyrus basket for him and coated it with tar and pitch. Then she placed the child in it and put it among the reeds along the bank of the Nile. The child's sister stood at a distance to see what would happen to him. Then Pharaoh's daughter went down to the Nile River to bathe, and her attendants were walking along the riverbank. She saw the basket among the reeds and sent her female slave to get it. She opened it and saw the baby. He was crying, and she felt sorry for him. "This is one of the Hebrew babies," she said.

Then the baby's sister, Miriam, asked Pharaoh's daughter, "Shall I go and get one of the Hebrew women to nurse the baby for you?"

"Yes, go," she answered.

So, the girl went and got the baby's mother. Pharaoh's daughter said to her, "Take this baby and nurse him for me, and I will pay you." So, the woman took the baby and nursed him. When the child grew older, she took him to Pharaoh's daughter, and he became her son. She named him Moses, saying, I drew him out of the water."

Pharaoh rose to destroy the lives of all the boys born in Egypt because he was afraid that one of them would rise up to challenge him. He also believed these boys would grow up and join in a rebellion if war were to break out in the country. Therefore, according to his wisdom, he gave the order to kill all the boys or throw them into the water so they would die. When God is for you and has His hands upon you, it does not matter who is against you. When God is on your side, wherever you are placed to be destroyed, someone will find you and spare your life.

You will be drawn out, taken up, and taken out of the destruction to be cared for.

God's Children

In Exodus 1, you will notice that God oversaw His people. He taught them very well. The new king and his government who did not know the power and wisdom that had been given to Joseph's heirs decided to be the only stakeholders in their lives. The taskmasters were told to kill the boys and save the girls. Not one question was asked of the parents to get their input or their opinion on the matter, but the people of God who are called the children of Israel, who fear God, rose up and did the right thing.

We will obey the law when it lines up with God's law. God's law is righteous and holy. But when it comes to the fear of God, and that which is honest and right, "we ought to obey God rather than men" (Acts 5:29 KJV).

Moses was born exceedingly fair; he was nourished and raised up in his father's house for three months. When he was cast out into the water, Pharaoh's daughter took him up and nourished him as her own son. He was educated in all the Egyptians' wisdom and in their speech and actions. His mother, Pharaoh's daughter, was instrumental in his life in terms of applying what he had been taught. Moses was taught to fear of God, and he stood up for what he thought was right. He stayed with Pharaoh until he was forty years old.

In Acts 7:23–27, we read about the time when it came into Moses's heart to visit with his people:

> When Moses was forty years old, he decided to visit his own people the Israelites. He saw one of them being mistreated by an Egyptian, so he went to his defense and avenged him by killing the Egyptian. Moses thought that his own people would realize that God was using

him to rescue them, but they did not. The next day Moses came upon two Israelites who were fighting. He tried to reconcile them by saying, "Men, you are brothers; why do you want to hurt each other?" But the one who was mistreating the other pushed Moses aside and said, "Who made you a ruler and judge over us?" And here he sarcastically claimed that Moses was trying to kill him as he killed the Egyptian the day before. Then fled Moses at this saying, and was a stranger in the land of Midian, where he begat two sons." (Acts 7:23–29)

"After forty years had passed, an angel appeared to Moses in the flames of a burning bush in the desert near Mount Sinai. When he saw this, he was amazed at the sight. As he went over to get a closer look, he heard the Lord say, 'I am the God of your fathers, the God of Abraham, Isaac, and Jacob'" (Acts 7:32 NIV). Moses, afraid, trembled while he kept on looking. Then the Lord told him, "Put off thy shoes from thy feet, for the place where thou standest is holy ground" (Acts 7:33 KJV). The Lord God told him: "I have indeed seen the oppression of My people in Egypt. I have heard their groaning and have come down to set them free" (Acts 7:34 NIV). "If the Son therefore shall make you free, ye shall be free indeed" (John 8:36).

The Lord God told Moses, "Now come, I will send you back to Egypt" (Acts 7:34 NIV). Amazingly, the Lord called the same Moses whom the people had rejected and refused because he had made himself a judge and a ruler over them. "The same did God send to be a ruler and a deliverer by the hand of the angel who appeared to him in the bush" (Acts 7:35). Moses returned to Egypt to school the king and those who were both old and young. "But God has chosen the foolish things of the world to confound the wise … and God has chosen the weak things of the world to confound the things which are mighty that no flesh should glory in his presence" (1 Corinthians 1:27, 29). Our God is impressive. "The Lord lifteth up the meek: He castest the wicked down to the ground" (Psalms 147:6 KJV). I will never let go of this awesome God, Jesus Christ.

You Teach Your Children

When you are called by God and commissioned, you will not be afraid to speak His Word, as He told Moses, "These are the commandments, the statues, and the judgments that I the Lord your God commanded." Moses did not hesitate to tell them to Israel so that they might honor such commandments in the land that they were going to possess.

> That thou mightest fear the Lord thy God, to keep all his statues and His commandments, which I command thee, thou, and thy sons, and thy son's son, all the days of thy life, and that thy days may be prolonged. Hear therefore O Israel and observe to do; that it may be well with thee, and that you may increase mightily, as the Lord God of thy fathers promised thee.

> Hear O Israel, the Lord our God, is one Lord. And thou shall love the Lord thy God with all thy heart, with all thy soul, and with all thy might. And these words which I command thee this day shall be in thine heart. Thou shall teach them diligently unto your children. And shall talk of them when you sittest in thine house, and when thou walkest by the way, when you liest down, and when thou risest up. And thou shall bind them for a sign upon thy hand, and they shall be as frontlets between thine eyes. And thou shall write them upon the post of thy house, and on thy gates. (Deuteronomy 6:2–9)

This is true rising up for real.

So, to say that you believe that the government should be co-stakeholders in what our children learn is to be wrong. For God taught us, His bigger, older children, to teach our children the things that are right and just. Can you please tell me, somebody, when the right

to teach our children was given to the government? Why are the schools disguising this fact and keeping this critical information from parents? Critical race theory has become part of schools' curriculums. It is intertwined and woven throughout school curriculums in the United States. It is only right that schools should strive to teach history to the max.

Teaching one part of history and blotting out and hiding another part does not mean that the event or thing did not happen and does not exist. You record the happenings of the past and teach children of current events. You look at the great gains and successes that black people have achieved in the United States and allow this to be the driving force to propel us into the future, saying that the process should be emulated. To teach that black people are being oppressed and black people are left behind is to say that blacks have not attained high office. Barack Obama was made president by the people of the United States. He, not Hillary Rodham Clinton, was chosen. Black people have risen to the highest heights possible in the United States. It is so real!

Getting to the White House is the greatest achievement, the highest office anyone can reach, and Obama reached it. So, to teach otherwise is ludicrous. To believe otherwise is insane. I have my God-given freedom while striving to do those things that are right. The opportunity to get a decent education and be taught about God's existence is the best thing that could ever happen to any of us. In this country, we must be taught the truth. Only then will we be able to know, accept, and embrace it. Our children must be taught the bad, the good, and the horrible. It will all make sense in the end.

Why Hide the Things You Do?

Then the Lord said, "Shall I hide from Abraham the thing I am about to do? Abraham will surely become a great and powerful nation, and all the nations of the earth will be blessed through him. For I have chosen him, so that he will command his children and his household after him to keep the way of the Lord by doing what is right and just,

so that the Lord will bring about for Abraham what He has promised him" (Genesis 18:17–19 NIV). Communists hide things! Socialists and thieves, in order to gain an advantage, conceal things that they do not wish others to investigate or find out about. To keep the people from looking into what is happening is the best way to push programs and policies, and when the people become aware of a new policy or program, it is too late. We all need transparency. Please, rid our schoolrooms of conspiracy theories. Why would anyone teach children about a man putting a boy's private body part in his mouth unless there is some nefarious ulterior motive? How is it OK to instruct children about men dating boys and having sex with them? Some teachers are instructing girls twelve years old and under that it is OK to have sex and, if they become pregnant, not to worry. "We have the answer to all your problems. We will help you get rid of the pregnancy and hide it from your parents."

These people are depraved, are sick, and have smutty minds. Get rid of those crazy thoughts; learn to do well. The conniving governing operatives rose up, hiding, teaching from behind the curtain, hoping that the things being taught would remain hidden. "For nothing is secret that shall not be made manifest; neither anything hid, that shall not be known and come abroad" (Luke 8:17 KJV). Whatever is being kept secret will be brought out into the light, out in the open, so that all may see the evil the communists and the socialists are engaged in. Because the 2020 election was fraudulently stolen, we are now experiencing consequences. In such a brief time, many detestable and horrible things have happened—and are still happening all over the place.

Sick Minds

The mess must be cleaned up, or the stink will continue to spread out of control. We see that parents are listening very carefully and going into these schools as a bull that has taken something by its horns, speaking up and exposing the mess. When the people are tired and fed up with circumstances and have a mind to work and do so without partiality,

people will take notice and the followers will be many. Deception will only take place when people are not aware of what is really happening. Our ancestors were deceived, kept on the plantations and denied an education. But as time moved on, they started wising up and began fighting for their basic rights. We can now look back and reflect on this and say, "We have truly come a long way."

To keep dealing in conspiracy theories, hoping to convince black people that they are victims of white oppressors, is to keep peddling something that is far from the truth. Those doing the teaching are the real conspirators and oppressors, and they are doing everything in their power to conceal the truth, as they do for many other things. For us to rise up above our circumstances, above our community, and above our environment is to be involved in the education that is available. Just as Moses was learned in all the wisdom of the Egyptians and became mighty in word and deed because he was obedient to the voice of God, and the Lord God taught him all that he needed to know, the same is available to you.

Rising Up to Be Teachers of Good Things

In *The Holy Scriptures*, compiled by the First Church of Our Lord Jesus Christ in Philadelphia, Pennsylvania, in Jasher 47:7–8, these words are recorded:

> And Isaac called Jacob and his sons, and they all came and sat before Isaac, and Isaac said unto Jacob, "The Lord God of the whole earth said unto me, 'Unto thy seed will I give this land for an inheritance if thy children keep My statues and My ways, and I will perform unto them the oath which I swore unto thy father Abraham.' Now therefore, my son, teach thy children and thy children's children to fear the Lord, and to go in the good way which will please the Lord thy God, for if

> you keep the ways of the Lord and His statutes, the Lord will also keep unto you His covenant with Abraham, and will do well with you and your seed all the days."

The fear of the Lord should be the ultimate goal of all our teaching. "Every good gift and every perfect gift is from above, and cometh down from the Father of lights, with whom is no variableness, neither shadow of turning" (James 1:17).

> And Joseph's wife Osnath the daughter of Potiphera bore him two sons, Manasseh and Ephraim, and Joseph was thirty-four years old when he begat them. And the lads grew up and they went in his ways and in his instructions; they did not deviate from the way which their father taught them, either to the right or to the left. And the Lord was with the lads, and they grew up and had understanding and skills in all the affairs of government, and all the king's officers and his great men of the inhabitants of Egypt exalted the lads, and they were brought up among the king's children. (Jasher 50:15–17)

There is an evil that I have seen under the sun, the sort of error that arises from a ruler: fools are placed in in many high positions. Most of them have a communist mentality and are dictators. We all have seen what communists and dictators have done in places like Cuba and Venezuela. It is very evident when the government begins to force people to take jabs in their arms and wear masks, or else lose their jobs, it is well weaved with communism and is dictatorial in nature. Just as Pharaoh in Egypt gave the order to kill his own people, killing their hope and their dreams, the rulers of the United States are enacting legislation that is detrimental to the people of the United States. The very people who were out risking their lives are now threatened with losing their livelihoods.

People are rising up and fighting back against conspiracy theorists and tyrants all over the country.

How long shall the wicked reign over you while you just sit back and suck it up? You must fight for your rights and never give up or run away. Even if you were to run, be bold and return with fervor, never giving up the fight. Fight for what you know is right, and fight for transparency. Moses returned to Egypt to face the king and brought forth a great deliverance as a judge and a ruler. Sometimes it is good to run and settle elsewhere, then just let them watch you come storming back.

Cuba in Chaos

Fidel Castro rose up in Cuba and took hold of power by force decades ago. He indoctrinated the minds of the people and their children with his communist ideology. Although there are many brilliant and smart people in that country, their lives have never been the same. The government controls the people, contends with the people, and teaches conspiracy theories. The government pays them, and now they are hooked, held, and kept under a barbarous regime. They are only partially free because the authorities have held them captive. By whom you are held captive, you are their servant and must contend with their dictates.

If at any time the spirit of a ruler rises against you, leave not your place, for yielding pacifies great offenses. And only the power and Spirit of the almighty God can break up strongholds. God will make a way for all those who desire to do good and do the right thing. But wicked and evil men and women only get worse.

You are brainwashed with, or born having, the mentality of a dictator. The devil is a dictator. People do just as their father the devil teaches them. As you grow, you show signs of your learning ability and the direction in which you are heading. You will need to possess the power of God or have His intervention in your life to break up those catechisms and the folly grounds of your heart and mind. When the hyenas and

lions grab hold of their prey, only Jesus Christ will show mercy, or you will be destroyed by those teeth. When you have wholly obeyed and put all your hope and trust in the Lord God, He will deliver you right on time. He will deliver you when people rise up against you and ride over your head. He will be right there with you.

Venezuela in Chaos

Venezuela was a thriving country. Its sale of oil sustained the people, and the country was stable until its ruler died. An election was held, but it was rigged. By using the Dominion voting machines and others, which change votes in real time, fraud was perpetrated. The real president, Juan Guaidó was subjected to a "terrifying ordeal." Because of the fraudulent election, which Nicolás Maduro won by fraud, Venezuela is engulfed in chaos. Two men claimed to be the rightful leader of the country. The former National Assembly leader, Juan Guaidó, who was appointed acting president in January of 2019, pushed to oust Madura, who took over after Hugo Chavez in 2013 and has consolidated power across the country, which he maintains with an authoritarian grip.

Guaidó is backed by the United States and has declared Maduro illegitimate. These two men are at the heart of democratic crisis in Venezuela. The root of the crisis developed years earlier, with the crisis accelerating after the death of Chavez and the collapse of the socialist, state-managed, oil-dependent Venezuelan economy. Despite being established as holding the world's largest oil reserves, the country's debt exploded. Inflation intensified the stress that was already on an economy going in the wrong direction. The huge vacuum that Chavez left, his right-hand man, Nicolás Maduro, stepped in to fill. Amid a fire that caused a total economic meltdown, Nicolás Maduro is still clinging to power. Laws were imposed that totally wiped out all pretense of Venezuela's being a democratic country.

Although members of the opposition were elected by a large majority in 2015, which led the National Assembly, the single-body legislature

that is Venezuela's version of Congress. They tried to put Maduro under their control with their newfound power. Maduro rose up quickly and called a special election, which took place in 2017. It was widely denounced as rigged. Because of that election, a constituent assembly, a 545-seat body filled with loyalists to Maduro, was formed with one purpose in mind: to draft a new constitution for Venezuela. Since then, the constituent assembly has granted itself unlimited virtual powers and refuses to recognize the National Assembly under Mr. Guaidó, preventing the National Assembly from passing any laws. In fact, the constituent assembly has banned the National Assembly. Do you get my point of view and see the direction that I am pointing out to you?

So, my beloved friend, as you can see, consequences come from having an unfair election. We all need free and fair elections. But when you have conceited, self-serving, wicked men and women in control, all you have is shipwreck. Mr. Maduro's Supreme Tribunal of Justice (Supreme Court) is filled with those loyal to him and to the late Chavez. After the strong uprising, the tribunal dissolved the National Assembly under Mr. Guaidó and granted themselves the power to write their own laws, creating one-party rule in the country. An uprising erupted in 2017, fueled by hundreds of thousands of Venezuelans who were opposed to the destruction of electoral democracy and alarmed by a deteriorating economic situation that left millions strapped in poverty and starvation, lacking basic medical care and even electricity.

The inflation rate of Venezuela, an oil-rich country, currently stands at about 1,000,000 percent. More than a million residents have fled the country. The wicked Maduro sent the military and his security forces to crack down on the protesters; that operation sometimes turned deadly. They detained political protesters without trial. Opposition party members have been detained and jailed. The sadistic Maduro has the army under his control; the larger portion is loyal to him. He also has the vigilante units called *colectivos*, which are estimated to be about 1.6 million strong, under his control. They run the intimidation campaigns against the population and democratic protesters.

The telegenic, vibrant, young Guaidó has argued that he is the

rightful president. He classified Maduro as a usurper. Maduro's previous presidential election was in 2013, when he won by a narrow margin over his opponent, Henrique Capriles, who described the win as "an illegitimate process." The United States has supported Mr. Guaidó's claim to the presidency. Russia backs Mr. Maduro. Mr. Trump and his administration refused to recognize Maduro's government, calling him a dictator, and hit his regime with financial sanctions that further crippled and weakened the economy.

Maduro, the dictator, sent his forces to detain Guaidó and his chief of staff, putting them in jail. In February 2019, Mr. Guaidó traveled to Colombia for a summit, where he asked regional leaders for backing and help. There he met with then vice president Mike Pence, who expressed US support for Guaidó's leadership. At that same time, Maduro's troops, at his order, unleashed tear gas on the Venezuelan people and blocked trucks loaded with humanitarian aid supplies. The very next day, Mr. Guaidó rose up, announced that part of the military supported his claim to the leadership, and called on Venezuelans to rise up against the Maduro regime in an effort he called Operacion Liberttad (Operation Freedom). There was a large crackdown by Mr. Maduro's security forces. That very night, Mr. Maduro claimed victory. Mr. Guaidó called for no more protests, leaving the economy and the presidential crisis to continue in its current form.

MANY TROOPS SURROUNDED THE WHITE HOUSE

Shortly after the January 6 episode, several thousand troops descended upon Washington, DC, where they remained until May 24, 2021. It was a remarkable sight. Many soldiers were in the Capitol and surrounding the White House. One wonders, *Is this a Third World country mentality under siege, or what?* All this happened because of an unfair and fraudulent election that God revealed to me before it took place on November 3, 2020. The election was stolen for the sole purpose of defaming and defeating Donald Trump, making him look bad and stupid.

If this information had been conveyed to the citizens by the news outlets and pundits, it would have influenced President Trump to give up and just walk away as a nice loser, when in fact he really won. The president still has not conceded the election. He is working extremely hard to prevent the country he loves from becoming like Cuba and Venezuela. "A little leaven leavens the whole lump" (Galatians 5:9). So, Mr. Trump is busy doing everything he can to get the right people in place and make sure that election integrity is in force. The cancer of fraud is all around. Trump's rising up is like nothing you have ever seen before. He is trying his absolute best to cut out the cancer before it metastasizes and spreads any further. If he fails, then very, very soon this country will become like Cuba and Venezuela. Watch!

CHAPTER 5

BLACKS ARE RISING UP FOR TRUMP

Years ago, the Republican Party was able to garner only 5 percent of the black vote. For one reason or another, blacks in the beginning supported Republicans. Now it is the Democrats who have the support of blacks, including African Americans. I assume that economic issues were as important then as they are now. Bill Clinton was very instrumental. During his run for the presidency in 1992, he campaigned on the slogan "It's the Economy, Stupid." This phrase was cleverly coined by James Carville. Blacks loved it, and they flocked to Clinton and voted for him. He won by a landslide. After Bill Clinton came Barack Obama, whose campaign slogan was "Hope and Change," neither of which ever materialized. Yet still Obama shattered the black vote and won over John McCain.

Then came Donald Trump. Despite the bombastic nature of his

tone, there was something about his voice and words that struck blacks as genuine. Mr. Trump asked the black voters his now famous question, "What the hell do you have to lose?" Blacks gravitated to Trump in their hour of need. In 2016, Trump received 8 percent of the black vote. In 2020, that number changed as a massive number of blacks rose up for him. Blacks decided it was the right time to make a change. The time was right to cross over, but they kept their intentions under wraps! When they were asked by the media and those who did polling surveys, they never mentioned Donald Trump at all. They rose, went to the voting booths, and did the honors for him.

Donald Trump has opened Pandora's box and has shined a light on many of the things that both the Democrats and their allies were up to. Because of his bluntness in telling what he calls the truth, he continues drawing people to him like a magnet. Trump has a swagger when doing the things he does best at his rallies. Then comes the roar and the shout from the crowd, "We love you; we love you; we love you." His response to them is, "I love you too." No one I have ever seen or read about is able to draw a crowd like Donald Trump.

Mr. Obama, in his time campaigning, drew large crowds, but nothing compared to the crowds drawn by Donald Trump. No one has ever shouted out and sung for a presidential candidate like people did for Trump. People attract people, and Trump is attracting a lot. Everyone who runs for office will always attract somebody. But to get people to turn out in great numbers and cross party lines to vote for you must be something special. As in a relationship where you grow to love another person over time, so it is with Mr. Trump. Just as it is in a marriage, where you grow to love your husband and your wife, so the people are loving Donald Trump.

Oh, how they love him! That's the reason they are crossing over. As Stephanie Mills sings in her 1982 song, "True love don't come easy." It has not been easy for Mr. Trump, but he keeps right on Trumping his way into the hearts of the people. He is now receiving his due. The forty-fifth president, and may I say forty-sixth also, is one of the greatest of our time. You will not find another of Trump's likeness. In the

same way you see people singing and shouting "We love you," you also see those who are opposed to Trump's rhetoric, calling the media "the enemy of the people." In everything you do in life, there are those who are for you and those who are against you. But the Word of God has the answers for all your struggles. The Word of God has the answer to why you do the things you do. The Word of God has the answers for your hating, and your love, and all of your pretending.

"Love is patient, love is kind; love does not envy; it does not boast, it is not proud; love does not dishonor others. Love is not self-seeking. Love is not easily angered. It keeps no record of wrongs. Love does not delight in evil but rejoices in the truth. It always protects! It always trusts! Love always hope and always perseveres" (1 Corinthians 13:4–7). The people are saying, "We love God, and we love Donald Trump." There are certain groups behaving like crows, viciously sitting on top of the flying eagles, biting and pecking away as the eagles glide through the sky. Sometimes the eagles start flapping their wings, leaning from one side to another just to avoid the pain and pressure of the bites, figuratively speaking. Donald Trump is doing the same thing. His haters are on his back for the ride. He is gliding as best he knows how.

Trump has the gravitas, and if you listen to him for long, he will probably change your mind. That's why he has lots of people following him. News media canceled him from their platforms so that his followers could not hear his messages or his voice, or know his next move. The news media loved on him for their ratings, but all that changed in 2020. The reason for this is that he called them "enemies of the people" and "fake news." They all have an agenda, and Donald Trump does not fit within their circle, as he goes against their narrative.

So, they, the big bosses, social media and the top-notch reporters among the news media, decided to act aggressively against Trump. They thought that by canceling him and shutting him out, the people would give up on him and turn against him. But what they did backfired on them. They forgot that Trump was holding a magic wand. He found a way to keep his proud patriots informed.

BUILD BACK BETTER

Mr. Joe Biden affirmed that the theme for his presidency would be "Build Back Better." But on January 20, 2021, when he was sworn into office without the concession of the real president, he went straight to work rolling back the programs that were in good order. Joe Biden made the most rollbacks that have ever been made by any president in one day. This he did to prove he could. Because he now holds the key and the pens, he erased all of Trump's accomplishments and achievements. He stopped the building of the border wall; he stopped the Keystone XL Pipeline; he reopened the border; and he did many other things, all of which caused him to be seen as a big bad bully.

Heaven knows Joe Biden is president, but he is not the true president. He did not win the 2020 election fairly. He and those working on his campaign waited and waited until they knew exactly how many votes they needed to overcome Trump's lead, then they added that exact number. The real president is Donald Trump. Because the office was attained beneath such a shadow of clouds, those clouds are still hanging over Joe Biden. He came to power with a Stalin mentality, a "big bad bully" attitude, so all could see how radical he really is.

To put an end to Donald Trump's successful achievements, the Biden administration stopped building the border wall. To stop Trump's success, Joe Biden rolled back Trump's "remain in Mexico" policy. To eliminate Trump's gains, Biden stopped building the Keystone XL Pipeline. Mr. Biden signed seventeen executive orders on his first day in office. This is what God revealed as the fix. Mr. Biden claimed that nine out of the seventeen executive orders were controversial. Biden is the VP I saw back in 2007 when I had my vision. I love this man with the love of the Lord. It would be very foolish of me to speak evil of him or anyone else.

Who is it that condemns? "And this is the condemnation that light is come into the world, and men love darkness rather than light, because their deeds were evil. For everyone that doeth evil hateth the light, neither cometh to the light, lest hid deeds should be reproved. But he that

doeth truth cometh to the light, that his deeds may be made manifest, that they are wrought in God" (John 3:19–21).

As a true and honest seer who has been commissioned to cry aloud and spare no one, lift up your voice like a trumpet and show the people their wrongs. To do otherwise is to disregard authority. You should not just go about criticizing for the purpose of destruction and prating against anyone with your words. But you should be critical for the purpose of edification, speaking the truth in love, encouraging others to do the same. "I urge, then, first of all, that petitions, prayers, intercessions, and thanksgiving be made for all people—for kings and all those in authority, that we may live peaceful and quiet lives in all godliness and holiness. This is good and pleases God our Savior, who wants all people to be saved and to come to the knowledge of the truth" (1 Timothy 2:1–4 NIV).

If Mr. Biden is the true and honest winner, then why all the secrecy? The people want to be very sure who the real winner is. God knows the winner and chooses the winner. He showed me the winner. I hope you do not have a problem with what I just said. "An honest witness does not deceive, but a false witness pours out lies" (Proverbs 14:5 NIV). If I have committed fraud, I do not want anyone taking a closer look at what I have done or what I am doing. That is a fact. But if you have a problem with what I say, take the issue up with God. I am commissioned to cry aloud and spare no one, to lift my voice as a trumpet. I have no problem obeying my God.

Mr. President, you refuse to submit to an audit when one is requested; you have a problem with those who are asking for one. I assume you know very well what they might find. So, what do you do? You proceed to hide and destroy the evidence. You drag things out until the cries die down. When action is taken, the declaration of "No standing!" is heard. To prove me wrong, submit to an audit. Let the whole truth be known, and I and those like me will be satisfied.

Someone Has a Problem

In September 2019, while I was completing the final addition to my first book, *Make the Vision Plain: The Lord Showed Me Donald Trump—Others*, before it was sent to press, I sent a letter to President Trump by way of certified mail. In my letter, postmarked September 11, 2020, I told Mr. Trump what I had seen. My letter reads as follows:

Mr. Trump,

On April 19, 2015, the Lord God shewed me Donald Trump, who came in the building where I was, as president of the United States. As of February 10, 2020, I was taken to the DC Central Detention Facility. While I was there, in March, the Lord showed me these words: "The coronavirus pandemic was created to hurt President Donald Trump in the upcoming election."

On October 20, 2020, I sent an email to a few friends and family members, saying, "This is your man, the dreamer of dreams. Make the vision plain. I sent a letter out to the president, Donald Trump, letting him know what God has done. I told him in the letter the Lord had chosen him to be president in 2015." When I was locked up in Morgantown, West Virginia, you walked in the building where I was, as president of the United States. After I had made mention of it to many of the guys who were locked up with me, they said lots of crazy things and did not believe me. I told them, "If Trump is not the president, God has not spoken to me." The Lord has chosen you and not Joe Biden as president.

"The Lord has chosen you, and there is nothing the Democrats can do about it until Mr. Biden, his

supporters, the media, and you, sir, know that the Highest God rules over the kingdom of humankind and gives the office to whom He will. You are doing a good job, sir; keep up the excellent work. The Lord has chosen you for such a time as this, and there is nothing that your opponents can do about it. He has confirmed that he has received the mail.

Some responded favorably to the email; a few were critical of it and made derogatory comments, which does not change the fact of what is to be. I know that I am blessed when people ridiculed me and say all manner of evil things against me. I rejoice in the Lord and am glad about it for I have touched a few nerves.

I will not retaliate, because judgment belongs to God. He will repay me for my hurt. I cannot allow my flesh to get the best of me. When my flesh rises and tries to convince me to take matters into my own hands, to cuss somebody out, I grab hold of my flesh and bring it into subjection to God's Word. Jesus Christ is risen in me. I am not my own. I am bought with the precious blood of Jesus Christ our Lord. I will never be caught up in politricks, as some people call it, but I speak truth in love. And we know that some people love truth. Others do not mind being lied to all the time. They are foolish and will not come to knowledge of the truth.

Power belongs to God; He gives it to whomever He pleases. What if some people do not believe? Their unbelief will not make the truth of God ineffective. God is Truth, and He is without iniquity. He cannot lie. We have two presidents! One has been chosen, and one was given the presidency because of the fix. You can take it or leave it. Let God be true. Trump is the winner. Why don't you, Mr. Biden, prove me wrong and audit all the states as the people have asked? I will gladly humble myself if it comes to pass that I have spoken from my own mouth and was not inspired by God to do so. For of myself I know nothing. God revealed His secrets to His son who serves Him. All of us know when we

have cheated. Just as folks curse you, giving you a piece of their mind, and still refusing to obey the truth of God even if what they are saying has some truth connected to it, if you do not do what God said, then you are in danger of hellfire.

The True and Mighty God

We support men and women! We vote for men and women! The mighty God does not need our vote. He wants us to love Him with all our hearts, souls, and minds and to love one another as ourselves. People will argue with you because they lack the understanding, and if you are not careful you will find yourself arguing, cursing, and fighting back. I have been raised from dead works to walk in the newness of life. I must act like my heavenly Father. Jesus spoke to the Pharisees in this manner: "'I speak that which I have seen with My Father, and you do that which you have seen with your father.' They answered and said unto Him, 'Abraham is our father.' Jesus said unto them, 'If you were Abraham's children, you would do the works of Abraham. But now you seek to kill Me, a man that hath told you the truth, which I have heard of God, this did not Abraham'" (John 8:38–40).

In Genesis 15:6, God made a promise to Abraham. "And [Abraham] believed in the Lord; and He counted it to him for righteousness." The people started arguing with Jesus, the Lord. They do so because they are ignorant and will never understand God's language. People who are looking for the truth will listen, to learn. They will take what they have heard and go and search to see if those things are true. All the truth you and I need is to be found in the Word of God. The devil knows the truth, but he is a liar, as he has been from the beginning, and no truth is in him. A liar will influence you to lie. You can only have one president ruling a country at a time. We have only one true God, who rules over the kingdom of humankind. He reveals the secret things to His servants. Because He has not revealed Himself to you, you question His authenticity.

Jesus Christ is the true and mighty God. Everyone must come to the knowledge of this truth. "And ye shall know the truth and the truth shall make you free" (John 8:32). To you who are troubled, join me in believing. Who is Jesus Christ? He is the Savior of the world. He is the Son of God, and the Spirit in His body was and is God's Spirit. "God was manifest in the flesh, justified in the Spirit, seen of angels, preached unto the Gentiles believed on in the world, received up into glory" (1 Timothy 3:16). Soon He will be revealed from heaven with His mighty angels. This He will do with flames of fire, delivering His vengeance upon those who know not God but pretend they know Him.

If you know God, you will obey the gospel truth of Jesus Christ. He does not need your vote. He needs you to open your mouth and confess that He is Lord and that, in your heart, you believe in His righteousness. All the things you have achieved and accomplished in this life you are now living will be worthless unless you acknowledge the truth about God and repent. Liars will always be lying, adding things, and twisting things to fit their purposes. Soon they will not remember some of the lies they have told.

Rising, I declared what I heard and what I saw to the people, so that we all could take counsel together. Since a long, long time ago, who has foretold truth? Who declared it from the distant parts? Was it not the Lord God? There is no other truth-teller like Him. He is the righteous God our Savior. There is none other than Him. Neither Joe Biden nor Donald Trump can save any human being, as they need to be saved themselves. "Turn to Me and be saved, all you ends of the earth, for I am God, and there is none other. By Myself I have sworn, My mouth has uttered in all integrity a word that will not be revoked: Before Me, every knee will bow; by Me, every tongue will swear. They will say of Me, 'In the Lord alone are deliverance and strength. All who have raged against Him will come to Him and be put to shame. But all the descendants of Israel will find deliverance in the Lord and will make their boast in Him'" (Isaiah 45:22–25 NIV).

Deceitfulness and Lies

> For the secret mystery power of lawlessness is already at work; but the one who now holds it back will continue to do so till he is taken out of the way. And then the lawless one will be revealed, whom the Lord Jesus will overthrow with the breath of His mouth and destroy by the splendor of His coming. The coming of the lawless one will be in accordance with how Satan works. He will use all sorts of displays of power through signs and wonders that serve the lie, and all the way that wickedness deceives those who are perishing. They perish because they refused to love the truth and so be saved. For this reason, God sends them a powerful delusion so they will believe the lie, and so that all will be condemned who have not believed the truth but have delighted in wickedness
>
> —2 Thessalonians 2:7–12 (NIV)

The voters rose up and voted for Donald Trump, putting the number of votes for him over and above the number of votes he received in the 2016 election. To keep him from returning to the White House for another four years, Mr. Biden and his operatives used hocus-pocus to deter him. But all the lies they told are showing, telling us that Trump did win in 2020. Be aware; watch out! You will see Donald Trump rising, and you will watch him come storming back to the White House. Just remember that Saul was king of Israel, yet God sent Samuel to anoint David as king of Israel. It may seem confusing to you, but it is not. God does whatever He so pleases; and who will ask Him about His doings? If you do not know, if you do not understand, then ask the Savior for His help, as He is willing to aid you and see you through. He will not leave you hanging. You will know the answer when you have searched diligently with all your heart. Try it and you will see.

It has been said that Donald Trump received 29 percent of the Latino vote in 2016. In 2020, "the Latino surge," "the sleeping giant," came through in a big way for Trump. Trump had his way with the Hispanic people. O how they love him! Polls may be important to Mr. Trump and those who are associated with him, but with God it is not so; you can throw your polls out the door. The false prophets, diviners, pundits, and news analysts really love the polls to fit their narrative and their talking points. God doesn't deal with polls. He deals with numbers, but not in the way we deal with them.

God chose Donald Trump, and He caused Hispanic people to turn out for him in considerable numbers in 2020. They will do better for him in 2024 than they did in 2020 because their love for him is growing and they believe in him. Be it known unto you, Donald Trump will run in 2024 and will win for the third time. Mr. Trump won the 2020 election honestly. Mr. Biden was given the victory because of the election fix. The Lord prepared for Trump a good man by the name of Mike Lindell. "And the Lord spake unto Moses, saying, 'See, I have called by name Bezaleel the son of Uri, the son of Hur, of the tribe Judah: and I have filled him with the spirit of God, in wisdom, and in understanding, and in knowledge, and in all manner of workmanship'" (Exodus 31:1–3).

Just as the Lord instructed me, I wrote it down. He showed me Donald Trump as his president, and I made it plain. Then God said, "Joe Biden will win because of the fix." You must understand that the Lord is the Master Tactician and a revealer of secrets. Joe Biden wanted to be president very badly, and the Lord allowed the fraud to take place. *Boom*, Mr. Biden became the forty-sixth president.

God gives you the desires of your heart even when He knows it is not good for you. He sets before you both good and evil. If you choose to go after the evil, He will not stop you. You have made that choice. And I know it was Joe Biden who rose up and mentioned in his speech in Delaware in the summer of 2020 the fraudulent organization he had in place. Again I ask, was this a slip of the tongue or the true intent of his heart? Remember, the mouth speaks that which comes from the heart. All that Donald Trump was asking for was honesty in the counting of

the votes. A concerted effort has been made to conceal the truth about the 2020 election.

The man mentioned two paragraphs prior, Mike Lindell, whom the Lord filled with wisdom, set out on a mission. Rising to the challenge, he spent lots of his own money to unearth volumes of evidence proving the fix. For there is nothing hidden that shall not be exposed. The fraud and the switching of the votes has come to light. Mr. Joe Biden will have to answer to God for this. Honestly, he did not receive eighty-one million votes as he asserts. If honesty is the best policy, and it is, then why are we dishonest? Ecclesiastes 8:11–13 reads: "Because sentence against an evil work is not executed speedily, therefore the hearts of the sons of men is fully set in them to do evil. Though a sinner do evil a hundred times, and his days be prolonged, yet surely, I know it shall be well with them that fear God, which fear before Him. But it shall not be well with the wicked, neither shall he prolonged his days, which is as a shadow; because he feareth not before God" (KJV). Just look at what is happening in the country. Under Mr. Biden's governance, thirteen brave young men lost their lives. Innocent Afghans were killed. Eighty-three billion dollars' worth of the best equipment was left out in the open on a US military base in Afghanistan. The crisis on our southern border is chaotic and out of proportion. Criminals and drugs are flooding the country because of the bad policies enacted by the Biden administration. All these things have happened because of the fix. The Democrats and the bias-controlled news media called Donald Trump's claim that he won the 2020 election "the Big Lie." "Let God be true, and every human being a liar" (Romans 3:4 NIV). Oh yes, I cannot deny that Joe Biden won. But the truth has become known. He is spiraling downward, not because of Build Back Better, but for being a big bad bully.

What person can understand his or her own errors? A person's way is always right in his or her own eyes. God knows our cheating ways. I believed Mr. Biden when he said he had in place a fraudulent organization. The words came not from another person's mouth but from his. One is snared by the words of one's own mouth. No person can change his or her own behavior, his or her cheating ways, his or her secret faults,

or his or her wicked ways, the things that are dominating him or her, unless he or she allows God to intervene in his or her life. The people were given the privilege to vote and were told to turn to Trump or suffer the consequences. We are all facing the same dilemma because of the actions of Joe Biden and his administration. God is giving His people one more chance to obey His voice and to obey His Word. Therefore, Donald Trump will be on the trail back to the White House.

Big Bad Bully

None of the talk of fraud regarding the 2020 election was investigated. It was taken with a grain of salt and seen as sour grapes. Listen to the conversations most of those who voted for Mr. Biden are now having. The look on many faces tells the real story. All the witnesses who came forward and testified to what they had observed, under the penalty of perjury for lying under oath, were ignored. On the other hand, the authorities went after those on the other side like ravenous wolves. Some of these people were fired from their jobs. Some were constantly badgered. Others had their homes raided and their property confiscated. This was done to show how desperate the Democrats and their allies are, relentless in their "Big Bad Bully" aggression and with their rules. And this they do, and will continue to do, toward all who disagree with them about who won the election.

I have heard the saying "It is either my way or the highway." This is what the Democrats and their (Just Us) Justice Department are thinking. It was Mr. Biden who said he would take Mr. Trump behind the dumpster to do you-know-what with him. I heard it from his own mouth. During the 2020 campaign, when both men were on the same stage, Mr. Biden was very flagrant in his tone toward Mr. Trump because he disagreed with him. Nothing is wrong with disagreeing with another person. Nothing is wrong with thinking someone else does not share your thoughts or your views. You could be right! You could be wrong!

We should be civil to each other, not biting and devouring one another, for in doing so we will destroy ourselves.

Why would you slay the innocent and the righteous if you are righteous? Folks are quick to condemn and pronounce false judgments. Be it known unto you that the same attitude and judgment you dished out will come back to you soon.

"Therefore, all things whatsoever ye would that men should do to you, do ye even so to them: for this the law and the prophets" (Matthew 7:12). When someone disagrees with you about anything, it's because they do not believe the things you have spoken. If I am speaking to you about earthly things and you do not believe me, neither will you believe me when I speak to you of heavenly things, until the eyes of your understanding are opened. If they are not opened, then you will remain blind to the subject in question.

You might assume that because you are big and bad and have power, no one can talk to you. There were many before you who behaved as big bad bullies, and they are no longer here. Be it known unto you that very soon you will be cut off. Your place will be diligently considered, but you will be cut off. The giver of life is the taker of life. Your life will be taken, and if you failed to meet the requirements while you were living, in hell you will lift up your eyes, where your (worm) body will die not, but you will be tormented. So, rise and awake to righteousness. "Then said Peter unto them, 'Repent, and be baptized every one of you in the name of Jesus Christ for the remission of sins, and ye shall receive the gift of the Holy Ghost'" (Acts 2:38). When you do this, you arise to walk in the newness of life and secure your future, preparing yourself to avoid hell, brimstone, and fire.

Black Lives Matter and their cohorts, backed by their champion, rose nationwide and did extensive damage to the police and police property. They damaged some of your sons and your daughters. They damaged many of your businesses and buildings and tore down monuments and statues. Finally, they rose to loot and steal from you, and walked away scot-free. Because Trump was the man in the White House, the goons, robbers, and thieves were commissioned to take drastic actions. *Whatever*

happens, we will blame it on Trump, the Democrats thought. One of the big bad bullies stood and said, "If we don't get the result we need, we will fight in the streets." This kind of behavior from public officials is not good at all.

Of all the things I have just mentioned, who was held responsible for them? No one! The fault is Donald Trump's! He is the culprit!

Trump rose up and boldly suggested jail time for anyone who attempted to harm federal monuments, including the Lincoln Memorial and the Jefferson Memorial, saying, "They will automatically receive a substantial prison term of ten years." They quickly halted their despicable acts. They used the death of George Floyd in police custody at the end of May 2020 as a ploy to carry out their plans and to vandalize during what they called protests.

The Order

When there is a disorder or a ruckus in the courtroom, the judge uses his or her gavel to strike the bench, saying, "Order in the courtroom." President Trump gave an order, and he was taken very seriously. He showed strength through his peaceful means, here at home and abroad. He tried his best to set in order the things that were disorderly. Don't be afraid to give credit where credit is due. Even the Word gives you credit, and then asks you a question: "Ye did run well; who did hinder you that you should not obey the truth?" (Galatians 5:7).

CHAPTER 6
B & B AND H & F

During my time authoring this book, the thought came to me, *B & B, H & F. What exactly does this mean?* It means you are so badly broken that you are destined to be cast into hellfire. Many have had broken dreams, broken marriages, and broken desires. Throughout history, millions have been through these things at one point or another. All this said, if you have not gotten your heart right with God, if you do not believe His Word, confess your sins, and be submerged in water in the name of Jesus Christ, washing away your sins and being baptized with the Holy Ghost and with fire, then all the good you do on earth will be of no benefit to you when you die. You will be burned right here on earth repeatedly, only to be cast into hell to be burned again, where the fire is never quenched and the worm never dies. Brothers and sisters, friends, men and women, God placed us here to fix things, make them right, and occupy this earth until He comes again. You have been given much; therefore, much is expected of you.

You are not here only to have a good time, gain power, and accumulate wealth. You must seek to save your soul. "But God said unto him, 'Thou fool, this night thy soul shall be required of thee, then whose shall those things be, that thou hast provided?'" (Luke 12:20).

Bill Barr is the blocker of Trump's progress. He is no longer the attorney general of the United States, but Trump is president and will be president in 2024. As a seer, I was told by the Lord to write these words: "The winner will be announced, and it will not be Donald Trump, but Joe Biden, because of the fix. A fraudulent organization exists in the United States." As good stewards, we must strive to do our best in pleasing God. Be filled with the Holy Ghost and fire in order to escape hellfire. Donald Trump won on the night of the election in question. Then the fixers got together and did their evil work. It took days for them to amass the numbers needed by Joe Biden to overcome the deficit created by Trump. Lo and behold, the winner was Joe Biden!

Now you are looking at a man battered and whose leadership is doubted and in question. He said he would fix the virus. He never did. But he did fix the election. "If a ruler listens to lies, all his officials become wicked" (Proverbs 29:12 NIV). You are wicked if you set up a fraudulent organization to take care of changing the election results to make it look as if you are really the winner. Can't you all see what is happening in our country? God gives people whatsoever their hearts desire. "For out of the abundance of the heart the mouth speaketh" (Matthew 12:34). How can anyone understand his or her own ways? "The steps of a good man are ordered by the Lord: and he delighteth in his way. Though he fall, he shall not utterly be cast down: for the Lord upholdeth him with His hand" (Psalms 37:23–24).

"Let the wicked forsake his way, and the unrighteous man his thoughts. And let him return to the Lord, and He will have mercy upon him, and to our God, for He will abundantly pardon" (Isaiah 55:7). The Lord wants to pardon Joe Biden. He wants to pardon all the corrupt officials within the government and outside the government. The Lord wants to pardon the corrupt news media and their correspondents. The Lord wants to pardon all the people of the United States. Will you let

Him fix things for you and pardon you? He knows just what to do! If you honestly pray to let the Lord have His way, then I am very sure He will fix your life for you. Touched by the power of the Highest, this seer rose up and is speaking on conservative matters. This seer rose up to cause you to understand that you must be diligent in business. You must be fair in terms of elections and be honest. Honesty is the best policy. If a person can be so dishonest in his or her actions, how can he or she say, "I have a clean heart"? But this is what the Lord commands: "'Wash yourselves, make yourselves clean. Take your evil deeds out of my sight; stop doing wrong. Learn to do right; seek justice. Defend the oppressed. Take up the cause of the fatherless; plead the case of the widow. Come now, let us settle the matter,' says the Lord. 'Though your sins are like scarlet, they shall be as white as snow; though they are as red as crimson, they shall be like wool. If you are willing and obedient, you will eat the good things of the land; but if you resist and rebel, you will be devoured by the sword.' For the mouth of the Lord has spoken" (Isaiah 1:16–20 NIV). Now, my people, did you hear what the Lord said to Joe Biden and to all who were engaged in the election fix? "Come now, let us settle the matter." The Lord God put a thought in Donald Trump's heart to call his officials and some of the senators together to reason. That is what January 6 was all about, to protest the election result. Then the disruptors and the copycats joined in, creating what is now called "the insurrection."

The Democrats and some Republicans refused to reason honestly. Mr. Biden needs to return the loot. Oh no, he will not! Mr. Biden and the Democrats have called the seventy-five-million-plus people who voted for Trump "domestic terrorists." Accordingly, the terrorists are not only those who participated in the January 6 episode, but also all those who supported Trump. From what I have seen, I know in whom I believe. So, what about all those supporters who were in the streets in 2020, and the Democrats and most of the news media supported their actions, never once calling them domestic terrorists? They called them peaceful protesters.

Those peaceful protesters burned buildings, destroyed statues and properties, and abused the police. They said that what they did is what democracy looks like. The Democrats are behaving as if they are the only

ones who care about the country. Because I voted the way I did, I now carry the label of "domestic terrorist." Oh, help me, Lord Jesus! I rose up. I am standing up, defending conservative and righteous values, and following those things that are made for peace.

I do not see Donald Trump as an inciter. I see him as a troublemaker who rose up, aggressively standing with his supporters and asking questions. I see him as a man whom God wants to save. He stands up and fights for what he believes. His supporters love that about him. And wherever he shows up, they show up too. Something you had never seen before in this country was suddenly staring you right in the face. The White House had tall barricade fences and soldiers all around it. Washington, DC, was looking like Syria under Bashar al-Assad and like Libya under former president Muammar Gaddafi. The Lord has shown Joe Biden who he really is. The Lord has shown the people who Joe Biden is. Now Mr. Biden and his associates are using scare tactics to cause the people to be afraid. Biden has an official named Dr. Anthony Fauci who is an enemy of the people. This man is ludicrous. He is a political scientist who has served as part of the administration from the days of Trump until now. Often on TV, he is full of evil. How can you take counsel from such a man as he? When giving advice about the virus, Fauci changes his theory and his trajectory as quickly as a lizard changes color from green, to black, and to green again. Death has come up into the houses of the powerful and has entered their palaces to cut their children off from society. My people, with all the failures of our leaders, I will assure you that Jesus Christ will never fail you. Everywhere I go, I want the world to know that Jesus Christ has never failed me yet. The judges jail the people. The governors fail the people. Presidents fail the people. Joe Biden, the current president, is failing the people. But bold new strong conservatives are rising to the challenge to take the big bad bullies by their horns and do something about the condition of the United States, with the help of God. We must abide until Jesus comes.

These people must be removed from office very soon. If we allow them to stay in much longer, they will continue to manipulate us and use their trickery to keep people's support. In 2020, Mr. Biden said in an interview,

"If you have a problem figuring out whether you are for me or Trump, then you aren't black." Now, if you continue to support the woke people and their policies, why do you cry when things go wrong? You have no one to blame but yourself. Go to the polls and show these people what you can do. Show them what you are made of. Just as they have been teaching you lessons, you can, in turn, show them that even though you may be little, you are *tallawah* (strong-willed) and that you have a mind of your own. God set before us good and evil, right and wrong, life and death. He never leaves us standing there. He told us to choose life. When you have tried everything and everything has failed you, try Jesus.

TEACHERS ARE RISING UP

Because of the behavior of the Democrats and their administrators and the things they are allowing to be taught in the schools, teachers are rising up and turning toward the Republicans and toward Donald Trump. They are speaking fearlessly, confronting some of the bullies, and putting up a fight. They are fighting for life and for the survival of their students. Teachers are striving trying to do the right thing and are not giving in to the woke mentality. Teachers who support the America First agenda, and teachers who love their country, are rising up and storming back. "MAGA," they are saying. They are rising up for the movement, confirming that teachers are good fighters.

They are fighting not with physical destructive weapons, but with words used as weapons—words that will allow change. For when you say John Doe must be removed from the office he holds, you turn those words into action. You go to the polling booth and vote. When you are standing up for what is right, there is nothing anyone can do about it. And there is nothing for you to fear other than fear itself. When you are standing for honesty, you have nothing to fear at all. Teachers are in the schools to teach the basics to your children, namely, civics, English, history, love for one's country, and mathematics. Love for God should be the number one topic, but because all mention of the Lord God has

been removed from the classroom, and replaced with the gods of ideology, falsehood, and money, I say what I've said. The uprising of teachers is fascinating. They are true patriots, holding down the fort.

When honest teachers give in to pressure and begin to teach the mess that the Democrats and the woke mob are forcing into the schools, they become monsters. I applaud and honor the teachers who are striving to the fullest. I honor the teachers with conservative principles who are rising up and letting the opposition see them come storming back, because they mean business. As the late Whitney Houston sang, "I believe the children are our future. Teach them well and let them lead the way." Teaching is a gift handed down from God above for parents to use. One cannot teach that which one does not know, for one is not more than what one is taught. We all need sound words that are good for the body and the soul—sound words that cannot be condemned. Then folks will quickly let a teacher know that he or she is not teaching right at all.

Are They Children? Or Are They Kids?

> Children are a heritage from the Lord; offspring, a reward from Him. Like arrows in the hands of a warrior are children born in one's youth. Blessed is the man whose quiver is full of them. They will not be put to shame when they contend with their opponents in court.
>
> —Psalms 127:3–5 (NIV)
>
> Now therefore, my son, obey my voice according to that which I commanded thee. "Go now to the flock and fetch from thence two good kids of the goats; and I will make them savory meat for thy father, such as he loveth."
>
> —Genesis 27:8–9

> Then ye shall sacrifice one kid of the goats for a sin offering, and two lambs of the first year for a sacrifice of peace offerings.
>
> —Leviticus 23:19

> Then were there brought unto Him little children, that He should put His hand on them and pray, and the disciple rebuked them. But Jesus said, "Suffer little children, and forbid them not, to come unto Me: for of such is the kingdom of heaven." And He laid His hands on them, and departed thence.
>
> —Matthew 19:13–15

Children are a fruit of the womb. Kids come from the goats that themselves were kids that grew up to be goats. Let us do as Jesus did and say as Jesus said. "He said unto [Peter], 'Feed My lambs'" (John 21:15).

You will never, ever hear this brother, or call me what you will, call children kids. Sheep and lambs are followers of Jesus Christ. You may be right in calling them kids as both the goats and kids that I used to care for, waking up early every morning under my mother's orders to go barefooted in the dew and in the rain and care for them, only to have them wanting to go their own ways. Many times, I cried. But I did what I had to do with the goats and their kids to keep them organized. For they were, as all goats are, as stubborn and destructive as can be.

Citizens Are Rising Up for Trump

Citizens across the country are rising and fighting tyranny without going out into the streets to cause chaos and vandalize property. Instead, they are going to PTA meetings to face off with +school board officials. They are speaking up as never before because they have seen Trump as

a leader who is relentless. They watched Trump carefully and listened to him attentively whenever he spoke, hanging onto his every word. To use a metaphor, you could say that he put the pedal to the metal. Now that the car is in motion and is getting the energy it needs, it is moving full speed ahead. Going, going, gone! Soon you will see more people standing up to challenge the current administration, who before would not even say a word. They are now rising up with passion and goodwill, unwilling to allow communists and socialists to take control of their country.

They are rising up and crossing over because they want to build a community of young learners and leaders, a community where diverse people from various levels of society come together to build a better future by building a community, a city, and a country where everyone has the freedom to make an honest living, worship as they please, and get an education to improve their own lives and their family's living situation—a community, a city, and a county where one participates in the health-care system for one's own welfare and where one does not have to wait in order to be seen by a doctor for treatment. The citizens are rising up; oh yes, they are. Determined, strong, and vibrant, they are coming out, so to speak. Where there is a will, there is a way.

The people have seen a man with an attitude of not giving an inch and not giving up. He just keeps on driving, hammering until the nail is finally in place. Never have I read of or seen such a man as Donald Trump fighting with such tenaciousness on the Republican side. The citizens, having carefully observed his pattern of behavior, are rising up and moving to the front of the line, ready to influence the process. Since Mr. Trump came to power, several women rose up, campaigned, and won seats in Congress. They did this because they love their country and they love Donald Trump.

The Lord has truly blessed this man to motivate people. In 2019, Doug Mastriano from Pennsylvania rose up, representing the Republicans in the House, serving the Thirty-Third District. He ran for governor in the 2022 election, but conceded to John Fetterman. From Florida, Byron Donald rose up for America First and won his state's Nineteenth District seat in 2021. In Utah, Burgess Owens rose up and won, representing the

Fourth District, as he has been doing since 2021. Wendy Rogers from Arizona rose up also and won, representing her state's Sixth District, as she has been doing since 2020. This is to name only a few. Because the citizens are burning with passion, there are stalwarts who are willing to shine. Vernon Jones, Georgia state representative, switched sides from Democrat to Republican. He is now a patriot.

Currently, Herschel Walker from Georgia, running for US senator, is awaiting a runoff election to see if either he or his opponent, the Democrat Raphael Warnock, will win. Keri Lake ran for governor of Arizona. The election took place, with her opponent purportedly winning, but she has not yet conceded because of the many irregularities she observed in the voting process. Not lacking in zeal, they are keeping the fervor, determined to mend what is broken and to make things as orderly as they possibly can. With the help of God, they will succeed. Now, friend, remember that the names I've just mentioned are only a few of the fiery patriots on the America First / Trump train. To them, Donald Trump is the president, but he is not in office; Joe Biden is. Trump is more popular now than he was when in office. This man, Trump, is a straight shooter when it comes to bread-and-butter issues that affect the people. Because Trump addresses these issues, everywhere he goes, the people show up to hear what he has to say. Surely, he has many things to say to them.

Donald Trump's Rising Is Justified

From the day Donald Trump came down the escalator at Trump Towers and gave a speech where he announced his bid for the presidency, the media—all-forms—have been playing the game of love-hate. Whenever Trump opens his mouth and says something controversial, they hate him and do what they do best, that is, scandalize his name. Then he says something that tickles their fancy, so they reaction neutrally. They keep playing the game of "He hates Mexicans because he called them gangsters and rapists." Then they say, "He's a racist!" They

continue to say such things when they believe that it helps their narrative and their ratings.

The media have always used their power of convolution to incite the people. The Republicans never fare too well amid such an environment. In an election, sometimes they win, but most of the times they lose. The Lord stirred up Donald Trump, a no-nonsense man, who came into the political game with a low batting average. From the start, Trump was doomed to be struck out, or so it seemed. He began facing pitchers on the mound, first basemen, second basemen, and third basemen. There was no way that this racist lunatic and xenophobe would get a hit or get on base. The pitcher is supposed to use the pitcher's mound when an official game is being played, but such was not the case for this New York batter without much on-the-field experience. The media were sending Trump messages, even asking him to sign documents laying out their intent: "Not only will we not use the mound, but also we are going to pitch to you from wherever it seems good to us, anywhere on the field."

Trump, knowing all this, and having a good understanding, although he was inexperienced in the game of politics, made up his mind to play on anyway. He adapted quickly, gaining knowledge and understanding of the game, and came onto the field with confidence. Not afraid or timid, he started hitting balls all over the field. He hit one news media outlet, then the next, all the while remaining civil, giving interviews here and there after each game. Even though he was set up and trapped, God was on his side. After he had placed several pitchers in the dugout, Trump the xenophobe still had two pitchers to face, one from each party, apart from those in the media.

Jeb Bush pitched. Trump took care of him early. He withdrew. My friend Ted Cruz pitched at Trump, and it was a strike. He pitched against him again. Another strike. Trump was now down two strikes. Would he recover? Only time would tell! On the third pitch, Trump hit Cruz's ball out of the park, out of the race. How do you love Trump now? Or will you love him at all?

Donald Trump was now in a spot he had never been in before, having to face the Democrats' ace, who knew the type of pitches that would

get him out of the game quickly. She even had a pitch that could shatter his bat. Remember, Trump had been told that pitches would be coming at him from every angle on the field, not necessarily from the mound. Things were looking good for Mrs. Clinton. She was being cheered on. She knew just how to throw a curveball. But she made one big error: she threw him a slider. Trump, justified in his confidence, hit the slider. Going, gone, goodbye! The ball ended up in CNN's building. Not having come to a complete stop, it was now bouncing all over the place.

Mrs. Clinton had just lost! Surely she was asking herself, *What did I just do? Why did I throw a slider at him? Trump, who has just risen, has just made history. That bombastic racist xenophobe is the forty-fifth president of the United States!* The Democrats' hatred of Donald Trump persisted, nonstop. Nevertheless, Trump supporters kept singing the song of my cousin Bob Marley: "I wanna love you and treat you right." It was truly a bittersweet moment for Mr. Trump's supporters; there was happiness and rejoicing, but the people on the other side were foaming at the mouth.

Ever since the day Trump won, the Democrats tried using all the tactics and tricks in their repertoire to get rid of him. They did not succeed at all. Realizing this, they quickly turned their attention to 2020. "Well, well," they said, "this time we will make sure we have all the bases covered. If we must steal, we will. But we will not allow Trump to wield power over us again." In this vein, they all stick together, everyone saying the same thing: "The Big Lie." Thank God we know better. Thank God we know the truth.

What The Democrats Feel for Trump

He rose! He soared! He was the forty-fifth president! Even though the Democrats hate Donald Trump, they pretended as though they really loved him. "He is good for our ratings until the love we pretend to show for him is over," they boasted. They really felt something for Trump. It was not love; it was the opposite. They looked into their playbooks and searched for tricks in an attempt to throw him out, but he remained

standing. They now have their new president, yet they blamed Trump for the problems in Afghanistan. And now they are trying to pin the January 6 riot on him.

You would assume that since the Democrats have tried everything in their playbooks to get rid of Donald Trump and have remained unsuccessful, they would have given up by now. No! They have not done so because their purpose and their plans are futile and ineffective. But, oh no, this man is a threat to the Constitution. This man is holding the Big Lie. He is the loser.

The Democrats have said that Trump does not know when to quit. They have said he is a threat to democracy because he has been saying repeatedly that he won the 2020 election. Do you remember what Hillary Clinton warned? "If there is a challenge, under no circumstances should Biden concede." The Democrats have convinced themselves that they have Trump wrapped around their little fingers, just where they want him. Now they are holding the Big Lie, telling it and not wanting the truth to be known.

Insanity

Meet the Press moderator Chuck Todd joined Willie Geist to discuss former president Trump's repeated claims that he won the 2020 election. They discussed the possibility of his running in 2024. Todd said, "Nobody around Trump actually believes he actually won." Hello! Trump did win!

My Righteousness

My righteousness is, I believe, God. I believe in God. I am not behaving as those who have corrupted themselves with the Big Lie theory. On the contrary, in Jesus Christ I speak the truth of God with all sincerity as those sent directly by God speak the truth in love. Chuck

Todd is filled with insanity. How did he come to know that nobody around Trump believed he won the election? Who told Chuck Todd that Trump lost? "For what if some did not believe? Shall their unbelief make the faith of God without effect? God forbid, yea, let God be true, but every man a liar; as it is written, 'That thou mightiest be justified in thy sayings, and mightiest overcome when thou art judged'" (Romans 3:3–4). Mr. Chuck Todd is a natural man who is paid to say what his boss thinks. Or he is saying things that he believes certain people want to hear.

I am not a paid spokesperson. I am not a pundit. "Verily, verily, I say unto thee, we speak that we do know, and testify that we have seen, and you receive not our witness" (John 3:11). "But the natural man receives not the things of the Spirit of God: for they are foolishness unto him: neither can he know them, because they are spiritually discerned. But he that is spiritual judges all things, yet he himself is judge of no man. For who has known the mind of the Lord, that he may instruct Him? But we have the mind of Christ" (1 Corinthians 2:14–16).

President Trump won the 2020 election. The coronavirus was unleashed to hurt him. It did hurt him, both by infecting his body and causing him to lose votes. God, who is rich in mercy, preserved him, letting him recover. The people around Mr. Trump who believe he lost have been paid and programmed to think that way. Those in the Republican Party, if they are not for Trump, they are against him. They cannot have it both ways. One does not have to agree with every word spoken by Trump. Some will never agree completely with him, just as people will not always agree with you, and just as Mike Pence blatantly says that he believes there was fraud.

How can one say there was no fraud? Trump's patriots believed fraud took place. I know there was fraud. Trump knew that fraud took place; he is right. I do not agree with everything that Trump does and says. I do not agree with Trump's having divorced his former wife and married Melania. But death has now separated Ivana and Donald, so Trump is now free from the bonds of the vow he took. I do not condone Trump's use of profanity. I do not agree with many other foolish things that I

have seen and heard him do. That does not mean he did not win the election. I believe what God said. Do you believe what He said? If you do, you will obey Him. "And from that time Jesus begun to preach and to say, 'Repent, for the kingdom of heaven is at hand'" (Matthew 4:17).

Carnal Mind

It is hard to address the blind, liars, and thieves as spiritual. If I were to come to your house, enter through the door alone, but leave someone standing outside, or in the vehicle waiting and watching, then that person is an accessory to the fact. Aren't we all guilty by association? Don't be deceived. If anyone in the news media, wherever you may be, seems to be wise in this world, become a fool for Jesus Christ so that you may truly be wise.

"For the wisdom of this world is foolishness in God's sight. As it is written, 'He catches the wise in their craftiness.' And again, 'The Lord knows that the thoughts of the wise are futile.' So then, no more boasting about human leaders. All things are yours" (1 Corinthians 3:19–21 NIV). Your carnal mind is an enemy of God. Your mind will not line up with the true things of God. God does not trust your mind. There are paid liars, and then there are truth-tellers who are paid by no one but by God. Therefore, you must obtain the mind of Christ. And the truth is, President Donald Trump is the rightful winner of the 2020 election. I am one of God's ministers (spokespeople); He revealed to me what happened. I saw with my own two eyes the evidence that has been revealed to me. But there is spiritual wickedness in high places. People are being paid big bucks to hide the truth. But no one can buy God or pay Him off. I am not speaking about worldly wisdom, which is based on lies. I am speaking of the wisdom of God, which is given to those who believe. "But the wisdom that is from above is first pure, then peaceable, gentle, and easy to be intreated, full of mercy, and without hypocrisy" (James 3:17 KJV).

Look at all the things Joe Biden has said and done. No one has really

pressed him to give an account. Birds of a feather stick together. All the ugly things that have come out of Joe Biden's mouth and his son Hunter's mouth have been swept under the rug. This has been done because those who support Biden are respecters of persons. At the same time, they are doing anything and everything they can to destroy Donald Trump. He who destroys another destroys himself. Oh, the hypocrisy! I am coming to you not with the wisdom of humankind; I must speak the truth as a servant of Jesus Christ and as one entrusted with the mysteries of God. It is required that stewards be found faithful. But because of the grace that God has given unto me, a seer, I can see straight. I have 20/20 Holy Ghost vision. What about you? I cannot see on my own; neither can you.

I know nothing of myself, yet I am justified by God. It is God who revealed the transgressions that Joe Biden, Kamala Harris, and the rest have committed. If my God, Jesus Christ, were like you, I would not be here. Donald Trump would be behind bars. From Drum Street, they, the powers that be, have been digging and digging, and still they have come up empty. I am one of God's men. That is who I am! I am filled with the Spirit of truth. This can happen to you too if you only believe. I am anointed to prosper. You can be too. I am blessed to be a blessing to you. That is why I rose to do what God said: to bless Donald Trump and let the truth be known about him. All of us, along with Joe Biden and Donald Trump, must get rid of the carnal mind.

CHAPTER 7
THE MIND OF THE SPIRIT

The people in the news, Mr. and Mrs. Know-It-All, say that Mr. Trump and those around him are spreading lies and conspiracy theories, saying that Trump won the 2020 election. I am led by the Spirit of God; dare you try to fool me. "And He who searches our hearts knows the mind of the Spirit, because the Spirit intercedes for God's people in accordance with the will of God" (Romans 8:27 NIV).

In scripture, God says to Pharaoh, "I raised you up for this very purpose, that I might display My power in you and that My name might be proclaimed in all the earth." Therefore, God has mercy on whom He wants to have mercy on, and He hardens whom He wants to harden (Romans 9:17–18 NIV). God revealed to me that the coronavirus pandemic was created to hurt Trump. Trump was indeed hurt by it, but he recovered and won the election. The votes that were switched or added were given to Joe Biden. With the blind leading the blind, the Democrats all will fall. The devil has blinded the eyes of the people, some of whom

are walking around in the White House, in the halls of Congress, in courthouses, in the House of Representatives, and in the Supreme Court. God has given them the sleep of slumber, and they cannot see. But the Spirit of God reveals the deep things.

Do you remember what happened in March 2021 when Mr. Biden was going up the steps of Air Force One? He fell to his knees two, three, or four times. God could have just cut him off right there, but He had mercy on him and hardened his heart. Just as God raised up Pharaoh to show His glory, so has He raised up Trump. Queen Jezebel of old had four hundred fifty prophets of Baal and another four hundred prophets of the groves who ate at her table. They prophesied whatsoever she needed to hear, and her husband, Ahab, allowed it and said nothing. That wimp! These prophets were competing against the true man of God, Elijah, to prove him wrong. They were taken to task. First Kings 18:22–24 says,

> Then said Elijah unto the people, "I, even I only, remain a prophet of the Lord; but Baal's prophets are four hundred and fifty men. Let them therefore give us two bullocks; and let them choose one bullock for themselves, and cut it in pieces, and lay it on wood, and put no fire under: and I will dress the other bullock, and lay it on wood, and put no fire under: and call ye on the name of your gods, and I will call on the name of the Lord and the God that answereth by fire, let him be God." And all the people answered and said, "It is well spoken."

I am speaking well and writing well. You know it.

Jezebel's prophets prepared the sacrifice, and Elijah did the same. They called on the name of their god from morning till noon, but their god did not answer them. Elijah mocked them because they called, but their god did not answer. So, Elijah called them near him. He repaired the altar that had been torn down, taking twelve stones and building an altar in the name of the Lord. Then he dug a large trench around

the altar. When everything was in order, he asked the people to fill four barrels with water and pour the water on the sacrifice and on the wood. He told them to do it a second time and a third time.

First Kings 18:36–39 says:

> And it came to pass at the time of the offering of the evening sacrifice, that Elijah the prophet came near, and said, "Lord God of Abraham, Isaac, and of Israel, let it be known this day that Thou art God in Israel, and that I am Thy servant, and that I have done all these things at Thy word. Hear me, O Lord, hear me, that this people may know that Thou art the Lord God, and Thou hast turned their heart back again." Then the fire of the Lord fell, and consumed the burnt sacrifice, and the wood, and the stones, and the dust, and licked up the water that was in the trench. And when all the people saw it, they fell on their faces: and they said, "The Lord, He is God; the Lord, He is God."

You will understand that God is good and God is real. Elijah believed in his God, the true God. The false prophets and the seers, those who spoke from their own hearts, would not call on the true God. They called on their false god, who did not answer them. Elijah demonstrated the power and wisdom of the King of kings and the Lord of lords. If you call on God, I guarantee you that He will come to your rescue anytime, anyplace, anywhere. So, don't stop praying, for the Lord is nearby. Patriots, do not stop praying. Saints of God, do not stop praying; the Lord will hear your prayer. What He has promised, that will He do. Don't you ever stop praying; He will answer you. The Lord God is the only One who teaches you how to make a profit. He will always lead you in the way you should go. The Lord our God is truly awesome. Your mind should always be thinking on the things of God or be focused on the thing that is important to Him. He alone searches the deep things of your spirit, and He makes an effort and responds to you.

How My Rising Up Started

My rising up occurred in 1992. In my vision, I went out from my apartment where I was living with my wife, Amy, went to the sidewalk, and started preaching and prophesying. Suddenly, the Lord showed up. The voice said, "You need the blessing; you need the power." I was speaking with my eyes closed. Hearing the voice, I opened my eyes, and I saw the man who had spoken to me. He was robed in white, His stature reaching as far as my eyes could see up in the heavens. His eyes were shining brightly like the sun. He was looking down on me. I had to look away. I heard Him say to me again, "Young man, you need the anointing." When I looked up, He was gone.

I called a pastor with whom I was worshipping and told him what I had seen. He scheduled a meeting with me and with two other ministers. I was asked to tell what I had seen. The meeting was cordial when it ended. Soon after, the pastor was on a radio program ridiculing me with his words, instead of encouraging me. "Young man, you must wait. You need power because you want to show off." I was devastated in my spirit. I asked the Lord for direction, and He answered me. We all have done things we believe to be good, but not with perfect hearts in the sight of the Lord. You need to get rid of your crazy thoughts; it will do you good.

In the same apartment where I lived for six years, the late bishop Woodrow Roach appeared in my bedroom in a dream. He said to me, "Son, get ready; I am here to anoint you and bless you. Get ready." I jumped off the bed in the dark and turned the light on to see where the bishop was. My wife got up and asked me, "What happened?"

"Bishop Roach was just here to anoint me," I said.

"Well, he's not here. You just had a dream," she said.

"I have to go and see the bishop; he has my blessing," I said to her.

A few Sundays passed. I said to my wife, "Get ready! We are going to worship with Bishop Roach today." We got ourselves ready for worship and began driving to Capitol Heights, Maryland. When we got there, I found a spot and parked my wife's Camry. She and I got out the car and entered the building. The bishop was standing at the podium

speaking. One of the ushers was standing by the door and escorted us to be seated. While walking behind the usher, I heard the bishop say, "Here comes a changed man, a brand-new man." After he was finished speaking, he asked me to say a few words. I did so, then returned to my seat. The bishop came back to the podium and said, "Praise the Lord, church! Those were encouraging words from the minister; may the Lord bless his heart. I am hoping to see him back worshipping with us soon."

After the benediction and shaking of hands, I went to the bishop's office to speak with him. I told him how I had seen him in Hyattsville, in my bedroom, a few Sundays back. He said, "I was there to bless you, son. You are an anointing young man." He set a date when I would speak and told me to invite as many people as I desired. Just as the leader Moses was convinced by his ministers, Caleb, and Joshua, so Bishop Roach was with convinced by me. He told the bishops and pastors about his young minister speaking sound, encouraging words. My next speaking engagement was in Tennessee in 2005 at the international convention, where I spoke boldly in the Lord.

The next convention was held in Tallahassee, Florida, in June 1996. I attended the worship service on Sunday night at the start, which was very inspiring. When the worship service was over, Amy and I got into the rented car and drove to the hotel where we were staying. As soon as we got out of the car and entered the building to go to our room, the enemy afflicted my body with excruciating pain. My dear friends, it was a lightning rod type of pain from the left side of my head moving down to my left shoulder, pulling me down to the ground. I had no easy time. I cried tears. I could not stand up. I could not sit. I kneeled at the side of the bed with a pillow at my head and one under my left arm. The enemy turned up the heat on me. It was now two thirty in the morning. I called one elder to pray for me. After he prayed, the enemy turned up the pain with even more heat, now six to ten times greater than it was before.

Time passed quickly! It was now seven o'clock in the morning. I'd had little sleep. A few of the saints came to me and told me to go back to Maryland. I asked them, "Will that make the pain go away? I am not leaving. The enemy is trying to stop me from receiving my blessing."

For three days I was in the hotel in pain. On Thursday I decided to go to worship before Friday came and, along with it, the closing out the meeting. I was one of the speakers for the day. When I spoke, the Lord touched my body, and the people were blessed by my words. After the speaking engagement, the bishops and pastors came together, laid their hands directly on my body, and blessed me in the name of Jesus Christ.

The meeting came to an end midday Friday. Amy and I returned to Maryland that same evening. On Monday I went to see my primary care physician. Giving me his diagnosis, he said, "Your pain is known as 'bursitis.'" He gave me a prescription that I got filled. Since then, I have not had that problem again. At the convention, I received a fresh anointing to preach and teach. Doing so with meekness, and instructing those who oppose themselves, hoping that God will grant them knowledge of the truth and rescue them from the trap the enemy has them in, I have a better understanding of the Word of God. I have a better understanding of conservatism. Listen carefully to the words of people, but do not mimic their wickedness and wrongdoing.

First John 2:27 reads, "But the anointing you have received of Him abideth in you, and ye need not that any man teach you; but the same anointing teacheth you of all things, and is truth, and is no lie, and even as it hath taught you, ye shall abode in Him." When the Lord spoke to me about the anointing in the vision, He was not talking about the anointing in 1 John 2:27 but about anointing by "the laying on of the hands of the presbytery" (1 Timothy 4:14). I am commanded and commissioned to cry out loud and spare no one, lifting up my voice like a trumpet, showing people their transgression and their sins. I have no fear because my Jesus walks beside me. I am sheltered in the arms of God.

Since humankind was created and destined to live on the face of the earth, people have been lying to each other. Most times they do so to save themselves from embarrassment. Sometimes it works, and other times it does not work. It is extremely hard to tell the truth to people if you are engaging in the same things as they are. You first must cleanse yourself from all the filthiness of the flesh and of your spirit and adhere to the engrafted Word of the Lord Jesus Christ, always abounding. A hypocrite

is a person who tells you what to do but then does the opposite of that. I rose up to tell you the truth, whether you believe it or not, whether you will accept it or not.

God did not choose Trump because he was righteous. The Lord chose Trump and raised him up, giving him his heart's desire, in order to make the United States great again, to save the country he loves from radicalism and socialism. The people were given the privilege to turn to Trump. Many followed their foolish hearts' desires and got caught up in the fix, the fraud, and the Big Lie. I know someone who calls herself a Christian who voted more than once. I could not turn over my sister to an unjust person. I could not turn over my sister to an unjust judge. "For the time is come that judgment must begin at the house of God: and if it first begins at us, what shall the end be of them that obey not the gospel of God? And if the righteous scarcely be saved, where shall the ungodly and the sinner appear?" (1 Peter 4:17–18). "But he that is spiritual judgeth all things, yet he himself is judged of no man" (1 Corinthians 2:15).

The Lord raised me up as a spiritual man. The Spirit of God leads me. The Spirit is life in me because of righteousness. Donald Trump has been raised up as a political leader with a good plan to save his country from radicals who will do almost anything to implement their agenda, subject all Americans to their system, and promote their cancel culture mentality. That is why they are wasting lots of time and making lots of noise about Mr. Trump. But whatever they do, they will not succeed in their pursuit against him.

Trump won on the night of the 2020 election. The devil is a liar, a robber, and a thief. He went on a rampage on the night of the election. Seeing as the devil goes about to kill, steal, and destroy, his children went out and implemented one of the biggest fixes in our nation's history. They are guarding, hiding, and protecting, and they refuse to give an account. God said to me, "Write, 'Joe Biden will win because of the fix. Donald is the real and true winner.'" Therefore, someone said to me, sarcastically, "Your God didn't tell you the truth."

America First Is Alive

My question to you, smart one, is, do you know the mind of God that you might instruct Him? I thank God I have His mind. The Lord allowed this to happen for a reason; He knows the truth. Donald Trump knows he won. Mr. Biden knows he won because of the fraudulent organization he has all over the country, as he spoke with his own mouth. The Lord is allowing Joe Biden to see what is in his own heart. The Lord has shown Donald Trump what is in his heart. What comes out of the mouth proceeds from the heart. Listen to the Word of truth: "This same Hezekiah also stopped the upper watercourse of Gihon and brought it straight down to the west side of the city of David. Hezekiah prospered in all his works. However, in the business of the ambassadors of the princes of Babylon, who sent unto him to inquire of the wonder that was in the land, God left him to test him, that he may know all that was in his heart" (2 Chronicles 32:30–31).

The Lord knows my heart; that is why I sing, "You raised me up to stand on my feet, to leap over spiritual walls and run through the enemy's troops." Because He strengthens me, I can do all things. As a son of God, I honor my Father, Jesus Christ. Because He is my Master, I fear His name. From the time the sun rises until it sets, my God's name is great with me among His people. His name is great among the heathens. The preacher's and the seer's lips should hold and keep knowledge. We seek the truth and speak it from God's mouth. I am one of God's messengers. I am fighting the good fight of faith, so that I can hold firm to eternal life in Jesus Christ, who calls me to be an exceptionally good soldier and to profess a good message before many witnesses.

President Donald Trump's movement "America First" is alive; the people love it. They are turning out in record numbers to hear him as he delivers his message. He doesn't want a socialist country. Neither do I. So, now, many are turning out to hear and see their leader as he lays out his plan for the party and the Make America Great Again movement. Free people love to have a great leader. Free people were given their freedom and greatness by God.

Great people love living in a country that is great. Although they may not understand many things about government, they are still great. They just need to find a bright political leader who means the things he or she says and who does as he or she says. The people found this in Trump, as their best friend and mentor, and they are holding to him. They have found Trump to be honest and to be a motivator; he gets things done. He is as tough as a rock and as straight as a plumb line.

Again, I say the Lord raised up Trump not because he was righteous. He raised him up because he is a good man with excellent ideas. He assures the people: "The United States belongs to you, not to the radical Democrats with their socialist agenda." To me, this is wonderful. Many leftists want power for the purpose of controlling the population. But they have shown that they do not really love this country. Whatever they may do or say, standing in their way is the man with a plan; that man is Donald Trump. He is not in the White House now; he is in their heads. He is in their minds. He is in their bedrooms. He is in their dreams. That's why he is in the news, because they need something to talk about. Because if Trump is a failure, your association with him will give you and his opponents more insight. You will either fail with him or progress with him. And the good that he is doing will become known.

The America First movement will not go along with the tactics that the news media and their surrogates are using against Trump. He is the man who had the support and the votes of 93 percent of Republicans. He is the man of the movement. He is the star of the show. He is the man for tomorrow. Trump will not mince his words. He will beat the Democrats for a third time. He is making sure election integrity takes root. All that he is interested in is ensuring that we have free and honest elections. The Left really hates this. Some Republicans hate his attitude because he came as a disrupter and a drainer of the swamp. They cannot seem to get over the way he came so forcefully to show them up.

Mr. Trump has true patriots supporting him who are loyal to him. They are embracing his dreams. Trump's endorsement means a lot to a candidate. He will be helping to break many records in the midterm elections. The Democrats are worried that if Trump's candidate succeeds in

Virginia, it is because Trump's victory in 2024 is imminent. The Virginia gubernatorial race could lead to the return of former president Donald Trump to the White House if the Democratic contender loses, according to Terry McAuliffe himself, the Democratic candidate. McAuliffe also called Glenn Youngkin "a Trump wannabe." While on the campaign trail, McAuliffe stated he was running because of Trump.

As it seems, McAuliffe just wanted to eat Trump alive and spit him out. But he lost badly to the newcomer Youngkin. He also brought up Youngkin's aim to ban abortion and what he called "Georgia antivoting laws." Because Trump had called out Brad Raffensperger and Brian Kemp over the vote count for the 2020 election, McAuliffe thought he had enough ammunition to use against Trump. He said Trump endorsed his opponent five times and that Trump was looking for a way to get off the mat, to kick off his 2024 election run. "We can't let it happen," he said. Al Sharpton asked a question, wanting to know whether a loss in the race would mean a Trump comeback. "If I were not to win this, this would be, as I say, the comeback of Donald Trump," McAuliffe replied. "This would lift him off the mat." Trump is coming back, and that is a fact. Watch and see!

FORENSIC AUDIT

In Michigan, protestors crowded the Michigan State Capitol and demanded an audit of the 2020 election. The protestors were frustrated by the lack of transparency and the lackadaisical attitude shown by those opposed to the audit. On October 12, 2021, Donald Trump held a big rally in Lansing, where many patriots demanded a forensic audit, suspecting fraud in the 2020 election. But those who are against Trump, and those from the other side, did not want to give an inch to satisfy Trump's desire, even though the fraud was beyond what anyone could believe. People who really care will rise up and stand up for what they believe in, and some Michiganders believed fraud was committed in 2020. But justice is just so hard to come by. Trump was adamant

and determined, working hard to fix what happened in 2020 so that it would never, ever happen again. Winning does not come easy; one must persist, bob and weave, and keep the work going until one succeeds or until something happens.

Fighting can be excruciating and very lonely. It can be very tiresome. It can be dangerous, yet still, to achieve the outcome, you must keep on fighting. The election might not be overturned, but there will be changes to the 2022 and 2024 election procedures.

Maricopa County Forensic Audit

The patriots fought extremely hard to get an election audit in Arizona. It was a "hammer and nail" struggle. The true patriots were driving the nails, but the nails refused to go in. In carpentry, when you are driving a nail, if it bends and you want to use it again, you must straighten it. Otherwise, you must remove it or leave it in the same crooked position. After removing the bent and crooked nail, you must use a brand-new one, hammering till the nail is totally in place to keep the work sturdy and steady. Now, imagine that the nails are the fake ballots of dead people and duplicate voters that were found in the audit. Yet for all this, the power grabbers and dishonest people did not flinch. Wicked people and seducers will only get worse and worse. One thing is for sure: we must get rid of mail-in ballots. The number of days for voting must be reduced to one.

The Blind Can't See

The patriots hammered the stubborn nails into the election walls and the wood. All they need to do now is the daubing and refining to have a perfect house. The people at the top with the power refuse to take any action. I wonder why? A house that is divided against itself will not stand. That is why the honest, God-fearing people at the top who believe in

honesty and justice will stand up for their rights and yours and will not give up. If only in one county alone there were so many problems, what about the whole state of Arizona? That is why those who are oblivious to what is going on need the eye salve of honesty and the fear of God, to open their eyes so that they can see that the rain from Noah's days is gone—no more rain—and the fire of God is coming their way to burn up every evil and dishonest work.

> Hear now this O foolish people, and without understanding, which have eyes, and see not, which have ears, and hear not. Fear ye not Me? saith the Lord. Will ye not tremble at My presence, which have placed the sand for the bound of the sea by a perpetual degree, that it cannot pass it: and though the waves thereof toss themselves, yet can they not prevail, though they roar, yet can they not pass over it? But this people hath a revolting and a rebellious heart; they are revolted and gone. Neither say they in their heart, Let us now fear the Lord our God, that giveth rain, both the former and the latter, in His season.

> He reserveth unto us the appointed weeks of the harvest. Your iniquities have turned away these, and your sins have withholden good things from you. For among My people are found wicked men. They lay in wait, as he that setteth snares; they set a trap, they catch men. As a cage is full of birds, so are their houses full of deceit: therefore, they are become great, and waxen rich. They are waxen fat, they shine, yes, they overpass the deeds of the wicked. They judge not the cause, the cause of the fatherless, yes, they prosper; and the right of the needy they do not judge. Shall I not visit for these things? saith the Lord. Shall not My soul be avenged on such a nation as this? A wonderful and horrible thing is committed in

the land. The prophets prophesy falsely, and the priests bear rule by their means; and My people love to have it so. And what will you do in the end thereof? (Jeremiah 5:21–31)

The wicked covered up the loot, the biggest and most horrible hoax they have devised to prevent Trump from being reelected. Behold, your sin (fix fraud) will find you out. Luke 12:1–3 says: "Meanwhile, when a crowd of many thousands had gathered so that they had trampling on one another, Jesus began to speak first to His disciples, saying: 'Be on your guard against the yeast of the Pharisees, which is hypocrisy. There is nothing concealed that will not be disclosed or hidden that will not be made known. What you have said in the dark will be heard in the daylight, and what you have whispered in the ear in the inner rooms will be proclaimed from the roofs'" (NIV). I know what I saw. Everyone will receive a reward for what they have done, good or evil. Do you love truth? I really do! Your actions speak loudly.

A Pastor and a Tax Adviser

A pastor and a tax adviser will be the first Republican to represent Newton in the Iowa statehouse since he, Jon Dunwell, won the special election to fill a vacancy in the once ancestrally Democratic manufacturing hub that has moved to the right in recent years. Jon Dunwell (R) beat Steve Mullen (D), his opponent, with a 60 percent / 40 percent margin. Many more big margins are coming with seats to be gained by the Republicans in 2022 and 2024. The people will not forget the reckless and violent behavior of the Democrats and their surrogates. They will certainly pay a political price for their actions and their deeds. Watch!

CHAPTER 8
THE SICK ARE RISING UP

There are many sick folks living in this world today. Only those who are cognizant of the pain that comes from sin will call for help—which is available.

> Is any sick among you? Let him call for the elders of the church; and let them pray over him, anointing him with oil in the name of the Lord: And the prayer of faith shall save the sick, and the Lord shall raise him up; and if he has committed sins, they shall be forgiven him.
>
> —James 5:14–15

There is a natural rising up and a spiritual rising up. Let me show you God's impressive power and how you can utilize it. Just as it takes

courage, belief, and determination to get you going to accomplish your goals and your plans, so it also takes faith.

If you did not believe you could get up, you would just lie there. If you did not believe you could go to the restroom, you never would do so. Because you believe you can, your faith kicks in and you get up and get out of your bed. You believe if you go to the restroom, the door will open, then you can take care of your business. All these things you do just because you believe: your faith kicks in, causing you to move. You have heard the saying "I am taking a leap of faith"?

By my faith in the Lord Jesus Christ, I believe that when I pray for someone who asks me to, the sick person will be saved, and the Lord will raise him or her up. The sin that has been committed by that individual will be forgiven. You must put your faith in action. Without doing so, you will not please God. In fact, you can do nothing without faith in action. Never forget that the most important thing of all is to put your trust in Jesus Christ. He will never fail you. Heaven and earth will pass away, but He will not fail you or forsake you. "Forever, O Lord, Thy Word is settled in heaven" (Psalms 119:89 KJV). Put your confidence only in Him no matter what. He will always come through for you. Just remember, you have been told.

Would you forsake your own children? What about your work? Would you give it your all? Jesus has given to us all the things we desire because He cares for us. Recall the story of the young man who had been lame since birth who was carried to the temple gate they called Beautiful, to beg for money from those entering the temple:

> Peter and John approached the young man, and he asked them for money. Peter fastened his eyes upon the young man along with John, too, and said, "Look on us." He looked, hoping to receive something from them. Then said Peter, "Silver and gold have I none; but such as I have, give I thee: in the name of Jesus Christ of Nazareth, rise up and walk." And he took him by the right hand and lifted him up: immediately his feet

and his ankle bones received strength. And he, leaping up, stood, and walked, and entered with them into the temple walking, and leaping, and praising God. (Acts 3:4–9)

When God has done something out of the norm for you, then people will look at you to see your reaction. God has done wonderful things for us repeatedly. All of us can rise up to do what we have been neglecting to do for a long time. Sick folks, whatever their condition may be, are saying, "We will not just sit here and do nothing. We must mobilize ourselves, taking an active interest in the direction of the country." Yes, you are sick; but life is still in your body. Do not just allow folks to take advantage of you, because they will. They will even squeeze the blood out of you and take everything you possess and walk away as if you never existed.

There were four leprous men in Samaria who decided to rise up and take matters into their own hands so they would not die. Elijah, the man of God, said, "Hear ye the word of the Lord. Tomorrow at this time shall a measure of fine flour be sold for a shekel, and two measures of barley for a shekel, in the gate of Samaria" (2 Kings 7:1). Because God's Word is true, what it says will happen must happen.

And there were four leprous men at the entering in of the gate: and they said one to another, "Why sit we there until they die?" They said, "If we say we will enter into the city, then the famine is in the city, and we shall die there: and if we sit still here, we die also. Now therefore come and let us fall unto the host of the Syrians. If they save us alive, we shall live; and if they kill us, we shall but die." And they rose up in the twilight, to go unto the camp of the Syrians. And when they were come to the uttermost part of the camp of the Syrians, behold, there was no man there. For the Lord had made the host of the Syrians to hear a noise of chariots and a noise of

horses, even the noise of a great host; they said one to another, "Lo, the king of Israel has hired against us the kings of the Hittites, and the kings of the Egyptians, to come upon us." Wherefore they arose and fled in the twilight, and left their tents, their horses, and their asses, even the camp as it was, and fled for their lives.

And when these lepers came to the uttermost part of the camp, they went into one tent and did eat and drink, and carried thence silver, gold, and raiment and went and hid it; and came again, entered into another tent, and carried thence also and went and hid it. Then they said one to another: "We do not well. This day is a day of good tidings, and we hold our peace; if we tarry till morning light, some mischief will come upon us; now therefore come, that we may go and tell the king's household. (2 Kings 7:3–9 KJV)

In this story, we see what faith can do. You can acquire faith if you really want to, for with God all things are possible. You must be cognizant of this: Without God, you can do nothing, but with faith in action, you will do the work and trust God to come through for you. Millions of people do not have this mindset, having diverse ways of thinking where their help comes from, who controls their lives, and their purpose for being here. God made this world for many people, and the world to come, He made for a few. The faith that millions possess today is not faith in our Lord Jesus Christ. Their faith is in their homes, their cars, money, and their possessions. They used their faith and their knowledge to build their homes. They used their faith and their knowledge to create new currency. They used their faith and their various abilities to amass their possessions. Then they will die, and in hell they will lift up their eyes. There they will learn of the big mistake they made: failure to receive the Spirit of God, which raised up Jesus from the dead. They did

not obey the Lord's Word, saying that being baptized in Jesus's name is the only way.

The lepers put their faith in action; they were not disappointed. Now, having many goods in their possession, they were not selfish in keeping everything to themselves. They sent word to the king, asking to participate in the gathering of the loot. For we are the helpers of one another. When people are truly in need, we extend a helping hand to them, showing them our faith and kindness by our works. In the end, Elijah's word came to pass. When the news reached the king that the Syrians had fled, he sent for and gathered up all the spoil that was in the tents. So, a measure of fine flour was sold for a shekel, and two measures of barley for a shekel, according to the Word of the Lord. As to the one who doubted the man of God, while he was guarding the gate, the people were in a hurry to get bread and they rushed upon him, trampling him. He died. Elijah had told him, "You will see it with thine eyes and shall not eat thereof."

THE PEOPLE ROSE UP

Here is Donald Trump, a witty man with scintillating gestures and vibes, arousing his troops of patriots. These patriots and troops, whom others have called "a basket of deplorables" and other such names, are on fire. Trump has lit a fire under them, and now they are on the move. There is no stopping them now as they fight the Left and their egregious leftist policies.

They are making a statement, saying, "We know where we stand. We are standing with Donald Trump; he is our man." God used the lepers, four of them in all, and sent the Syrian army into retreat, running for their lives. So is God stirring up the people who were once silent, causing them to be outspoken, some for Donald Trump, and some for the Truth of God that they might be saved.

The people know whom they voted for in the 2020 election. They were confident! They went out in droves and made history. How did the

election turn out the way it did? How could this be? Many black people, other people of color, Indigenous people, Latinos, and whites turned out for Trump. What happened? Inquiring minds want to know. God knows the truth. He is the truth, the way to life everlasting. God revealed to Trump the truth that he was the true winner of the 2020 election. With much fanfare, Trump mobilized his true patriots, and they all shouted, "We are going out to vote." They know in their hearts that they did not go to the polls or mail in their ballots for Joe Biden and Mrs. Harris. The people need an answer now. Not yesterday, next week, or next month, but now.

To their surprise—and O it was a surprise, what really took place—the leftist planners decided to muster some of their true Black Lives Matter villains to infiltrate the crowd and cause the madness that occurred on January 6, 2021.

Because people are enthusiastic about things and want to be part of the action, these individuals rushed to the Capitol Building. They thought that if they did this, they would get the outcome they voted for. They were incredibly surprised upon receiving an answer and realizing an outcome that left an indelible impression on them. *How can this be? Have we all been bitten in the rear? Can there be a justifiable solution to this debacle? There is always a solution! Will the authorities that exist understand? Will they be stringent enough to do that which they know to be good, right, and true?* No, they all sided with the conspirator, and said, "Joe Biden won honestly. He got eighty million people to vote for him." Come on, man! You know better than to live your life in a lie. Now the people are having a mood swing, going in the opposite direction, and they are not keeping quiet. They will make no bones about it. Seeing as one is what one eats, Trump is feeding them, and they love it. When you have captivated your audience as Donald Trump has captivated his, you know you have it made.

When people are lining up in droves to see you and hear you, then you must be special. It is a remarkable sight! With all the long lines of people who were waiting to see this man, Donald Trump, I asked myself, *What kind of man is this who has taken over the party? who has taken the*

country like a storm? who has won the people's hearts? Because he has won their hearts is why the people keep on saying to Trump at his speaking engagements, "We love you! We love you!" While some are loving him to death, others have a hateful attitude toward him that they cannot mend on their own. For the hearts of men and women are desperately wicked. God knows the human heart, including its desires that are vain.

Something that really caught my eye is the fact that Donald Trump always has people at his rallies or Save America Conferences who are talking about the Lord and giving Him praise. Everything that has breath must praise God. God loves us more when we give Him honor and praise. Some people do not want to have anything to do with God, whereas others will always try to say something good about him. All the former group is concerned about is giving the Lord God lip service. They will not submit themselves to the truth of God's Word or become fully committed to Him.

People talk about so many things they have no knowledge or understanding of because they are wise in their own conceit; they just keep on being flabbergasting. God will blow your mind by the way He runs things. So, you will say, "I don't believe God is in that." You will not know until He opens the eyes of your heart, so you are able to see clearly.

The lepers rose up, found food, and lived. You must get an understanding of who is motivating people to remain in their unbelief.

> And they rose up in the twilight, to go unto the camp of the Syrians: and when they were come to the uttermost part of the camp of Syria, behold, there was no man there. For the Lord had made the host of the Syrians to hear a noise of chariots, and a noise of horses, even the noise of a great host; and they said to one another, "Lo, the king of Israel hath hires against us the kings of the Hittites and the kings of the Egyptians, to come upon us." Wherefore they arose and fled in the twilight, and left their tents, and their horses, and their asses, even the camp as it was, and fled for their life. (2 Kings 7:5–7 KJV)

Now Biden's government is trying everything in its power to control people's lives. But my God is still in control! Let us not die! Let us live, and fight, and declare the work of the Lord in the land we live in. We do not use physical weapons to fight in this great war; we use the sword of the Spirit, which is the Word of God.

What God Allowed

God Almighty attired the four lepers, and they rose up to prevent themselves from dying. The Almighty caused the steps of the four leprous men to sound like an army. The Syrians, hearing the sound of chariots, horses, and many soldiers, fled in haste for their lives. It is no secret what God can do. "But God has chosen the foolish things of the world to confound the wise. And God hath chosen the weak things of the world to confound the things which are mighty. And base things of the world, and things which are despised, hath God chosen, yea, and things which are not, to bring to naught things that are: That no flesh should glory in his presence" (1 Corinthians 1:27–28 KJV).

Four men of inconsequence had the army in retreat. This is out of sight, having happened in the middle of the night. When people really think about it, they tend to say, "Well, men and women wrote the Bible. How do I know it is true?" We had all better know it is true. To justify themselves, people look through the Bible to try to find some verse to soothe their lustful need. When they are perplexed, sad, or weary, they go and read a psalm. But after they have read the psalm, hearing and seeing something that goes against their fleshly desires, they say, "Men and women wrote the Bible." Be it known unto you that every word of God is pure and is settled in heaven. "All scripture is given by the inspiration of God, and is profitable for doctrine, for reproof, for correction, for instruction in righteousness: that the man of God may be perfect, thoroughly furnished unto all good works" (2 Timothy 3:16–17 KJV). We become clean through the Word.

Outside the Word, we are filthy, messed up, and unclean. We should

desire the Word of God more than gold, yes, more than fine gold. The Word is sweeter than honey and the honeycomb. Moreover, by the Word we are warned to seek the kingdom of God first and His righteousness. In doing so, we will reap a great reward. Our disobedience will cause us to be in retreat, running like we are crazy, with no one chasing us. The four leprous men rose up, went to the Syrians' camp, and found booty. They came back extremely excited and happy and told the king's household. At first, the king was a bit apprehensive. But one of the servants spoke up and said, "Let us send them and see." He did!

The government of this great country, time after time, has sent people to other countries to observe elections. But right here at home we have a big problem with our own elections. Anyone who dared question all the cover-ups, the flaws, and the complaints, and all the whistleblowers who came forward, were ignored and not given the time to be heard. The great and mighty government started breathing out threats of prosecution against the people. The great and so-called mighty locked me up for five years. God allowed my adversaries and my foes, and the prosecutors, to have their way. But He keeps right on blessing me. He vindicated me. The authorities revoked my supervised release, revoked the charges, and removed the one million dollars in restitution I was to pay. Now I am still waiting to be paid myself, for the Lord showed me how to turn documents into money and help His people. The Lord told me to wait, saying it wouldn't be long.

Who can understand God's ways? I rose up and spoke what God said, and folks are on edge, cussing, calling me all kinds of names except a child or son of God. But God said, "Be not afraid of their faces, for I am with thee to deliver thee. I have put My word in thy mouth" (Jeremiah 1:8–9 KJV). When Elijah spoke of the famine, he had opposition. But he said, "Behold, thou shalt see it with thine eyes, but shall not eat thereof." Then a lord on whose hand the king leaned answered the man of God and said, "Behold, if the Lord would make windows in heaven, might this thing be" (2 Kings 7:2 KJV). Now watch this! Verse 17 says: "And the king appointed the lord on whose hand he leaned to have the charge of the gate: and the people trod upon him in the gate,

and he died, as the man of God had said, who spake when the king came down to him" (KJV).

This lord did not believe the man of God, so the Lord God caused the people to stomp on him, and he died. All those who were looking for Trump to die got the biggest shock in their lives. Mr. Trump will not be going anywhere until the Lord says so.

Hear what God said in Ezekiel 18:23, 27: "'Have I any pleasure at all that the wicked should die?' saith the Lord God: 'And not that he should return from his ways, and live? … Again, when the wicked man turneth away from his wickedness that he has committed, and doeth that which is lawful and right, he shall save his soul alive'" (KJV). Your life is in God's hands. You had better repent now and get right with God Almighty before he takes the breath of life that He gave you and casts you into hell, where your worm will die not and the fire will not be quenched.

What Are You Hiding?

The king's servant encouraged the king to send someone to investigate the deeds of the Syrians. The result was very promising for the king of Israel.

We must be honest with ourselves, or we will not be honest with others. The Democrats and their associates lied and said this was one of the freest and fairest elections we have ever had. They who said such things know that they are lying to themselves. You can lock up a thief to stop him from stealing; but he who tell lies, even when you handcuff him and put him behind bars, will still lie to you. So, the only thing that can stop a liar is death. Someone will say to me, "Preacher man, why do have to say death? You are going to the extreme." My answer is to point to Proverbs 6:19, which says that God hates "a false witness that speaketh lies" (KJV).

Brother Ananias and his wife sold a piece of his land. They decided to lie to Peter about the sale price. Peter asked Ananias these questions:

"'Why has Satan filled thine heart to lie to the Holy Ghost, and to keep back part of the price of the land? Whiles it remained, was it not thine own? And after it was sold, was it not in thine own power? Why has thou conceived this thing in thine heart? Thou hast not lied to men, but to God.' And Ananias hearing these words fell down and gave up the ghost. And great fear came on all of them that heard these things" (Acts 5:3–5 KJV). God finds no pleasure in the death of a sinner. He wants the lying sinner to turn away from his lying ways, make amends, and live. Why should anyone die before his or her time?

A liar acts just like his or her father, and the works of his or her father he or she will do, no more, no less. Do not fight with a liar, or you might just learn his or her ways. Whoever the president of the United States is, he or she must be held to a standard of honesty. I must speak the truth. "For the priest's lips should keep knowledge, and they should seek the law at his mouth: for he is the messenger of the Lord of hosts" (Malachi 2:7 KJV).

Just a Few More Words to Donald Trump and Joe Biden

The Lord God said, "Seek ye out of the book of the Lord and read: no one of these shall fail" (Isaiah 34:16 KJV). To Mr. Trump, God said, "I put you in power and made you the head for four years, and you did well. You could have done better, but I am giving you the credit. You turned the economy around and made things better for My people. One of My lookout guards is sounding the alarm. The day for God to visit you has come. Do not trust a neighbor; put no confidence in a friend, even the woman who lies in your arms to embrace. Guard the words that proceed out of your mouth. For your enemies are those of your own house.

"Look to the Lord God. If you let Me, I will save you to the utmost, along with your family. Seek to keep My ways, and do not stop doing good things for the people. I raised you up to act justly, to love mercy, and to walk humbly with Me. I have protected you from all the wickedness that has come your way. But wickedness is in your house, and you need to get rid of it. Because you fear Me to a point and honor Me, I spare your life. You have seen all the lives taken away by coronavirus, yet I spare your life. Although those close to you, in your house and in your

administration, wanted you gone, your haters wishing you were dead, I said, "Live," and you are still alive. I give life, and I take it away. I have seen your ways, and I heal your body because I love you. Your flesh is grass, just as that of all others are. The goodliness of your body is as the flowers that are in the field.

"But do not forget: I, the Lord God, heals all diseases and shows mercy to whom I will. I know that you are extremely disappointed about the outcome of the 2020 election. Fear not, thou worm, Donald Trump, and your seventy-five-million-plus followers. I the Lord will hold your right hand; don't you fear. Who has directed My Spirit? Who can counsel Me as I have My way in the storm and in the whirlwind? I had My hands in the election.

"My servant sent you a letter telling you to keep up the excellent work. My servant told you that you would be serving another four-year term. This is true. You did win the election. I hope you know that. I am God! I give to human beings the desires of their hearts. The kingdom is Mine. The country is Mine. All the money is Mine. You and Joe Biden are Mine. I made the both of you. None of you made yourselves. After you received the certified piece of mail from My faithful servant, I counseled with Myself. Seeing how desperate your opponent was, I gave him his heart's desire. I am God. I search the heart and examine the mind, to reward each person according to their conduct.

"Some people will say that I am partial. But they are the ones partial, not Me. For without Me, you can do nothing—nothing at all. At My rebuke, the mountains quake. All have seen the display of My power in the volcano in southern Japan. You have seen My power with the volcano in Hawaii. Why sayest thou, Joe Biden from Scranton, Pennsylvania, saying, 'I hid my ways from the Lord; and my power to make judgment is passed down to me from the people who helped me win'? I give power to the faint; to them who have no might, I increase their strength. When you were going up the steps of Air Force One and you fell, I could have ended your life. But I kept you alive, Joe Biden. For I know the thoughts that I think toward you, thoughts of peace, and not of evil, to give you an expected end.

"If you call upon Me and pray unto Me, I will answer you. If you seek Me with your whole heart and search for Me, you will find Me. All your children and the children of the United States have only done evil in My sight from their youth. Your children and the children of the United States have done evil to provoke Me to anger. Your past presidents, your governors, your priests, and your prophets have provoked Me to anger. All have turned their backs on Me and not their faces toward Me." To Donald Trump, God says, "Why don't you call Me and see if I will not answer you and show you great and mighty things that you do not know? I will bring you a cure and health. I have revealed to you the truth. I have caused the great fraud to take place so that both Joe Biden and you will know what is in your hearts.

"With whom have I taken counsel? Who is My instructor? Who taught Me in the way of judgment? Who taught Me knowledge and showed Me how to understand? The nation's capital and its states are like a drop of water in a bucket to Me. To me you are regarded as dust on the scales. I weighed all the states and islands; they are fine dust to Me.

"To whom then will you liken Me, Jesus Christ? I was dead because I gave up My life for you. I, Jesus Christ, rose up from the grave, triumphing over all My foes. I ascended far above all dominion, all might, and all principalities and powers. Seeing as I rose with such power, with whom shall I be compared? Do you know? Have you not heard? Were you not told from the beginning? Have you not understood since the earth was founded that I sit enthroned above the circle of the earth, and its people are like grasshoppers to Me? I stretched out the heavens like a canopy. I spread them out as a tent to live in. I caused the fraud to stand. That is why people kept talking about the Big Lie. Because My sentence against this evil, along with all others, was not executed speedily; therefore, the heart of humankind is fully set in them to do evil.

"All this have I seen and held My peace. There is no person who has the power over his or her own life (breath, spirit) to retain it. You will have no power in the day of your death, unless you repent and turn to Me, Jesus, to be saved. None of your scheming and none of your wickedness will deliver you. Go ahead, eat your bread and drink your wine

with a merry heart. Your time is surely coming when your work will be accepted, good or bad. Your work determines where you will be spending the rest of your life, in heaven or in hell.

"No person has a clue of the day of his or her death. Just as the fish that is taken in a net that is evil, so are the sons of humankind snared in this evil time. When the evil death falls upon you suddenly, what steps will you take? What move will you make? None! I the Lord brings presidents to naught. I the Lord reduces the judges of this world to nothing. Once they are seated on their judgment seats, as they immediately begin to judge unjustly, I let them live for a while. Then My whirlwind sweeps them away. Who is My equal? To whom will you liken Me? Just lift up your eyes on high: who has created all the wonders you see? When you look up in the night sky, you see My hosts by the numbers. I call them all by their names. By the greatness of My might have I done this. I am strong in power. Not one of them will fail in their power.

"Has thou not heard, has thou not known, that you must worship the Lord your God and Him only you shall serve? Me, the everlasting God, the Creator, I am the Lord of the whole earth. I faint not, neither am I weary. You cannot search out my understanding. When the needy and the poor need water and there is none, and their tongues fail for thirst, I the Lord will hear their calls and their cries. I am the God of Israel. I am the God of the United States. I will not forsake My people. I opened rivers in high places. I opened fountains in the valleys. I make the wilderness a pool of water. I make the dry land spring forth with water. I say all this so that you may see, and know, and consider, and understand that the hands of the Lord have done these things. Will you present your case? I am the Lord.

"Do you have serious questions you need an answer for? Bring them and set them before Me, and see what happens. Do the same and bring your judges to see if they will judge righteously. For they know not how to do right. They store up robbery and violence in their palaces. I will set an adversary there, even around the courts of the land; I will bring down their strength. I the Lord will remove these unjust judges from your midst. I will slay all the royal ones. I could go ahead and call the

names of your high-profile leaders who have recently lost their lives, but I will hold My tongue with My bridle. I the Lord will do nothing without revealing My plans to My servants the prophets. Does a lion roar in the thicket when it has no prey? Does the young lion growl in the den when it has caught nothing? There is a cry being sounded, but not for the right reason. It is people crying about the Big Lie, but they are the guilty ones.

"I will kindle a fire in the walls of the United States, and it shall devour your beautiful palaces. Do you all remember how the Twin Towers in New York crumbled? I saw the destruction. Do you remember the destruction in your streets in 2019–2020? I raised Myself up and stood by, watching the people's detestable and riotous actions, for which they will have to give an account later. I have caused the virus to be sent among you in the same manner as in Egypt. Your daughters, sons, mothers, and fathers have I caused to be taken away by the disease. You who are afraid of coronavirus, saying, 'We are doing everything in our power to keep ourselves alive,' watch out! Your lives will be like that of a man fleeing from a bear, only to be met by a lion, or like that of a man who, entering his house and resting his hand on one of the walls, is stung by a venomous spider or scorpion. He goes into the restroom and is bitten by a snake. In each case, with his blood pressure rising rapidly, his death will be imminent.

"Therefore, this is what I am saying to the United States, to Joe Biden, Donald Trump, and the entire world: prepare to meet thy God. I, who form the mountains, am God; and I created the wind. I revealed to Joe Biden and Donald Trump their thoughts, as I do to all humanity. I turn dawn to darkness. I tread upon the high places of the earth. I am God. I never change. O United States of America, why are you destroying yourself? All your help is in Me. I am and will always be your King. Where is your president? Is he able to save you from sin? Where are your rulers? You asked for a president and a vice president, right? In My anger, I gave you a president. When the time is right, I the Lord will remove him, mark My words. For the guilt of Joe Biden is stored up; his sins are kept on record. The day of My visitation is soon to come. The day of My recompence is coming.

"You will know that your prophets are fools. The spiritual men are mad. They have deeply corrupted themselves. I have a bone to pick with Joe Biden and the United States. Let no person strive nor reprove another. But do unto others as you would have them do to you. You are My people, you say. So, why are you destroying yourselves? For a lack of knowledge of My Word? That's it! For the more you increase, the more you sin against Me. You will not change and reframe your doings to turn unto Me your God. For the spirit of whoredom is in your midst. Who is wise? Please understand that My ways are right and that the righteous shall walk in them.

"Those who oppose My Word will be destroyed. I am the Lord thy God. I kept you in the womb. I took you out of the womb. I knew you before you were born. Donald Trump, you are not in the White House now, but you are My servant. I have chosen you. I have set you aside. The coronavirus was unleashed to take you out, but I had mercy on you. Here you are, still alive.

"Fear not, for I am here to save you. Be not dismayed. I am your God. I will strengthen you. Yes, I will help you and hold you up with My right hand. All who raged against thee shall surely be ashamed and disgraced. Those who oppose you will be as nothing. They will perish. You will not have to search for your enemies; you will see them. Those who raged and railed against thee will be as nothing at all. I am the Lord your God. I am taking care of you, and I am saying to you, 'Do not fear, I will help you.' See, I have made you like a hammer that breaks things up. That is why people are fighting tenaciously against you without success. But be it known unto you, worm Trump, I have My hands upon you. I am watching your ways. I know that you have a good heart. But it is up to you to allow Me to save you. I want to save your soul. I want to cleanse you and make you well. You have a choice.

"I, even I, am the Lord, and beside Me there is no savior. Call now, if you will, but who will answer you? To which of the priests will you turn? Fools are killed all day long because they resent My words, and the simple are slain by being envious. Make your appeal to God, will you? I would lay out my case before God. I performed wonders that you

cannot fathom. I performed miracles that you cannot count. I catch the wise in their own craftiness, and the schemes of the wily and the witty, I sweep them away. I saved the needy from the sword of the people's mouth. I know how to lift to safety those who put their trust and their confidence in Me. Those who mourn, I give them comfort, and the lowly I set them on high. I do all these things so that injustice will shut its mouth, so that the poor will have hope in Me. For I am your hope and your exceedingly great reward.

"The one whom I correct is blessed, so do not despise My discipline; it is good for you. When you are involved in six troubles, or even in seven, I will be there to protect you. Just remember, there is an appointed time for you upon the earth. I will teach you, so please be careful. I will always show you where you have erred. Always remember to pray. I will hear you. And what you wish to accomplish will be done for you. After you were banned from the biggest social media platforms, I gave you wisdom to take matters into your own hands and create your own social media. You have been out of the White House, but don't you see what I have done for you? I have made you more popular than before—so popular that your endorsed candidates will emerge victorious in the upcoming elections. Your new social media platform will be so large, it will be eye-popping and out of this world.

"My love for you cost Me my life. No one could ever care for you like I do. I came so that you might have life abundantly. Both you and everyone who lives and believes in Me shall never die. I do hope you believe this. I have come into the world as a light, so that no one who believes in Me should stay in darkness. There is a time for judgment of the one who rejects Me now and does not accept My words. The very words I have spoken will condemn such a person on that day. Do you see the way those people at your gatherings rise in exuberant praise, calling your name? It's because I have made you a god unto them. Don't you ever forget that I am the almighty God. I reign from heaven above with love, power, and wisdom.

"Talking about rising up, let Me tell you something else about My God and your God, about My Father and your Father. God was not

born. God is a Spirit from everlasting to everlasting. God overshadowed Mary, and the Holy Ghost came upon her, and she conceived Me. The holy thing that was born of her was called, is called, and shall be called the Son of God. For your information, the Son of God and the Son of man are the same person. Jesus is My name; and in My body is God the Christ, reconciling the world to Me. While on the cross, I cried out to My Spirit, 'My God, My God, why has Thou forsaken Me?' (Matthew 27:46).

"I cried to My God and to your God. If you believe Me and accept Me, you have both the Father and the Son. We who are one will come in you and take up our abode in you. There is not another God besides Me.

"I came and laid down My life for you. I was horribly treated, mocked, and scourged. I was taken before Pontius Pilate's judgment seat, and he sentenced me to crucifixion. While I was on the cross, one of the soldiers came to Me—My Spirit came out of My body—and, with a spear, pierced My side. "And forthwith came out blood and water" (John 19:34 KJV). They took Me down from the cross and wound up My body with spices in linen. They laid Me in a new sepulcher, 'wherein was never man yet laid.' You can find this written in John 19:41 (KJV). 'And [Joseph of Arimathea] rolled a great stone to the door of the sepulcher and departed' (Matthew 27:60 KJV). He covered Me in. The chief priests and Pharisees were not pleased with what had been done, so the next day they came back and sealed My tomb and sent men to watch over Me. I hope you are paying close attention to all of this.

"'At the end of the Sabbath, as it began to dawn toward the first day of the week, Mary Magdalene and the other Mary came to the sepulcher. And behold there was a great earthquake. For the angel of the Lord descended from heaven and came and rolled back the stone from the door and sat upon it. His countenance was like lightning, and his raiment white as snow. And for fear of him the keepers did shake and became as dead men' (Matthew 28:1–4 KJV). 'And the angel answered and said unto the women, "Fear ye not, for I know that ye seek Jesus, which was crucified. He is not here, for He is risen, as He said. Come, see the place where the Lord lay. And go quickly and tell His disciples

that He is risen from the dead; and behold, He goeth before you into Galilee, there shall ye see Him, lo, I have told you'" (Matthew 28:5–7). All this information can be found in scripture. It's not a secret. All you must do is search the scriptures.

"'For I am God, and there is none else' (Isaiah 45:22 KJV). As your God, I am making Myself as candid as I can. 'Some of the watchers came into the city and shewed unto the high priest all the things that were done. And when they were assembled with the elders, and had taken counsel, they paid large money unto the soldier saying, "Say ye, His disciples came by night and stole Him away while we slept. And if this come to the governor's ears, we will persuade him, and secure you." So, they took the money, and did as they were taught. And this saying is commonly reported among the Jews until this day' (Matthew 28:11–15 KJV). You'd better believe that My rising is real."

CHAPTER 9

MY LAST WORD TO DONALD TRUMP AND JOE BIDEN

"Dear friends, I allowed My life to be taken so I could taste death for everyone. So, after My death, I went to hell. I lifted up My voice and said, 'Lift up your heads, o ye gates, and be ye lifted up, ye everlasting doors, and the King of glory shall come in' (Psalms 24:7 KJV). A voice rhetorically responded and said, 'Who is the King of glory?' (Psalms 24:8 KJV). I replied, 'The Lord strong and mighty, the Lord mighty in battle' (Psalms 24:8 KJV). The devil did not open the gate as told. I cried again and said, 'Lift up your heads, O ye gates, even lift them up, ye everlasting doors, and the King of glory shall come in' (Psalms 24:9 KJV). The devil again responded with sarcasm, saying, 'Who is the King of glory?' (Psalms 24:10 KJV). I said to him, 'The Lord of hosts, He is the King of glory' (Psalms 24:10 KJV).

"He did not open the gate. So, I went in by My great power. 'And

the great dragon was cast out, that old serpent, called devil, and Satan, which deceiveth the whole world' (Revelation 12:9 KJV). He gave up the keys without a fight. 'For Christ also hath once suffered for sins, the just for the unjust that He might bring us to God, being put to death in the flesh, but quickened by the Spirit. By which also He went and preached unto the spirits in prison' (Peter 3:18–19 KJV). Many of those in prison were set free by Me. Some of the angels who sinned against Me, I cast them into hell and delivered them into chains of darkness to be reserved unto judgment. I did not go to hell to look for them. I went to hell to do the release.

"'For if God spared not the angels that sinned, but cast them down to hell, and delivered them into chains of darkness to be reserved unto judgment' (2 Peter 2:4 KJV).

"I went down there with My bloodstained sinless body, but I was alive in Spirit. I went and preached to the disobedient spirits, those who were not obedient way back when Noah was preaching and building the ark. All those who, all their lives, were subject to bondage, held captive by the devil, were set free. My rising up was accompanied by great power and might.

"I revealed Myself to John, and he wrote in the Revelation, 'Who bears record of the Word of God and of the testimony of Jesus Christ and of all things that he saw' (Revelation 1:2 KJV)."

> And from Jesus Christ who is the faithful witness, and the first begotten from the dead, and the Prince of the kings of the earth. Unto Him that loved us and washed us from our sins in His own blood. And hath made us kings and priest unto God and His Father; to Him be glory and dominion for ever and ever. Amen. Behold He cometh with clouds; and every eye shall behold Him: and they also which pierced Him: and all kindreds of the earth shall wail because of Him. Even so, amen. "I am Alpha, and Omega, the beginning and the ending,"

saith the Lord, which is, and which was, and which is to come, the Almighty. (Revelation 1:5–8 KJV)

"'When I saw Him, I fell at His feet as dead. And He laid His right hand upon me, saying unto me, "Fear not; I am the first and the last. I am He that liveth, and was dead; and behold, I am alive for evermore, Amen; and have the keys of hell and of death"' (Revelation 1:17–18 KJV).

"You will notice that John was afraid when he saw Me. He said, 'I fell at His feet as though dead. Then He placed His right hand on me and said, "Do not be afraid. I am the First and the Last. I am the living One. I was dead; now, look, I am alive forever and ever. I hold the keys of death and Hades"' (Revelation 1:17–18 NIV). For there is no grave that could hold My body down. I hope I am giving you inspiration. While I was on the cross, you, Donald Trump and Joe Biden, were on My mind. The pain I felt for you caused me to cry loudly, saying, 'Eli, Eli, lama sabachthani,' which means, 'My God, My God, why hath Thou forsaken Me?'" (Matthew 27:46 KJV).

"'Some of them that stood there when they heard that, said, "This man calleth for Elias." The rest said, "Let be, let us see whether Elias will come to save Him"' (Matthew 27:49 KJV). I cried out again with a loud voice, and the Spirit left My body. That is, I ended My body's life as a sacrifice for you. I gave up the temple of My body to death.

"'Jesus, when He had cried again with a loud voice, yielded up the Ghost. And behold, the veil of the temple was rent in twain from the top to the bottom; and the earth did quake, and the rocks rent; and the graves were opened; and many bodies of the saints which slept arose, and came out of the graves after His resurrection, and went into the holy city, and appeared unto many' (Matthew 27:50–53 KJV).

"I was torn when they pierced My hands, feet, and side. I laid My life down and took it up again. As I have said before, so say I again, 'I am your God.' Up from the grave I arose, with a thundering triumph over My foes. The earth shook, and the rocks split, and the tombs broke open. You just watch, I will come storming back again. 'And the bodies of many holy people [saints] who had died were raised to life. They

came out of their tombs after My rising up. They went into the holy city [Jerusalem] and appeared unto many people.' You can find this written in Matthew 27:46–53."

Are You Listening, Man?

"It was impossible for death to hold Me down. So, I triumphed over death, the grave, and its sting. Simon Peter gave a wonderful testimony about Me on the day of Pentecost, saying, 'Men of Israel, hear these words; Jesus of Nazareth a man approved of God among you by miracles and wonders and signs, which God did by Him in your midst, as you yourselves also know. This man was delivered up by your determined counsel and the foreknowledge of God, ye have taken, and by wicked hands have crucified and slain. Whom God raised up, having loosed the pains of death: because it was not possible for death to hold Him down.' You can find this in Acts 2:20–24.

"Peter continued his oration, saying, 'Men and brethren, let me freely speak unto you of the patriarch David, that he is both dead and buried, and his sepulcher is with us until this day. Therefore, being a prophet, and knowing that God had sworn with an oath to him, that of the fruits of his loins, according to the flesh, he would raise up Christ to sit on his throne. David, seeing this before, spake of the resurrection of Christ, that His soul was not left in hell, neither did His flesh see corruption' (Acts 2:29–31 KJV). King David in his day also gave this testimony about Me: 'I have set the Lord always before me: because He is at my right hand, that I should not be moved' (Psalms 16:8 KJV).

"'Therefore, my heart is glad, and my glory rejoiceth, my flesh also shall rest in hope. For Thou wilt not leave my soul in hell; neither will Thou suffer Thine Holy One to see corruption. Thou wilt show me the path of life: in Thy presence is fullness of joy; at Thy right hand there are pleasures for evermore.' This is written in Psalms 16:8–11 (KJV). David truly spoke about Me, Jesus, the Messiah. David is not in the heavens

above. He saith himself, 'The Lord said to my Lord, "Sit Thou at My right hand until I make Thy foes Thy footstool"' (Psalms 110:1 KJV).

"My soul was not left in hell. My flesh did not see corruption. I am alive! And I am ready and waiting to save your soul if you will allow Me to do so. You will find this written in Acts 2:29–31 (KJV.) Peter continued his exhortation, saying, 'This Jesus hath God raised up, whereof we are all witnesses. Therefore, being by the right hand of God exalted, and having received of the Father the promise of the Holy Ghost, He has shed forth this, which you now see and hear,' which is written in Acts 2:32–33 (KJV).

"Finally, Simon Peter, my illustrious servant, told them they had crucified Me, the Lord and Christ."

> Therefore, let all the house of Israel know assuredly that God has made that same Jesus whom ye have crucified, both Lord and Christ. Now when they heard this, they were pricked in their heart, and said unto Peter and unto the rest of the apostles, "Men, and brethren, what shall we do?" Then said Peter unto them, "Repent, and be baptized every one of you, in the name of Jesus Christ for the remission of sins, and ye shall receive the gift of the Holy Ghost. For the promise is unto you, and to your children, and to all that are afar off, even as many as the Lord our God shall call." And with many other words did He testify, and exhort, saying, "Save yourself from this untoward generation." Those that gladly received His Word were baptized; and the same day there were added unto them about three thousand souls. (Acts 2:36–41 KJV)

"Because I rose, Donald Trump and Joe Biden, and all people, have a hope for tomorrow and beyond, if you believe and put your trust in Me. All your problems and troubles will be temporary. All your fears will dissipate. But if your hope is only in the things you possess in this world,

such as cars, boats, houses, land, money, and an empire, know that I will not allow you to take anything with you. I brought you here with nothing; I will take you away carrying nothing with you. During your stay here, you make plans, and you formulate and implement policies. Some of them you vigorously defend to have things go your way. I am God; I have things My way. My way is holy, and holiness. I started a holy church. All My churches have the same name wherever they are in the world. All My people who are preparing and waiting to be caught up in the heavens with Me must speak the same things. I have no respect for any persons at all, and My Word is final.

"I arose and came storming back to life. Now, if you would like to have the same privilege, you must find your new life in Me, Jesus. No one else can do this for you. Do you understand? All your blasphemies and your sins will be forgiven you if you walk away from your religion and your religious beliefs. I will not forgive you if you blaspheme the Holy Ghost, either in this world or in the one to come, so be incredibly careful. Beware lest any person spoil you with philosophy and vain deceit, after the tradition of humankind, after the rudiments of the world, and not after Christ (Colossians 2:8 KJV). If the both of you want to be risen with Me, Jesus Christ, you must seek after Me.

"'If ye then be risen with Christ, seek those things which are above, where Christ sitteth on the right hand of God' (Colossians 3:1–2 KJV). Here, the right hand means the right hand of power. If you do as Colossians instructs, you will find peace with Me in God. You are complete in Me. I will come back to receive you, so that you will reign and rule with Me in My kingdom in the coming ages. The White House reign is temporal as you know. The honor you sought after, Mr. Biden, I gave it to you, but it will not last. Like a beast is caught and slaughtered, so will you be slaughtered and perish by death. And in hell you will lift up your eyes, having no one to help you there. You, being a man of honor all these years with your riches, will die. You can only find your life in Me if you repent of your sins and get baptized in My name.

"Do you understand My speech? By no means can you redeem your wife, mother, brother, or children. Neither are you able to pay ransom

for them. You deceived your fellows and the people of the United States. You know you stole the election, Mr. Biden. You gave your mouth to evil, and your tongue frames deceit. These things have you done, and I held My peace, keeping silent. You thought that I was such a one as you. I will reprove thee and set thee in order before thine own eyes. I am the almighty God, Jesus Christ. I rose up in My servant and invigorated him to pen these words. Now, don't you forget about God. If you do forget about Him, surely He will forget about you, and you will die without having any hope for a better life."

WRONG PRIORITIES

Because of the stolen election, cancel culture, and mask wearing, job loss is prevalent. The government's attitude is, *Do as we say, not as we do.* When you rise up and start speaking truth, liars get mad and upset and become ready to kill. For men and women would rather believe a lie than the truth. These political leaders wielding their powers, being persuaded by the powers of darkness and spiritual wickedness in high places, are led away by their errors. They are in a rut, being covered by their own errors; they just can't see the things that have been revealed. They just can't see the truth. You must be given discernment to fully understand all spiritual things. I am writing as my God inspires me, for I have the mind of Christ. God chose me and showed me what took place in the 2020 election. The people's eyes are opening little by little to the truth. The Biden regime has prioritized dishonesty over honesty. They have prioritized giving illegals more rights than are given to the citizens of this country. They all have the wrong attitude. Even when things are not working the way they are supposed to, the Democrats refuse to be corrected or take righteous counsel.

Multitudes, Both Men and Women, Are Turning to Donald Trump

Believers will always be added to you by way of anything you do or say. Let us look at the spiritual aspects of rising up now; later we will deal with the political aspects. "Believers were the more added to the Lord, multitudes, both of men and women" (Acts 5:14). These believers looked and saw the wonder-working power of God in the apostles. "Insomuch that they brought forth the sick into the streets and laid them on beds and couches, that at least the shadow of Peter passing by might overshadow some of them. There came also a multitude out of the cities round about unto Jerusalem, bringing sick folks, and them which were vexed with unclean spirits, and they were healed, everyone" (Acts 5:15–16 KJV).

To continue the story, the ringleader rose up, and all those who were with him were filled with indignation. They caught the apostles and put them in the common prison. But in the night, the angel of the Lord opened the doors of the prison and told the apostles to go tell the people about everlasting life. At daybreak, the officers entered the prison to see the men; but the apostles were not there. Released from prison, they entered the temple courts at daybreak and began to teach the people about everlasting life. The officers returned and reported that they went to the prison and found the doors closed and the guards still standing outside, but when they looked inside, they did not find the men. The chief priest and the temple guards were livid, wondering what this might lead to. But someone immediately came and told them that the men they had put in prison were standing in the temple courts instructing the people.

Motivated by and with the spirit of wrath, the captain went with his officers and caught the apostles. This time, they did not use force; they brought the apostles in to appear before the council to be questioned by the high priest, who had strictly commanded them not to teach in Jesus's name. They told the apostles they were filling Jerusalem with their doctrine, making them guilty of Jesus's death. Peter and the other apostles told them they would rather obey God than humankind. "'The

God of our ancestors raised up Jesus from the dead, whom you killed by hanging Him on a cross. God exalted Him to His own right hand as a Prince and Savior, that He might bring Israel to repentance and forgive their sins.' Peter told them, 'We are eyewitnesses of these things, and so is the Holy Spirit, whom God has given to those who obey Him'" (Acts 5:30–32 KJV).

It is better to have people who are upset with you than to disobey God and be at His mercy in the end because you did not obey His voice. The people on the council were very furious when they heard what Peter said and learned of how the apostles stood their ground; they wanted to put them to death. The kingdom of God is constantly under attack because the world system is under Satan's control. He goes about as a roaring lion, taking people at his will to kill them, steal from them, and destroy them. But as soldiers of the cross, the apostles stood by the power of God and valiantly fought the good fight of faith. Their fight was never about destroying people's lives, but saving them so that they might receive the inheritance set aside for those who are sanctified by faith in Jesus Christ the Lord our God.

> But a Pharisee named Gamaliel, a teacher of the law, who was honored by all the people, stood up in the Sanhedrin and ordered that the men be put outside for a little while. Then he addressed the Sanhedrin: "Men of Israel, consider carefully what you intend to do to these men. Sometime ago Theudas appeared, claiming to be somebody, and about four hundred men rallied to him. He was killed; all his followers were dispersed, and it all came to nothing. After him, Judas the Galilean appeared in the days of the census and led a band of people in revolt. He too was killed, and all his followers were scattered. Therefore, in this present case I advise: Leave these men alone! Let them go. For if their purpose or activity is of human origin, it will fail. But, if it is from God, you will not be able to stop these men;

you will only find yourselves fighting against God." ... His speech persuaded them. They called the apostles in and had them flogged. Then they ordered them not to speak in the name of Jesus and let them go. Filled with excitement, the apostles left the Sanhedrin rejoicing because they had been counted worthy to suffer disgrace for the name. Day after day in the temple courts and from house to house, they never stopped teaching and proclaiming the good news that Jesus is the Messiah. (Acts 5:34–39, 41–42 NIV)

IF YOU HAVE A REASON TO DO SO, COMPLAIN

Donald Trump and his supporters were not pleased with the 2020 election results. His counselors and lawyers filed several lawsuits, but these were not looked into and, instead, were pushed aside by the judges. Trump told his supporters to come to Washington, DC, on January 6, 2021, to protest peacefully on the Mall and at the Capitol Building. Many prayers were spoken that day, but they were prayers that dishonored the Lord God. The men prayed to God with their heads covered, so they did not receive the answers they sought ("Every man praying or prophesying, having his head covered, dishonoureth his head" [1 Corinthians 11:4]). The women also dishonored God by praying to the Lord Jesus with their heads uncovered ("Judge in yourselves: is it comely that a woman pray unto God uncovered?" [1 Corinthians 11:13]). Trump's spiritual adviser, Paula White-Cain, a false prophetess and televangelist, failed to give him wise counsel. The people had a valid reason for complaining, but they went about it the wrong way.

As the disciples increased in the ways of the Lord just after the Pentecostal experience at Jerusalem, there arose a murmuring of the Grecians against the Hebrews, because their widows were neglected in the daily ministration. The disciples had a valid reason for complaining,

so they audibly murmured their frustration and dissatisfaction. The apostles jumped into action to address the situation head-on.

> Then the Twelve called the multitude unto them, and said, "It is not reason that we should leave the word of God and serve tables. Wherefore, brethren, look ye out among you seven men of honest report, full of the Holy Ghost and wisdom, whom we may appoint over this business. But we will give ourselves continually to prayer, and to the ministry of the word."
>
> And the saying pleased the whole multitude: and they chose Stephen, a man full of faith and of the Holy Ghost, and Phillip, and Prochorus, and Nicanor, and Timon, and Parmenas, and Nicholas a proselyte of Antioch: whom they set before the apostles: and when they had prayed, they laid their hand on them. And the word of God increased, and the number of the disciples multiplied in Jerusalem, greatly; and a great company of the priest was obedient to the faith.
>
> —Acts 6:2–7 (KJV)

They Seized Stephen

> Stephen, a man full of faith and power, did great miracles and wonders among the people. Then there arose certain of the synagogue, which is called synagogue of the Libertines, and Cyrenians, and Alexandrians, and of them of Cilicia and of Asia, disputing with Stephen. And they were not able to resist the wisdom and the spirit by which he spake. Then they suborned men, which said, "We heard him speak blasphemous words

> against Moses and against God." And they stirred up the people, and the elders, and the scribes, and came upon him, and caught him, and brought him to the council. And set up false witnesses, which said, "This man ceased not speak blasphemous words against this holy place and the law: For we heard him say, that this Jesus of Nazareth shall destroy this place, and change the customs which Moses delivered us."

—Acts 6:9–14 (KJV)

The council rose up against Stephen and deliberately and seditiously set up false witnesses against him to prove something about him that was ultimately a big lie, which they perpetrated themselves against Stephen to discredit him and his mission about his God and about his ministry. This brother held on to God's Word fervently; his faith was made strong. He was a true patriot in his day for Jesus Christ, holding to something he believed in and was enthusiastic about, turning the people from darkness to light by baptizing them in the name of Jesus Christ for the remission of their sins. For when you know whose you are and whom you are working for, you are motivated to work even harder when you are challenged to the point of death. Because God has placed the Holy Ghost fire in the heart of the believer, you, building yourself up with your faith in God, your faith will propel you ahead no matter what. You will have the strength to carry on.

We dare not trust in ourselves, but we should rely on the Lord our God, who does things that blow the minds of millions of people all over the world. It is amazing how far people will go to stop your progress when they realize that you have a good message that does not fit their own agenda and narrative. They did this evil to Stephen to interrupt the excellent work this man of God had set his heart on accomplishing. They did all they could to discredit him.

Analyzing the Complaint, and Seizure of Stephen

Obviously, the distribution was not going very well, for the widows had been overlooked, not getting the food they needed, so they had a reason to complain. Their complaint was immediately addressed by the authorities. They sought out honest men, trustworthy men filled with the Holy Ghost and wisdom, and put them in charge of the business. *Bam*, problem solved! The Word of God was preached nonstop, and the disciples' numbers increased immensely. We need honest people to work in positions of leadership, people who fear God. The scripture tells us how dishonest and wicked humanity is.

The council had a problem with the apostles, so they ill-treated them and then let them go. The council then turned to Stephen and accused him wrongfully. It takes only a spark to get a fire burning. Very soon, all around will be caught up in its flames. It takes the power of God to put out these suborned fires set by humankind. You can put a liar behind bars, but he or she will still lie. If you bind the liar and put him or her in a box and place the box in a grave, if he or she is not dead and you open the box, you find that the liar still lies. We are warned about the dangers of lying constantly, to our own detriment and downfall.

"Lie not one to another seeing that ye have put off the old man [the devil] with his deeds; and have put on the new man [Jesus Christ], which is renewed in knowledge after the image of Him that created him" (Colossians 3:9–10 KJV). The Lord God created a beautiful good angel and placed him in Eden, His garden. Every precious stone that God made was his covering. The workmanship of his tabrets and of his pipes was prepared in him the day he was created. The lying devil is the anointed cherub that covereth because God made him that way. "Thou wast perfect in thy ways from the day that thou wast created, till iniquity was found in thee" (Ezekiel 28:15 KJV).

Lucifer's Gang Rose Up but Got Defeated

Lucifer became immensely proud in his heart on account of his beauty; he corrupted his ways because of his splendor. Lucifer looked at himself and was amazed with his beauty, his intelligence, his power, and his position; he began to desire for himself the honor and glory that belongs to God only. He self-generated a lie and had a third of the heavenly host join him. This mighty angelic being was judged by God. "Thine heart was lifted because of thy beauty. Thou hast corrupted thy wisdom by reason of thy brightness: I will cast thee to the ground, I will lay thee before kings, that they may behold thee" (Ezekiel 28:7 KJV). Lucifer, who is called the devil, was cast out of God's heavenly government and place of authority. "He [Jesus] said unto them [the seventy He sent out on a mission], 'I beheld Satan as lightning fall from heaven" (Luke 10:18 KJV). For the scripture says, "He that worketh deceit shall not dwell within My house: he that telleth lies shall not tarry in My sight. I will early destroy all the wicked of the land; that I may cut off all the wicked doers from the city of the Lord" (Psalms 101:7–8 KJV).

A liar is like his or her father, the devil, and the lust of this father is what he or she will do. "You will be murdered with lying [words] because there is no truth found in a liar's mouth. He convinced himself to sin. If you believe there's only one God, you do well; the devils also believe and tremble" (James 2:19). This lying serpent keeps confusing the people, saying, "You have God the Father, God the Son, and God the Holy Ghost, three loving Spirits that never disagree." Hear ye this, all you people: There is only one God. He loves the world. He came and overshadowed Mary, and she conceived. After nine months, a son was born, given the name Jesus. In the body of Jesus was God the Christ. After thirty-three and a half years, the Son, Jesus, gave up His life and rose on the third day. God the Christ never dies. As Christ Jesus, He is the anointed. As Jesus Christ, He is a Son who saves and who laid down His life. He has a dual nature, being a Spirit and mighty in power. Lucifer rose up against the wrong man, the One with all power, and lost the battle.

Here Is the Truth

The risen Savior is Jesus Christ, God in creation. He is without father, without mother, without descent; having neither beginning of days, nor end of life; but made like unto the Son of God [Son of man], abideth a Priest continually.

—Hebrews 7:3 (KJV)

The Son in redemption, humanity, gave His life for us. "Whom He hath appointed heir of all things by whom also He made the worlds. Who being the brightness of his glory, and the express image of His person, and upholding all things by the word of His power, when He had by Himself purged our sins, sat down at the right hand of the Majesty on high."

—Hebrews 1:2–3 (KJV)

Today He is the Holy Ghost [Holy Spirit] in the church. He that believeth on Me, as the scripture hath said, out of his belly shall flow rivers of living water. (But this spake He of the Spirit, which they that believe should receive for the Holy Ghost was not yet given, because that Jesus was not yet glorified.)

—John 7:38–39 (KJV)

As many as received Him, to them he gave power to become the sons of God, even to them that believe on His name. which were born, not of blood, nor of the will of the flesh, nor of the will of man, but of God. And the Word was made flesh, and dwell among us, and we

beheld the glory, of the only begotten of the Father, full of grace and truth.

—John 1:12–14

He shall baptize you with the Holy Ghost and with fire.

—Luke 3:16 (KJV)

No man has seen God at any time; the only begotten Son, which is in the bosom of the Father, He has declared Him.

—John 1:18 (KJV)

We know the truth. We just need to be honest with ourselves. We know we are of God, and the whole world lies in wickedness. And we know that the Son of God is come, and hath given us an understanding, that we may know Him that is true, and we are in Him that is true, even in His Son, Jesus Christ. This is the true God, and eternal life.

—1 John 5:19–20 (KJV)

If there come any unto you, and bring not this doctrine, receive him not into your house, neither bid him Godspeed.

—2 John 1:10 (KJV)

As you have read, every time truth is told, evil is present to challenge it.

Whosoever transgresseth, and abideth not in the doctrine of Jesus Christ, hath not God. He that abideth in

the doctrine of Christ, he hath both the Father and the Son. ... For many deceivers are entered into the world, who confess not that Jesus Christ is come in the flesh. This is a deceiver and an antichrist.

—2 John 1:7, 9 (KJV)

As He spake these words, many believed on Him. Then said Jesus to those Jews which believed on Him, "If ye continue in My word, then are you My disciples indeed, and ye shall know the truth, and the truth shall make you free." They answered Him, "We be Abraham's seed, and were never in bondage to any man. How sayest thou, 'Ye shall be made free'?" Jesus answered them, "Verily, verily, I say unto you, whosoever committeth sin is the servant of sin. And the servant abideth not in the house forever. If the Son therefore shall make you free, you shall be free indeed."

—John 8:30–36 (KJV)

I do hope you will understand that if the Master Himself were here on earth and people had a problem believing Him, how much more of a problem will it be for you? Some will not believe you; some will receive you. But he or she who receives you, receives Him who sent you. Don't ever be dismayed if people don't believe you. Jesus Christ will understand and will say, "Well done." Rest assured that some will believe the good report. You must tell it on the mountaintops and declare it in the busy streets everywhere you go.

Lift Up Yourself, Arise

I have told you the truth. What are you going to do about it? If you do not have the truth, you are lying to yourself. What will prevent you from lying to me? Only the truth can prevent you from lying. Truth is freedom! And God is truth! Let freedom reign. When you know you have truth and you are sure of the truth, lift up yourself and arise as one who has just been awakened from sleep, which is not hard to do. As the apostle Paul said in Philippians 1:27–28, "Only let your conversation be as it becometh the gospel of Christ, that whether I come and see you, or else be absent, I will hear of your affairs, that you stand fast in one spirit, with one mind striving together for the faith of the gospel; and in nothing terrified by your adversaries: which is to them an evident token of perdition, but to you of salvation, and that of God" (KJV).

One of the times our lives show the worth of the gospel is when Jesus Christ makes us bold, courageous, and unafraid. Here is another powerful conformation that states the truth: "The wicked flee when no man pursueth, but the righteous are bold as a lion" (Proverbs 28:1 KJV). There is a correlation between fear and wickedness on one hand, and courage and righteousness on the other. The gospel truth is about how wicked people can get right with God through Jesus Christ. They may lift themselves up and rise to His righteousness, which makes them not ashamed, but as bold as the lion. When you come boldly to the throne of His grace, you will obtain mercy and find help in your need.

"Beware of dogs! Beware of evil workers. Beware of the concision" (Philippians 3:2 KJV). Such arguments should convince the hearers or readers of this fact. The watchers were paid big money to lie about Jesus's resurrection from the dead, having been instructed to say that His disciples came and took His body away unlawfully. Today, people still believe that lie. All government workers, church preachers, and parliamentarians who speak lies and spread false information are classified as dogs and evildoers. You must cut yourself off from such people, but not in malice. Just beware of their mixed bag of tricks and their falsehoods. The Democrats and some Republicans lied about the 2020 election, when in

fact the whole thing was fraudulent to its core—and they know it. The apostle Stephen stood up against the hypocrisy of his day and spoke the truth. Acts 6:9–10 says that the men who were arguing with Stephen "were not able to resist the wisdom and spirit by which he spake" (KJV) when being accused.

I Am Not Ashamed

> For I am not ashamed of the gospel of Christ, for it is the power of God unto salvation, to everyone that believeth, to the Jews first, and also to the Greek. For therein is the righteousness of God revealed from faith to faith. As it is written, "The just shall live by his faith."
>
> —Habakkuk 2:4 (KJV)
>
> For the wrath of God is revealed from heaven against all ungodliness and unrighteousness of men, who hold the truth in unrighteousness. Because that which may be known of God is manifest in them; for God has shown it unto them.
>
> —Romans 1:18–19 (KJV)

God has shown you, as He has shown every one of us, what He wants you to know. He has shown you what is right. You chose to go your own way and made us believe your lies. To all those who were involved in the scam, your sin shall find you out. Fraudulent acts and scams are committed to cover up one's wicked ways so they might carry on in them. When you are bent on evil or you are an accessory to evildoers, this is what happens: "For this cause God gave them up unto vile affections; for even their women did change the natural use into that which is against nature." Women are having sex with women, burning in their

lust. Likewise, the men, leaving the natural use of the woman, burn in their lust one toward another, men having sex with men, working that which is unseemly and receiving in themselves that recompence of their error. And even though such people do not like to retain God in their knowledge, God gives them over to a reprobate mind to do those things that are inconvenient.

"Being filled with all unrighteousness, fornication, wickedness, covetousness, maliciousness, full of envy, murder, debate, deceit, malignity; whisperers, backbiters, haters of God, despiteful, proud, boasters, inventors of evil things, disobedient to parents, without understanding, covenant breakers, without natural affection, implacable, unmerciful, who knowing the judgment of God, that they which commit such are worthy of death, not only do the same, but have pleasure in them that do them" (Romans 1:26–32 KJV). "But he that is spiritual judgeth all things, yet he himself is judged of no man" (1 Corinthians 2:15 KJV).

"For if we would judge ourselves, we should not be judged. But when we are judged, we are chastened of the Lord, that we should not be condemned with the world" (1 Corinthians 11:31–32 KJV). I have judged myself, and He who judges me is the Lord. You just watch me come storming back. When the Lord is leading you, there is no reason for you to be afraid or ashamed to move forward. How precious are God's thoughts about me! That is why I have never hated anyone and will never hate anyone. I will distance myself from people who do not value me. I will not force attention, conversations, friendship, love, or relationships. Anything forced is not worth fighting for. Whatever flows, flows! You can judge! Just make sure you are part of the solution, not part of the problem.

When things do not go my way, or the way that I thought, when I'm feeling low and my heart is burdened, I sit in silence until God comes through for me. His raising me up to rise above them all is what I am expecting the great God to do. Every morning that I rise, I have no doubt. I honestly believe God will bring me out. So, I get down on my knees and thank Him for another day, hoping that all will see the gentleness in my rising that I have attained in God, for I have judged myself. With

all the chaos, deception, and ungodliness in the world, please know this: "And the peace of God which passeth all understanding shall keep your hearts and minds through Jesus Christ" (Philippians 4:7 KJV). I strive for things that are admirable; I strive for things that are lovely; I strive for things that are noble, true, and just. I keep thinking on them. I strive not to do things for vainglory, but with lowliness of mind, I uplift others. I give credit where credit is due and esteem others as better than me. What do you think Jesus did? Just think about it!

The Rising Sun

The sun is a daily reminder that you can rise from the darkness that has blinded your eyes, your mind, and your very understanding, that the eyes of your understanding will be enlightened, that you will know your true reason for being here on earth. From the time you came out of your mother's womb and started learning, what have you hoped to achieve before giving up the ghost? Do you really know what your inheritance is? Do you know what true riches are, versus your earthly riches? The real reason Jesus died is so that He can raise you up from dead works to life and make you sit in the heavenly places with Him and the saints of God. He died so that you may strive and let your light shine so bright that men, women, boys, and girls may see your excellent work and glorify your Father who is in heaven. "For He raiseth up the poor out of the dust and lifted up the needy out of the dunghill; that He may set him with princes, even with the princes of His people. From the rising of the sun unto the going down of the same the Lord's name is to be praised" (Psalm 113:7–8 KJV).

CHAPTER 10

THE POLITICAL ASPECT OF RISING UP

I have just shown you the spiritual aspect of rising up. Now let us look at the political aspect of the same thing. Donald Trump was busy doing many things when God put a thought in his mind. Rising with confidence, he said to himself, *I think I can win.* His second wife, Melania, said to him, "If you run, you will win." The way he came out with his words and his statements, which he skillfully formulated offended many people. Rising, Trump honored God only with lip service. He stunned the political world with his win. People accused him and said many things about him from the start, trying to take him down. They tried everything to make the things he was accused of stick so he would be impeached. They all failed in their efforts. Metaphorically speaking, they took out the kitchen sink and cast it at him, to no avail, for the Lord God shielded him. The sink swooped away, out of sight.

Leaping ahead to 2020, the Democrats said, "It's game time now." They went ahead and had the game fixed. How clever they were in fixing the game (election). "But I serve a great God who revealed His secrets to His servants, and I cannot hold my mouth and my tongue. For the secret things belong unto the Lord our God: but those things which are revealed belong unto us and to our children forever, that we may do all the words of this law" (Deuteronomy 29:29). So, now that the fraud has been revealed, action must be taken. If no action is taken, why? What is the problem? People who do such things as have been done to Donald Trump are worthy of being cast into prison. Prosecute the offenders from Maricopa County, every one of them.

A coalition of audits for election integrity should be assembled soon. One bad vote spoils the whole election. If you are bad and spoiled, what do you expect you will produce? It was only one individual, the devil, who concocted a false claim and convinced a third of the angels in heaven to go along with it. Stolen votes change the game that the players desired to have. There were many participants involved, and *bam*, we saw a swing in the results. What a shame! What a shame! Folks are blinded by greed and are destitute for power. That is what Lucifer, the son of the morning, was seeking after, but he was kicked out of the government of God in heaven. He was belligerent and upset; things did not go his way, for he was cast down to the ground, where he brought the same attitude, behavior, and tricks with him to feed his agents and angels.

In Arizona, someone with backbone needs to stand up and play the game as if their life depends on it. If you, Mr. Mark Brnovich, Attorney General, will not play the game (i.e., the election) fairly, then who will? You have a law; you need to enforce it. Do not pick and choose whom to investigate and whom to arrest. If you will, just investigate and arrest the right people. When the apostles heard the news of how the widows were being treated, they acted immediately. They did not accuse any person of wrongdoing, for all things must be proved, then one holds fast that which is good. The devil is the accuser. You can take this and interpret it or twist it any way you wish. If you have been made a judge and you know that John Doe is a thief, you do not need to accuse him; you need

to bring righteous judgment. He or she who rules over humans must be just, ruling with the fear of God.

We have a fraudulent system and corrupt officials in high places who are respecters of persons. That is the reason why all this mess lingers. The mess must be cleaned up. But there are many who are content with the pungent smell and taste. This is the reason there are many "Hear no evil, see no evil, speak no evil" sorts of people. But on the other hand, they are content to speak accusations and evil against Donald Trump and his patriotic supporters. Kari Lake, the Republican Arizona gubernatorial candidate, said, "We want indictment! We want arrest! We want answers." Please, someone step up to the plate and do the right thing for the people of this country. You must be resilient and fervent in your business. Turning away your face does not mean the problem does not exist; it means someone is needed to take on the problem at hand and deal with the situation in a professional way, showing class and wisdom. Laws were broken in Arizona, and the election results were changed. Don't you think that demands justice? There are many in the Republican Party who do not want to rise and take control to clean up the mess. They are content to keep the windows closed, so all the honest law-abiding patriots suffer from the foul odor of the result. Their justice is about themselves. They all shall give an account unto Him who is ready to judge the living and the dead.

No one will escape the judgment of the living God, no matter how hard they try. All will have to appear before the judgment seat and give an account of all their actions in this life. This is something you should carefully think about before it's too late. Who persuaded you not to be honest and just in your business as a servant? Election plasma can be seen all over the country. And the bloody mess needs to be cleaned up now, not later. It will take professionals who are skilled in plasma removal to be involved in this project.

What happened in Arizona was a catastrophe that will leave an indelible stain. There are some people who, I believe, are readily available to take on the task of cleaning up all the messy splatters and spills all over the state, getting rid of the dangerous stains the plasma has left behind.

All of us have an agenda, some good, some bad. Make sure what you are expecting to do to others is what you are expecting to be done to you and for you. Is no one able to give an honest account of why you, Maricopa County, Arizona, have more ballots than voters? The answer to the question, my friend, is staring you in the face.

The reason you do not have a valid answer is because you are guilty by way of association. You are part of the problem, and you do not want to support a resolution that will expose your participation. Satan's agents are all over, in high places in governance. Everywhere you look, everywhere you turn, you see fraud. This is beyond human comprehension. Yet, for all of this, no one has been held responsible for the crime of the century. Democrats, you must be just in doing your business. How can you be justified when your justice is tainted and moot? Your greedy doggy-style behavior will cause you to vomit out your actions in public and return to them again.

But there are honest, law-abiding citizens rising to the occasion of fixing things for the better and not for the worse. These fixer-uppers do not have to block windows, block doors, and keep people at a distance so that they are unable to see clearly. They will be very transparent. All are not willing to participate in illegal activities. There are people of integrity willing to have influence and willing to be part of the solution.

Arizona Attorney General Mark Brnovish is sitting on his own hands, glued to his office chair. Someone will have to assist him out of his chair. You, Mark Brnovish, are not trying to hurt sick people; you should try to help them out of the things that have caused them to become stuck in the mess without having caused trouble themselves. Because of what the forensics team in Arizona and the other states brought to light, these fraudulent people in positions of leadership, they confirmed how Joe Biden had come to be president. He is the product at hand. Instead of investigating the fraud, it is the other way around—investing those who are crying foul. And many love to have it that way. No one has the willpower to stand up for what is true and right. Instead, people in power have arrested Trump supporters, harassed his patriots, and kept their false investigation going. The purpose of all this undercover stuff was to

do more damage and make a public show in order to make Trumpism the scapegoat. How long will the Democrats and Republicans be able to stand behind this antagonistic debacle? Their sin will find them out very soon.

As the law of sowing and reaping, and selling and buying, is, so is the law of stealing and hiding. But I serve a big great wonderful God who will not be silent forever. He will not hold His piece. He will avenge His adversaries very soon. You, Mr. Politician, who do think you are, Mr. Big Shot? Don't you know it is important to be subject to God? Don't you know that a man who is mortal should not proudly think of himself as if he were God? God sits on high, and He is looking down low at your evil ways. The pain caused by your evil will not cease until you are willing to make drastic changes in your life so you may be aided in your endeavor to assist others.

Right Is Right

Right is right! Evil is evil! Wrong is wrong! It makes no difference if you are a conservative, a Democrat, an Independent, or a Republican. Don't just sit or stand there with your bad self and make it seem as if all the sins are Donald Trump's alone. I am not sitting in any paid judge's seat, but I know this as a fact: the forty-fifth president was not responsible for what took place on the sixth of January in 2021. What happened is what the Lord God allowed to be revealed to us. But folks are blind and conceited. So long as Mr. Trump stands for my right to worship my God freely as I so please and stands behind all the other forms of freedom we have been given, not by humankind but by God, I am with him. The Lord God wants Donald Trump and his family to be saved, and I am making it plain. All the frail, simple, and weak Republicans who backed out on Trump at the last moment on Trump on January 6—it makes me wonder.

Do you really know what is in you? Your spirit does! To you, everything you do is right in your own eyes. But the spirit that is in you knows

better. That is the reason that when you try to do some good things, the evil that is in you shows up and causes you to change your mind and do the opposite. Don't you realize the reason you are so quick to accuse others and blame them is because you assume you are right? You just cannot see yourself! But God knows your heart, and your spirit knows better. You need the Spirit, the Great Physician, to perform a heart transplant on you, giving you a clean heart and renewing your spirit.

I strive to speak in words not of human wisdom, but those that the law of God requires. I am not my own. I must see things the way that God sees them, and you must do so too. Both sides, Democrats and Republicans, have had their sidebars to discuss the sixth of January. The committee figured that the only way to sink Trump was to make him the scapegoat. Who has believed the reports? Democrats have their report, and Republicans have their report too. But I believe God's report, for He knows all things. My God has books in which He writes things down and reveals the truth as He so desires to His servants. He even reveals things to you, and you do not serve Him. Or you are a pretender pretending you are serving God, giving Him lip service, but your heart is very far away from Him. It is funny.

I was placed under God's witness protection program the day I gave my life to Him. I am well guarded and fenced in. I am not an ordinary man. I will speak the truth. So, let God be true and all people be liars. All true Christians, as some call themselves, you should understand that the truth costs. If you do not think so, defend it. Make the truth your own. Stand for truth and you will see that it costs. It may cost you far more than you thought: friends, money, pleasures, yes, even hours of misery and pain. But evil men and women who seduce will receive worse. If you are really searching for truth, then why are you witch-hunting for those who does not share your ideology? Why the political persecution? Because wickedness proceeds from the wicked. But the truth is the truth. Yes, the truth costs! So don't try to pin the riot on Donald Trump. It will not work!

Way back when God showed me that Barack Obama would be president of the United States, I did not side with the naysayers. I told the truth of God and stuck to it. There is something wrong with one-sided

persecution. The enemy has taken his grip on the government, unleashing his venom at his will. He is doing his job of killing our political representatives, stealing from them, and destroying them. They are restless; they have no peace. There shall be no peace for the wicked. When they spoke of peace, sudden destruction occurred to their prized Capitol Building. It is not over! There is much more to come.

I Need Your Help

Mr. Trump said, "Julius, I need your help. Joe Biden is determined to destroy my administration's incredible America First legacy. If patriots like you do not step up now, there will be absolutely nothing left." Humankind's help is in vain. "I will lift up mine eyes to the hills, from whence cometh my help. My help cometh from the Lord, which made heaven and earth" (Psalms 121:1–2).

> And it came to pass after this, that Ben-hadad king of Syria gathered all his host, and went up, and besieged Samaria. And there was a great famine in Samaria: and behold they besieged it, until an ass's head was sold for fourscore pieces of silver, and the fourth part of a cab of dove's dung for five pieces of silver. And as the king of Israel was passing by upon the wall, there cried a woman unto him, saying, "Help, my lord, O King." And he said, "If the Lord doesn't help thee, whence shall I help thee? Out of the barn floor, or out of the winepress?" And the king said unto her, "What aileth thee?" (2 Kings 6:24–28 KJV)

The woman told the king her problem, and he blamed the man of God, using words to threaten death. Then he sent an executioner to Elisha's house. But before the executioner got there, the great God revealed to Elisha the king's evil deed.

A Special Word to Donald Trump

Your help comes from the Lord. God has given you all you need. Mr. Trump, you keep on saying, "I need your help. Step up." Let us go to the school of wisdom and knowledge. From the day that God showed me you would be president of the United States, I have stepped up and risen up! I stood up and prayed for you, your family, and your administration.

I have been called names because of my assertions about Donald Trump. The Word of the Lord according to Paul reads as follows:

> I exhort therefore, that, first of all, supplications, prayers, intercessions, and giving of thanks be made for all men; for kings, and for all that are in authority; that we may lead a quiet and peaceable life in all godliness and honesty. For this is good and acceptable in the sight of God our Savior. Who will have all men to be saved and come unto the knowledge of the truth? For there is one God, and one mediator between God and men, the man Christ Jesus, who gave Himself for us as a ransom for all, to be testified in due time. (1 Timothy 2:1–6 KJV)

At Jesus's trial, Pontius Pilate asked Him, "What is truth?" (John 18:38 KJV). The truth is that there is only one God, the Lord Jesus Christ. The Lord God is not your money, not your possessions, and not your husband or your wife. The Lord raised Jesus Christ from the dead, having all power and the keys of death and hell. He is alive in Me! He is the true God, who wants to save you from hell, from yourself, and from your own wickedness. Will you make yourself available for Him to penetrate your soul and your mind? He wants to be within you, a well of water springing up into everlasting life. Will you let Him in? Please do not turn Him away. If you do, you will be sorry in the end, then it will be too late for you.

To bring people to Jesus is why God made me a preacher and teacher. He allowed me to become a prisoner, showing me more great and

wonderful things, and now an author to spread His Word. I will speak the truth. You, Mr. Trump, are a political prophet, and the things you have said have come to pass. The Lord God has been exceptionally good to you. You have gifts and a calling. You have been called and made president. For sure you will be back in the White House, even though your opponents are searching your property, hunting for evidence against you just as bees search for nectar. As a seer, I am giving you what I have. You need to come and be baptized in water in the name of Jesus Christ for your sins to be removed. You shall receive the gift of the Holy Ghost as a promise from the Lord Jesus.

Do not be despondent; the Lord allowed the fraud to take place. You won twice. The Lord God wants you, Joe Biden, and everyone else to know how crooked you all are. But He can change you and make everything new. Will you let Him change you? Do not turn Him away. You, Donald Trump, know that you won the election. I, Julius Williams, know you won the election. Your patriotic followers know you won. God knows this! He is the revealer of secrets. No one can outsmart God. You can't hide from Him; his eyes are watching you. He sees all things, knows all things, and understands all things. His understanding is infinite. Joe Biden won because of the fraudulent organization he had in place. And no one had the guts to get up, stand up, and be honest. We know the truth, so let the chips fall where they may.

You have seen all the lives lost in the streets, neighborhoods, cities and states from 2019 until now. You all have seen the people whose lives were taken away by COVID-19. Do you believe that all those people were sinners above everybody else? Not at all! I am telling you this: unless you, Donald Trump and Joe Biden, repent and are baptized in water, in the name of Jesus Christ, for the remission and removal of your sins, you shall likewise perish. Mr. Joe Biden has a lot of people on his side who believe in him. To them he is all good. And to you, Mr. Trump, who had been living with your second wife, know this for sure: the law of God has dominion over you as long as you are alive. Melania has just become your real wife because of the death of Ivana. You are bound and tied to your first wife. While she was alive and you were married to

Melania, you were an adulterer. And no one living in adultery can have eternal or everlasting life.

For God did say a man shall leave his father and his mother, and shall cleave to his wife, and the two shall become one flesh. But the heart is deceitful and hard, and you rose up and put your first wife away because of some disagreement or misunderstanding. And that is having a domino effect. Can't you see? Your son is following in your ways. Let me make this very, very clear. My wife divorced me while I was in prison. But according to the truth of God, only death can separate us. She is still my wife because she is alive, as far as I know. I am still her husband because I am still alive; until death we do part. This is God's law; it will not change. I bought the truth, I have the truth, and now the truth is not for sale. I will tell the truth the way it is to be told.

A person needs to be raised from the dead works of his or her flesh, which defile him or her. "Now the works of the flesh are manifest, which are these: adultery, fornication, uncleanness, lasciviousness, idolatry, witchcraft, hatred, variance, emulations, wrath, strive, envying, murders, drunkenness, revellings, and such like: of the which I tell you before as I have also told you in time past, that they which do such things shall not inherit the kingdom of God" (Galatians 5:19–21 KJV). "But those things which proceed out of the mouth come from the heart, and they defile the man. For out of the heart proceed evil thoughts, murders, adulteries, fornications, thefts, false witness, blasphemies. These are the things which defile a man" (Matthew 15:18–20 KJV). Still, for all your misdeeds, the only true God made you president, Mr. Trump. You will be back in the White House once more to finish your course. And after all that you have said and done, unless you repent and are baptized in water in the name of Jesus Christ, you shall die in your sins.

I know you may think because you have Paula White-Cain and Robert Jeffress close to you, and all the others who are on your team, some of whom lay hands on you and pray for you, it means that all is well. For all those who have laid their hands on you, if they have not been baptized (fully immersed) in water in the name of Jesus Christ for the remission of their sins, they will all be heading to the same place. I

cannot stress this enough, that God had only one ark (way) for safety. He had Moses build a tabernacle, having given him the specifics on how to build it. The Lord God showed Moses one way out of Egypt (i.e., sin) and kept him in the way as he went along. The Lord called Joshua and showed him the way, with the Ark of the Covenant in the Israelites' midst. Joshua said: "If it seems evil unto you to serve the Lord, chose ye this day whom ye will serve; whether the gods that your fathers served that were on the other side of the flood, or the gods of the Amorites, in whose land ye dwell: But as for me and my house, we will serve the Lord" (Joshua 24:15 KJV). Why won't you serve the Lord?

Mr. Trump, the Lord God showed King David one way to be saved. The Lord God showed King Solomon one way to be saved. And Solomon wrote: "There is a way which seemeth right unto a man, but the end there of are ways of death" (Proverbs 14:12 KJV).

Mr. President, the Lord God showed the prophet Isaiah only one way to get saved and to be saved, and Isaiah prophesied, saying, "Seek ye out of the book: for not one of these shall fail" (Isaiah 34:16 KJV). He continued, saying, "And an highway shall be there, and a way, and it shall be called 'the way of holiness'; the unclean shall not pass over it; but it shall be for those, the wayfaring men, though fools, shall not err therein" (Isaiah 35:8 KJV).

The Lord God showed Jeremiah the way to salvation, and Jeremiah prophesied: "Thus, saith the Lord, 'Stand ye in the ways, and see, and ask for the old paths, where is the good way, and walk therein, and ye shall find rest for your souls'" (Jeremiah 6:16 KJV).

This way is not the way called Anglican. It's not called Apostolic, Southern Baptist, Baptist, Buddhist, Catholic, Confucian, Mormonism, Methodist, Seventh-day Adventist, or Jehovah's Witnesses—just to name a few religions currently practiced in the United States that have made God a laughingstock. Neither is it the way called Democratic or Republican. As Jesus said, "I am the way, the truth, and the life." His way is called the way of holiness in conduct and conversation.

CHAPTER 11
I THE PRISONER ROSE UP AGAIN

I, Julius Williams, a prisoner of Jesus Christ, am not afraid to tell what I have heard and what I have seen. God said, "Trump is the winner." Then God told me to write, "Joe Biden will be declared the winner." So, what is the deal? What is the truth? Joe Biden won the 2020 election, and we all know why. Or if you don't know, let me make you aware of what took place. He won because of the fix (fraud), he and all his followers who helped him. I am not afraid of the gospel truth, for it is the power of God unto salvation. If you want God's salvation, you must come clean. "For thou art not a God that has pleasure in wickedness: neither shall wickedness dwell with thee. The foolish shall not stand in thy sight: thou hatest all workers of iniquity. Thou shall destroy them that speak leasing: the Lord will abhor the bloody and deceitful man. But as for me, I will come into thy house in the multitude of thy mercy: and in thy fear will I worship toward thy holy temple" (Psalms 5:4–7).

Somebody must be held responsible for this act of fraud. The devil's

agents placed me in prison for fraud, filing a false tax return, and identity theft. I was sentenced to five years. Everything I had, I lost, except my God and my life (soul). I the prisoner rose up and did as I was instructed. The Great God moved me from a zero to a hero. "Know therefore that the Lord thy God, he is God, the faithful God, which keepeth covenant and mercy with them that love Him and keep his commandments to a thousand generations; and repayeth them that hate Him to their face, to destroy them: He will not be slack to him that hate Him. He will repay him to his face" (Deuteronomy 7:9–10). Joe Biden is using his own mouth to show how out of touch he really is. If Joe Biden does not humble himself, repent of his sins, and get baptized in the name of Jesus Christ for the removal of his sins, then he shall die in his sins. God wants to save him. I rose up to tell you that the Lord Jesus Christ wants to save you. Will you let Him do it?

The wicked put me in prison, but I am free. But they who put me in prison are bound in chains of darkness in this world. They are already condemned. They are so blind that they cannot see the error of their ways. You can be free by reading *Rising Up*, and I pray to God you will. I will make myself available to put submerge in water in the name of Jesus Christ for the removal of your sins, so that He can raise you up to new life in the Holy Ghost, preparing you to meet your God. He shall surely come.

He Judges among the Gods

> God standeth in the congregation [Congress] of the mighty; He judgeth among the gods. How long will you judge unjustly, and accept the persons of the wicked? They know not neither will they understand. They walk on in darkness: all the foundations of the earth are out of course. I have said, "Ye are gods; and all of you are the children of the Most High [God]. But ye shall die

like men and fall like one of the princes. Arise O God, judge the earth: for thou shall inherit all nations."

—Psalms 82:1–2, 5–8

Everywhere you turn, you find is a ruler, from the White House to the prison house. Rulers talk a lot. They are acting up, looking up, and making up things. Listening to Dr. Anthony Fauci, who has said many controversial and stupid things, is enough to drive anyone crazy. While serving under the Trump administration, Dr. Fauci said, "A mask is not necessary in no way or form to protect you from the virus. Mask wearing should not be mandated." But now that his man is in the White House, his speech (talking points) has changed completely. Now he says, "Mask wearing is necessary for the foreseeable future." Mask wearing was recently one of the orders of the day. Dr. Fauci made a 180-degree turn, flipping and flopping. But he will be silenced very soon. As a political prophet, he declares what he sees in his scientific crystal ball and what he expects to happen according to his own talking points. But God's man speaks from His mouth. Donald Trump declared that he is running in 2024 to return to the White House. Keep watching!

"The Jews who heard Jesus spoke were divided. And many of them said, 'He hath a devil, and is mad; why hear ye him?' Others said, 'These are not the words of him that has a devil. Can the devil open the eyes of the blind?'" (John 10:19–21).

> Jesus walked into Solomon's porch. Then came the Jews round about Him, and said unto Him, "How long dost thou make us doubt? If thou be the Christ [Messiah], tell us plainly. Jesus answered them, I told you and ye believe not: the works that I do in My Father's name, they bear witness of Me. But you believe not, because ye are not of My sheep, as I said unto you. My sheep hear My voice, and I know them, and they follow Me. I and My Father are one."

> Then the Jews took up stones again to stone Him. Jesus answered them, "Many good works have I showed you from My Father, for which of those works do ye stone Me?" The Jews answered Him, saying, "For a good work we stone Thee not; but for blasphemy, because that Thou, being a man, makest Thyself God." Jesus answered them, "Is it not written in your law, I said, 'Ye are gods'? If He called them gods, unto whom the word of God came, and the scripture cannot be broken, say ye of Him whom the Father hath sanctified, and sent into the world, 'Thou blasphemest'? Because I said, 'I am the Son of God'?" (John 10:23–37, 30–36)

The Lord God, Jesus Christ, presented us with two things. Every day we have a choice and a chance for a good life, the chance to make it better. If anyone wants to be ignorant, let them be ignorant.

KEEP ON WATCHING

Everything that Donald Trump put into place will not be eliminated. Mr. Biden tried his best to eradicate all his policies and programs and even his name. But it is not over until God say it is over. It's not over until God says it's the end. For every event under the sun, there is a season and a time. Mr. Biden is occupying the White House now, but Donald Trump is endorsing and attracting crossovers. Which party train are you on, the Trump train or the Biden train? Make sure. People are jumping off Joe Biden's political train while it is in motion and are running. He is really trying hard to impress. But now that he has been put to the test, things are a mess.

Joe Biden's poll numbers keep falling, and his favorability is waning. Biden's political train will soon come to a stop. Lots of voters will not get back on board with Biden or whoever tries to get in the engineer's seat. They have behaved badly from the start, meaning from the moment they

got behind the wheel of power. They have been driving recklessly along the way, leaving one to wonder, *Who is really driving?*

On the other side, Donald Trump is on an exclusive train. His favorability rating is high. Metaphorically speaking, he is on a superhot train now. So, start preparing; get your business straight, and get your ticket. There is no stopping Donald Trump now; he is on the move. He is going to win. If you stick around, you will see it. Mr. Trump is no superman. His rising up was God's doing, and God will cause him to rise up again. Trump is mortal. He has a set time to reign, and then he'll leave office. His organization is humongous! His patriots are very loyal to him. He draws massive crowds wherever he speaks. The man is practically impressive. It is no wonder his detractors are basically losing sleep, even losing their minds over him. What a shame! My beloved friends, Anthony Scaramucci, who served as White House communications director, said, "I do hope his investments do well so he doesn't have to run in 2024."

The news media are speculating and sizing up Mr. Trump against Florida governor Ron DeSantis for 2024. Biden is not so sure he will finish his term, much less run in 2024. So, the media is trying its best to prop up Biden's poll numbers to make him look good by saying that, head-to-head, Biden has the edge. He has the edge for sure. His teeth are on edge. Do not believe for a minute that what happened in 2020 will be repeated in 2024. Trump's America First team is working hard, doing all they can to prevent a recurrence of that mess. It will not be taken lightly this time around. Your sin has found you out, Joe Biden. You fooled me once, but you will not fool me twice. Be assured, just as night follows day, you will not be able to fool my God. For He is a great King and does as He pleases. I dare you question His intelligence. His understanding is infinite.

Keep On Watching Me

As a seer, I am giving you the heads-up as God enlightens me. You asked, "What shall we do now?" Get on Trump's train if you please. His

train is bound for DC. Can't you see?! Blessed are they who believe and have not seen. If you are hoping for something to happen, do not give up. Your question was, "What shall we do now?" I am asking the Lord to open your eyes so that you will see that many more people are with Donald Trump now than those who are against him. And what if some people will not believe my prophecy? The Word of God is still effective, and the Word will be accomplished. They can now see that all the things that have rained down upon Trump have run off him like water from a rooftop. Trump has been able to evade some of the obstacles his opponents have placed in his way. What happens to those obstacles? He keeps fighting them. He is a man with a strong will.

I told you, Donald Trump is on the move. His train is bullet fast. His conductors are ready to get you on board. Now, if for some reason you are not sure where the Trump train is heading, do not be afraid to ask. He is heading back to DC, to the White House. Please, if you are on the train with Trump, don't try to get off, or else you may be very, very sorry again.

Listen, please, to Jeremiah 21:1–9:

> The word which came unto to Jeremiah from the Lord, when King Zedekiah sent unto him Pashur the son of Melchiah, and Zephaniah the son of Maaseiah the priest, saying, "Inquire, I pray thee, of the Lord for us; for Nebuchadnezzar king of Babylon maketh war against us; if so be that the Lord will deal with us according to all His wondrous works, that he may go up from us."

> Then said Jeremiah unto them, "Thus shall ye say to Zedekiah: 'Thus, saith the Lord God of Israel, "Behold, I will turn back the weapons of war that are in your hands, wherewith you fight against the king of Babylon, and against the Chaldeans, which besiege you without walls, and I will assemble them into the midst of this

city. And I Myself will fight against you with an outstretched hand and with a strong arm, even in anger, and in fury, and in great wrath. And I will smite the inhabitants of the city, both man and beast: they shall die of a great pestilence. And afterward," saith the Lord, "I will deliver Zedekiah the king of Judah, and his servants, and the people, and such as are left in this city from the pestilence, from the sword, and from the famine, into the hand of Nebuchadnezzar king of Babylon, and into the hand of their enemies, and into the hand of those that seek their life: and he shall smite them with the edge of the sword; he shall not spare them, nor have pity, nor have mercy. And unto this people thou shalt say, 'Thus, saith the Lord; "Behold, I set before you the way of life, and the way of death. He that abideth in the city shall die by the sword, and by the famine, and by the pestilence: but he that goeth out, and falleth to the Chaldeans that besieged you, he shall live, and his life shall be unto him for a prey."'" (KJV)

I told you, Donald Trump is a political prophet. He told you long ago what Joe Biden was going to do. Those who did not listen are now looking at what we are now facing. I prayed for Donald Trump. May the Lord bless his heart if he listens to Him. For had it not been for the Lord God's having his protective arms around this man, he would be locked up in a jail as a laughingstock. If you cannot beat him, join him or leave him alone. God will deal with him in His own time. Lots of time has been lost fighting with Trump. Those who have been part of these fights will achieve nothing at all for their efforts. Their dreams for Trump's demise will not come true. So, for heaven's sake, give the man a break, or you may well be broken. Why are you chasing the wind? You are running after Trump as one runs after a shadow. Have you been able to run down your shadow and catch it lately? I guess not! So, I am warning you! Leave Donald Trump alone.

> After Cain rose up and killed his brother, the Lord God approached him and questioned him. He pleaded for mercy, saying, "My punishment is greater than I can bear. Behold, Thou hast driven me out this day from the face of the earth, and from Thy face shall I be hid; I shall be fugitive and a vagabond in earth; and it shall come to pass, that everyone that findeth me shall slay me." And the Lord said unto him, "Therefore, whosoever slayeth Cain, vengeance shall be taken on him sevenfold." And the Lord set a mark upon Cain, lest any finding him should kill him. (Genesis 4:13–15 KJV)

Just as the Lord put a mark upon Cain, lest any who found him might slay him, so has the Lord put a mark upon Donald Trump. He belongs to God. Let me remind you what Trump said of his willpower and the army of his followers: "We will not bend. We will never, ever surrender." What will you say and do when Trump wins the presidency in 2024 and comes storming back? Oh my! You are really wasting your time going after his shadow, which you will never catch. Just move on and find something better to do with your time. If you continue at your current trajectory, chasing Mr. Trump, you are going to fall down head-first. He is one of the greatest presidents this country has ever had. Just as Martin Luther King had a dream, Donald Trump has a dream—and it will come true. Just keep on watching.

Soon you will see Mr. Trump rise and come storming back into the White House after all the encumbrances have been removed. It will not be long. Mr. Trump is remarkably busy endorsing those candidates of whom he approves, hoping they win, giving good representation to the America First agenda and to the people of the United States.

On Wednesday, October 27, 2021, Wisconsin sheriff Christopher Schmaling held a news conference where he unveiled evidence about the 2020 election that he and his team had uncovered. They found proof of statewide election fraud. But while Schmaling tried his best to trace the statewide mess, many kept their hands glued to their office chairs,

refusing to move a muscle. The very people who are entrusted to preserved integrity are the same people who passed laws and legislation that ties up the progress of an election audit. As a fighter of crime, Schmaling will continue to fight for, and support the efforts to maintain, election integrity in his state and the country.

I have watched some of the old-time Hall of Fame prizefighters over the years and have made some observations. The trainers, knowing that their fighter is ahead in the contest, will tell him that he is behind and needs to step it up, to prevent him from becoming overconfident. Sometimes they will tell the fighter that he is ahead and should keep the lead, not leaving the decision of who won up to the judges. "You go out there and win this thing; you know you can!" Encouragement helps in so many ways; it is a game changer. Suddenly the fighter gets a second wind and jumps to his feet, rejuvenated. He gets knocked down, but before the referee can count to ten, he raises himself up on his feet. He shakes off his little mishap, just as Buster Douglas did when fighting Mike Tyson. Douglas was knocked down; it seemed the fight was over for him. But then he got up, beating the ref's count, and dramatically knocked out Tyson, shocking everyone. Now, Mike Tyson was not able to beat the referee's count, and Douglas was pronounced the winner.

The 2024 presidential contest will be dramatic to the fullest. All eyes will be focused on the fighters as they slug it out. It will be a beauty. If you are around, you will not want to miss it. To see these heavyweights in action as they just keep on punching, holding no punches back, is thrilling. Then, after the knockout, the announcer will read the scorecard or say who the winner is. Then the referee will hold up the winner's hand. President Trump is training extremely hard, preparing for the contest and looking ahead, doing his promotions. He will be going from state to state in his quest to retake the reins of power.

When you have a dream that no one else sees but you, you embrace yourself and rise up in pursuit of your dream. Jesus Christ had a dream (vision). It eventually cost Him His life, but He did not just sit still and allow people to walk all over Him. He is God, who wrapped Himself in flesh and humbled Himself to the point of death. God never died! The

Son of man did! He said some things that were hard to swallow. He was persistently challenged, watched, and ridiculed day after day. But His dream did come true. He gave up His life on the cross, was placed in the grave, went to hell and preached to the spirits, and returned with the keys of death and hell, and with all power in heaven and earth.

A certain man had prophesied many years back of dreams and visions that he had seen of a black man reaching the highest office in the land. Barack Obama did reach the highest office in the land, becoming president of the United States. He kept up the fight as he journeyed, neither wavering nor giving up. Just as Trump said, "We will never, ever surrender." Fight for what you believe is important to you, to the Lord God, to your family, and to the people of your country.

As a steward of Christ Jesus, I will not be afraid to take the fight to all the nations of the world, telling them about the love that Jesus Christ has for them. While some are fighting for power, money, control, and the pursuit of a better earthly life, we the knowledgeable do the opposite. Our pursuit of these things has a short life span. We are preparing to meet our God, Jesus, the Christ, who will be coming like a thief in the night. He is coming to take His patriotic followers, saints, and soldiers who have obeyed the gospel of Christ, the Anointed One, and are waiting for His glorious return. He shall come just as He was taken up into heaven; He will not tarry.

I encourage everyone to have faith in God. Fight feverishly to lay hold of life eternal in heaven, or else disobey Jesus Christ (God) and gain eternal damnation in hellfire, where your worm (body) will never die and the fire is never quenched. I would like to see a great many Americans rise up and let others watch them come storming back with their fire trucks and water hoses, and all the other firefighting equipment they possess, to try to put out the fire in hell. It will not happen, buddy.

We Are Watching You

> Be watchful, and strengthen the things which remain, that are ready to die: for I have not found thy work perfect before God. Remember therefore how thou hast received and heard, and hold fast, and repent. If therefore thou shall not watch, I will come on thee as a thief, and thou shall not know what hour I will come upon thee.
>
> —Revelation 3:2–3

I am serving an amazing God who has given us all good things to enjoy until He returns. The earth is our temporary habitation. We should watch over it with care because someone is watching us. "The eyes of the Lord are in every place, beholding the evil and the good" (Proverbs 15:3). There is a natural watch and a spiritual watch. Most of us will risk our lives to watch our personal belongings twenty-four seven. Yet we fail to do as the Master tells us. He said, "Watch!"

"Watch therefore: for you know not what hour your Lord doth come. But know this, that if the goodman of the house had known in what hour the thief would come he would have watched and would not have suffered his house to be broken up. Therefore, be also ready: for in such an hour as ye think not the Son of man cometh" (Matthew 24:42–44).

The Lord God made you ruler over your own house (body), which is also God's house. Take diligent care of it. Wash it often. Fed it often. Nurture it often with lotion and oils. Empty your body of waste often. Lastly, often groom yourself to make yourself look good. You make future plans and stock up on goods. You should be cognizant of the fact that you are not immortal. Humans in general pay little attention to the importance of the soul. The body will die, but the spirit lives on forever. Jesus is pleading with us to strengthen the inner person—the soul. Your soul (your spirit) needs to be raised up if you are to come storming back to spiritual life as a new man, new woman, new boy, or new girl. The

Father and the Son are watching you to see if you will take the advice you were given to strengthen the things that remain, that are ready to die.

You may be asking, how are the dead raised up? This is your answer: "But if the Spirit of him that raised up Jesus from the dead dwell in you, he that raised up Christ from the dead shall also quicken your mortal bodies by his Spirit that dwelleth in you" (Romans 8:11). God the Father, who was in the Son, the man Jesus, the anointed Christ, will change your life from the inside out. He will raise you up to a new way of walking, a new way of talking, a new way of dressing, a new way of loving, and a new way of living, that is, your new resurrected life in Jesus Christ. If you have not done so yet, then now is the right time to get your business straight with God. Even now, you are dead in your sins; you have no spiritual life in your body. "For this you know that no whoremonger, nor unclean person, nor covetous man, who is an idolater, has any inheritance in the kingdom of Christ and of God" (Ephesians 5:5).

What will your profit be if you gain everything the world possesses, but you never repent and get baptized in water in the name of Jesus Christ for the remission of sins, thereafter to be filled with the gift of the Holy Ghost? In hell you will lift up your eyes and will be unable to raise yourself up from that dungeon. Hell is the place where your worm never dies and hellfire is never quenched. There will be no way out of the fire for you.

Katie Hobbs, My, My, My

Katie Cobbs, Arizona secretary of state, who participated in the election cover-up, gave testimony before the Senate Rules Administration Committee stating that two weeks after the 2020 election legal challenge, armed protestors gathered outside her residence and shouted, "Katie, come out and play. We are watching you." Both Democratic and Republican officials, that is, officials on both sides of the political aisle, also described how, as the legal challenge of the election ramped up, supporters of former president Donald Trump left messages saying

they were being watched and their families might be harmed if they did not swing the election to benefit Trump. These statements were made before the committee that was addressing the "rhetoric," as they called it, of those who still have not accepted the results of the 2020 election, won by now president Joe Biden. Rules for thee and not for me, as some see it. But the Democrats have no problem mounting their legal challenges and pursuing their unjust, phony investigations to further their lustful agenda.

There were no threats to Ms. Hobbs. Someone apparently said, "Come out and play; we are watching you." Where did the threats come from? Nowhere, from what I have seen and read. Some people just make stuff up, presenting figments of their own imaginations. Prisons are built for murderers, thieves, and crooks, to name a few. The authorities lock people up so they can punish them and watch them constantly. Miss Katie Hobbs, you are part of the Arizona government. Who is really watching you? God sees you. He is giving you time to put your business in order. In a little while from now, the Lord God will send the death angel for you. You'd better get right with God—and do it now.

Jacob's son Joseph proved his brothers. When they came into Egypt to buy corn because of the famine in the land, he called them spies and held them to evaluate them and prove their honesty. Then, when they were about to go, he filled their carriages with produce at no cost to take back to their father, who was also his father. They were in every way transparent. Why couldn't Ms. Hobbs be transparent if there was nothing to hide about the election? It is the work of her father the devil she does.

I am speaking to you, Ms. Hobbs, because I know that you remember what you did to cover up the fix. You are a formidable fixer-upper, and you are very sly. Behold, your sins will find you out. Why are you so fixated having on the American people accept the fraud and move on? That's really what thieves hope for, for their victims to forget that they were just robbed blind. Of course, you are being watched. You will not get away with your clever and deceptive acts, and neither will your boss.

"The eyes of the Lord are in every place, beholding the evil and the

good" (Proverbs 15:3). Ms. Hobbs, your ways may seem right in your own eyes, but that does not make what happened right. You want all of us to just roll over. *Take it or leave it, or just drop dead,* you said in your heart. If someone really did threaten you, put it on my account. Let me be responsible for that. I know what a fix looks like. I know what a robbery is. I can attest to how the government of the United States took my house that I was paying for and took my money, both here and in Jamaica, that I worked hard for. They also took the church's money.

The authorities locked me up for five years. But I am free. For whom the Son of man has set free is free indeed. But I am not bitter against any of them. The judges were in on this debacle. The judge who sentenced me in the beginning is the same judge who, in July 2020, discharged all the violations. He discharged the three years' supervised release he had imposed on me. He removed the one million dollars' worth of restitution he had imposed on me. He never returned the loot the government took from me, but he told me, "I hope you have a good life. I hope I never see you again." How do you expect me to have a good life when you have just cleaned me out and taken hold of my God's property, me?! My God rolled back what the authorities had put in motion, including the charges and the restitution. But they are responsible for paying a heavy financial price for taking God's servant captive. I will leave it up to my Judge, my Lawgiver, and my Jury, the Lord Jesus Christ. He purchased my life with His blood and redeemed me from the hands of my enemies.

"And I will restore to you the years the locust hath eaten, the cankerworm, and the caterpillar the palmerworm, my great army which I sent among you. And you shall eat in plenty, and be satisfied, and praise the name of the Lord your God that hath dealt wondrously with you: and My people shall not be ashamed. And ye shall know that I am in the midst of Israel, and that I am the Lord your God, and none else: and My people shall never be ashamed" (Joel 2:25–27).

I have risen to another level in the Lord. Just watch me come storming back. This is what I do. "Bless them which persecute you, bless and curse not" (Romans 12:14). For if the Lord God had not been on my side when my enemies rose up against me, I would not be alive today. They

would have swallowed me up a long time ago when their anger flared up against me. All their floodwaters would have swept me away. Their torrents of rain would have engulfed me, and they would have pestered me with hail. Their raging rushing waters would have swept me away downstream. But thanks be to my God, who has not allowed them to tear me to pieces and chew me up with their teeth. It is so sweet to know that the Lord gives inspiration.

On election night 2020, Donald Trump was ahead in the count by thousands of votes. Then, little by little at first, then growing larger, there came a surge of votes for Biden, then a few here and there for Trump. The fraudulent votes were brought in very quickly to eliminate Trump's lead. Even the very blind could see that something was not in order. The Democrats had executed the fix to set Donald Trump back; that is what happened. Weeks later, Biden was officially ahead, and the certification took place, leaving Trump in a somber mood. But rest assured, soon, Trump will come storming back like a raging bull to the White House. The Lord God in His faithfulness, and all of Trump's faithful and loyal patriots and followers, will make sure his return happens.

CHAPTER 12
VIRGINIA RISING UP FOR DONALD TRUMP

In the Virginia gubernatorial election, which Glenn Youngkin will win handily over Terry McAuliffe, special emphasis was given to parents' role in the educational system. McAuliffe was leading Youngkin by more than seven points until he raised the critical point of indoctrination of children in the schools. His poll numbers fell dramatically by more than fifteen points with the K–12 set, which includes parents who liked his message. Lieutenant Governor Winsome Sears and Attorney General Jason Miyares were all leading in the polls ahead of their Democratic challengers. In a state where it is claimed Democrats far outnumber Republicans, the mood has swung dramatically. Everything is turning in Trump's favor. You just watch and see.

So, brace yourself for some earthquakes (politically speaking). You just watch and see the Republicans come storming back in their races as

they flex their political muscles. This is good news for Donald Trump and his supporters moving forward. Name-calling is never a particularly clever idea, but McAuliffe resorted to likening Youngkin to the January 6 rioters. This will not work for him one bit. Mr. McAuliffe brought in all his big heavyweight political backers and donors to help him in his fight and his quest to keep Virginia in their corner, but it will not work. Just as they tried to throw the kitchen sink at Trump, they tried the same with Youngkin, but he avoided it and got out the way. They will never catch up to him in their quest to keep the governorship.

Folks are fed up and frustrated with the Democrats at this point for behaving as radicals and failing to keep their word or even remember all the promises they have made. Do you remember this one? "I will not shut down the country; I will shut down the virus." Sorry! The country was shut down, not the virus. Since Mr. Biden took over the reins from Mr. Trump, more people have died from COVID than under Trump. What a difference in direction some months and a year can cause.

Now the coronavirus is not really Biden's fault, of course. Mr. Biden had no compunction blaming Mr. Trump for the deaths of hundreds of thousands of people. Who then will be able to blame the voters for using the very same standard of culpability? How could Mr. McAuliffe and Joe Biden brag about overseeing what promises to be the weakest economic recovery since the last time he was put in charge to oversee these things? Mr. McAuliffe will be politically dead, trying to raise himself out of the slip in the voting waters in his state. With Mr. Biden campaigning with him, the people were looking at what Biden was doing to create more opportunities for US workers. Clamoring loudly, he said he would put millions of jobs on the cutting board.

Can Mr. Biden boast about the border wall and all the activities surrounding it? Will he be able to explain credibly how high inflation actually is a positive development for consumers now? Will he boast about his foreign policy? He will never be able to boast about Afghanistan, because he has abandoned hundreds of US citizens to a terrorist regime. Biden rose to power, then he signed an order for the US soldiers to leave that country. The Taliban took Kabul like a storm,

without firing a shot. Biden had ordered the soldiers to leave hurriedly and come storming home to the United States as if they had just been defeated in the war. With all that has happened to Biden, Virginia rose up from the dead for the Republicans. They will rejoice in what the people have done, rejecting what the Democrats offered and going with what the Republicans were selling. Assuming it is a good offer, obviously the citizens of Virginia will accept it, because Virginia will never accept critical race theory. In fact, once the new governor gets into office, he will quickly remove that mess from the schools. He has a mind for change. He has a mind to work. And work he will do, to influence the direction the schools and education are going in.

Virginia Rising Up for Trump

Glenn Youngkin will rise to the task he has envisioned for Virginians. The voters' ears tried Youngkin's words and gravitated toward them amicably. Residents and citizens do not wish for big government to take them for granted while their children are snatched right out of their hands. A person who envisions power and grabs it will proceed with his hypocritical ways to ensnare the people.

Rising Up and Giving In

Mr. Biden is on the ropes. How did he get there? He was declared the winner over Trump in the 2020 presidential election, so he rose up to be the president. His Justice Department is doing his political bidding. It was ascertained that Joe Biden's administration was secretly trying to pay between $450,000 and $1,000,000 per immigrant family. How far will this go? Look out! Mr. Biden stopped the construction of the border wall. He signed an order making it easy for people to pour into the country like bees in a hive. From the look of things and the way they are progressing, Mr. Biden is poised to be one of the worst president in

the nation's history. He rose up, but he is giving in. He had better do something fast.

Vladimir Putin was given leeway to dominate OPEC. Soon he will be emboldened to move his troops into NATO countries, flexing his political muscle against Ukraine to devastate the country as the pharaohs did when they dominated Egypt, and as Adolf Hitler and Joseph Stalin did in their time. Biden giving in to the Far Left of his party will not make him look good. He gives in to their suggestive arguments and makes them into policies, and when those policies fail or are challenged, he blames the problem on Trump and his associates.

Construction on the border wall that Trump was building when Biden came to the While House has stopped because Biden signed an executive order to stop it. He blamed the building of the wall on Trump. All the undocumented immigrants who have been pouring in through the border, he has said it is Trump's fault. Catch and release? He blamed it on Donald Trump. And one of the greatest of all is the January 6 insurrection. It is Trump's fault for sure. Who else's could it be? It is his baby! He cannot deny it! But Trump will not own this little bastard who was born on January 6, 2021. The Democrats will have to go in search of the real father(s). Whichever way the political wind blows in Biden's party, he goes along with it. He is trying hard to finish the task at hand, but with the way the wind is blowing, he will need to be cared for and nurtured if he is to cross the finish line in 2024.

TRUMP'S BIG PLANS

President Trump is looking for a stunner in the Virginia election race. He will receive it when Glenn Youngkin wins. He will see his plans at work in Ohio. He will also see his plans at work in New York. Everything that he has ever dreamed of or hoped for is coming to pass and falling into place. One simply does not build a successful empire out of thin air. Trump sat down to count the cost of his challenge of the election result on January 6, and he learned it was steep. It is true that

the people gathered together in Washington, DC, on the sixth of January to protest the election. What is not true is that Joe Biden won the 2020 election fairly. Know this for sure: Donald Trump won the election, period. What else do you need to know? Just keep a cool head and do not get excited. Mr. Trump is and will be giving the naysayers the shock of their lives. In politics, it is an exceptionally good idea to toy with your adversaries and detractors without throwing a single punch. Words can hurt badly when hurled without a thought about their effect. But words are stunningly sweet when they are beautifully crafted and spoken. Just remember these words cleverly crafted by Trump: "We will not bend. We will not break. We will never, ever surrender."

He rises! The momentum is building up; all are striving to do better. Once all the members on the Republican side align themselves with the head, there will be smooth sailing ahead. There will only be a few encumbrances, and these can be easily dealt with. Although the scammers will remain in the house, Trump must not let them prevent him from achieving his goals. And you, reader, do not let such individuals hinder you for a moment. You must follow the man with the goods. You must stand with the man who says what he means and means what he says. Get it together: stand with Trump and the rest. Never break away. While others are breaking like sticks, you just say, like Trump, "I will not break." Seeing as Donald Trump is someone who is willing to hold the lead and not give in, not even a tiny bit, to pressure, you should hold fast to him. He will not yield.

When you have done your due diligence and you find a leader who will not give in, you must hold him or her close. When the going gets tough and others are caving in, you, having found someone who simply will not give up, should stick to your candidate like glue. When you have searched and searched and are sure that your search has yielded the fruits of promises made and promises kept, stick like a magnet to the person you have found. Trump is such a person, and he is determined!

Politically, the purpose of Trump's rise in the political arena was not just to get up then fold it up and roll over, surrendering. He is the new leader of the Republican Party. He has risen and taken control. He is

in the driver's seat now, and he has the momentum. Try your best to go by him carefully. Try your best to pass him in the right lane. Make sure you keep your eyes on the road, the track, and the trail. Trump's train is in full motion. He will only stop at designated stations. When his train stops and he gets off and makes request for proceeds, no problem.

Whenever and wherever he has organized a fundraising event to fill his campaign chest, he has no problem receiving many contributions. Participants for Trump? No problem at all. This man is going full speed ahead. Just get out of his way so he does not have to run you over. Better yet, get on board so he will not leave you behind. He is serious and he will not yield. He will not give up. Only the Lord God can bend him, break him, and stop him in his pursuits.

Trump will not surrender. Although people have tried to get him to do so, their efforts have yielded no fruit. How can you not love the man? But I can understand! You choose to love or to hate. Truth be told, whether you love him or hate him, he is pushing ahead until something happens. Trump has risen as the top-notch man in splendor. It is not over until God says it's over for him. It is not over for him until God says, "It's the end. It is your time to leave. It's your time to go." Only then will Mr. Trump lie down and take his sleep. If God doesn't take him away, no one can touch him, for God has put a mark upon him lest anyone should try to hurt him. Whatever his haters throw at him, as rainwater pours down from the sky onto a slanted rooftop and then runs off suddenly, so it is with Trump. He is like the rainwater just dripping and dripping all around. And although it may seem as if there is a problem with the water reaching its potential destination, watering things as it goes along, he will dig burrows and trenches to extend the water source. He will not give up. Trump will be in the driver's seat again as he remains focused. The rivers and streams of the Republican Party need to attain a certain level that cannot be attained or achieved unless the party experiences constant rainfall to bring the rivers and streams to the level they should be.

The Glasgow Spectacle

While Donald Trump was busy with his various watering activities here in the States, President Joe Biden took a trip with several staff members, his security crew, and a few chosen media personnel to Glasgow, Scotland, to attend the COP26 meeting. Within minutes of his taking his seat for the high-level global summit, he nodded off, sleeping. Maybe he just was not interested in hearing what the others were saying, or he was just bored being onstage. Or maybe his body was weary exertion and not having had enough sleep. The cameras were rolling and steadily focused on him for all the people watching the news and taking an interest in activities around the world to see. After he was awakened, he went to the podium to speak. He went on to attack Donald Trump and his administration by apologizing for the pullout agreement Trump had signed with the Afghans.

Biden was present at this summit to discuss climate change. What does the pullout agreement that Trump signed when he was in office have to do with climate change? Biden's discussion at COP26 is beyond my comprehension. He is now the man in charge of making decisions. He is now the man who is giving the orders. But I guess he must stand up for what he believes in. He can be so out of touch with reality, and he blatantly lies to the people time and time again. He will not give reporters the time of day to ask him any questions. He refuses to be honest with the people; it is because he is not honest with himself. He is afraid to tell the truth to the people, afraid that all will see that there is no truth in him.

"Wherefore putting away lying, speak every man truth with his neighbor: for we are members of one another" (Ephesians 4:25). "Forbearing one another and forgiving one another; if any man have a quarrel against any, even as Christ forgave you, so also de ye" (Colossians 3:13)." "But he that doeth wrong shall receive for the wrong which he has done; and there is no respect of persons" (Colossians 3:25). All these scriptures apply to Joe Biden.

What will you expect from the one who lies? More lying? For the

father of lies is the devil. He was a liar from the beginning, and Joe Biden is now the epitome of a perfect liar, for the spirit of his father is living and abiding in his heart. Because the devil has such pull is the reason why we all need spiritual medicine, to enlarge our hearts so that the Word of God can galvanize and purge our hearts, putting us in good and right standing with God Almighty. "All liars shall have their part in the lake which burneth with fire and brimstone" (Revelation 21:8).

Reader, be very careful when you are dealing with a skillful liar, as you may learn his or her ways. The devil is one such skillful liar. He has cleverly filled the hearts and minds of men, women, boys, and girls with deceit. For you to be free from the stronghold of lying and the devil's strangling and trickery, you must put off the old man (devil) and put on the new man (Jesus Christ) and be renewed in the spirit of your mind. Repent, telling God how sorry you are for all the wickedness you have done in your lifetime. Come and be baptized in water in the name of Jesus Christ for the remission of your sins. You shall receive the Holy Ghost, the gift that is promised to you and to your children. Start learning how to walk continually in the new life you just received, walking in the fear of God, and be not entangled again in the yoke that had you in bondage (sin).

THE REAL CLIMATE CHANGE

The climate is certainly changing, but not in the way scientists, geographical researchers, and meteorologists think. We are seeing earth erosion, hills breaking and burning, sea erosion, and wildfires blazing and destroying trees, houses, land, and grass, sending smoke fumes into the air, where it travels for miles. Then there are fumes from the emission systems of motor vehicles, planes, ships, and trains. We have hot weather and more frequent heatwave. We have freezing weather in winter and mild weather in spring. And finally, we have fall, when some trees shed their leaves and remain in a dark and somber mood. No flood will ever destroy the earth again. God made that promise to Noah very plainly.

"And I will remember My covenant, which is between Me and you and every living creature of all flesh. And the waters shall no more become a flood to destroy all flesh" (Genesis 9:15).

God makes promises, and God keeps promises. Do you want real climate change? If so, then just do as God commanded you. You need the wind of your obedience, which is better than any sacrifice that you can offer. It will cause a sweet smell in the nostrils of Jesus Christ. Listen, Mr. and Mrs. Smarty-Pants, I have a question for you. Have you ever known anybody who has changed the direction of the air we breathe? Do you know anyone who is clever enough to change the direction of the sea? Have you been able to change the direction of the sun or the sunrays?

Do you know of anyone who has the ability to change the four forms of weather we have? Are you, or is anyone you know, able to change the night from the day? You are able to control the air and the temperature in your cars, houses, planes, and ships. The Lord God has given you the ability to do these things. You will never be able to change the direction of the wind, however. Please, bring your wise counselors and let us reason together. Noah obeyed God and the wind of God shifted. And the sweet savory odor from Noah's burnt offering went up into the nostrils of God.

"And the Lord smelled a sweet savor; and the Lord said in his heart, 'I will not again curse the ground anymore for man's sake; for the imagination of man's heart is evil from his youth; neither will I again smite anymore everything living, as I have done, while the earth remaineth, seedtime and harvest, cold and heat, summer and winter, day and night will not cease'" (Genesis 8:21–22).

You are going to die; that is a fact that the climate will not change. Hell is real, and its fire will never be quenched. In hell, there will be no water to cool your thirst. You will be constantly burning, and no one will be able to help you. You can change the direction you are now going in now if you will just listen and not be so hardheaded, stiff-necked, and enamored of your own ways. You will experience the real climate change, Mr. Joe Biden, Mr. Al Gore, and Mr. Bill Gates. You all need to shift away from the weather of hypocrisy and the deceitfulness and lying. Change the climate from Catholicism to holiness. Change the

climate from Baptistic to holiness. Change the climate from apostolic to holiness. Change the climate from Jehovah's Witness to holiness. Change the climate from Methodism to holiness. Change the climate from Buddhism, Rastafarianism, Pentecostalism, Church of the Living God–ism, Mormonism, Judaism, Islam, and Seventh-day Adventistism to holiness.

God has only one way. He started only one church, called the way of holiness or the way of salvation. Your religion is the climate that needs changing; you need to change it now. When God showed Moses His way of holiness, he said, "I exceedingly fear and quake" (Hebrews 12:21).

"For you are not come unto the mount that might be touched, and burned with fire, nor unto blackness, and darkness and tempest. ... But you are come to Mount Sion, and unto the city of the living God, the heavenly Jerusalem, and to an innumerable company of angels, to the general assembly and church of the firstborn, which are written in heaven, and to God the Judge of all, and to the spirits of just men made perfect" (Hebrews 12:18, 22–23). "For our God is a consuming fire" (Hebrews 12:29). Whether you are in the White House or out of it, or wherever else you may be, when the Lord God sends this consuming fire, if you don't repent and get baptized in water in the name of Jesus Christ for the remission of your sins and receipt of the gift of the Holy Ghost, your global body will be set on fire.

"For our God has not called us unto uncleanness, but unto holiness" (1 Thessalonians 4:7).

The moment you rise to talk to some people and give them few words of encouragement, they begin to speak, saying things such as, "My church does not do this. My church does not do that. My bishop said this. My pastor said that." What does God say? God has called us to be members of none of the aforementioned religions. Nor did He start those religions.

"But as He which has called you is holy, so be holy in all manner of conversation, because it is written, 'Be ye holy; for I am holy'" (1 Peter 1:15–16).

Our God Is a Consuming Fire

The floodwaters rose up and prevailed upon the earth for one hundred fifty days. All flesh and every living thing that moved upon the earth died—fowls, cattle, beasts, creeping things, and humans. The birds of the heaven were also destroyed. The destruction that took place in the earth in Noah's day was cataclysmic in nature and horrifying with a pungent smell. There was a real climate change that took place because of humankind's disobedience and hardness of heart. For the imaginations and the behavior of humans begin in their youth. And the sinful behavior of the gay and lesbian lifestyle is causing the temperature to change.

When a man goes to a doctor to change his anatomy so it looks more like a woman's and to change his voice so he may sound like a woman, it is a change that affects the atmosphere. When a woman goes to the doctor to have her breasts removed, her vulva and clitoris remade into a scrotum and penis, and her voice altered to sound like that of a man, the climate and temperature changes and it affects the atmosphere around the world. When a man claims to have a burning feeling rising up in him that causes him to look upon another man with sexual feelings, and when he has anal sex with such a man, the climate has changed. A person who fits any of these descriptions is filled with demons, which have taken over the person's body. Now, only the power of God can reverse this climate change and have such an individual sitting at His feet in his or her right mind. No wonder people don't know who they are. You, young woman, walking around patched up with someone else's body parts or injected with silicone that will deteriorate very soon, do you not know that a leopard cannot change its spots? A dog, whether male or female, will bark. If you have a female dog and have her spayed, she remains a female. It does not matter if you dress up that female dog to look different, she is still a female dog. Do you get my point? I hope you do!

I speak to whomever fits the foregoing descriptions. Being filled with burning lust and insanity, you have created a natural human disaster, having failed to remember that it is God who has made you male or female. You did not make yourself. You should glorify God in your

body and be thankful unto Him, blessing His name for who and what he made you to be. If you can change the direction of the sun and manipulate its power, then you will be able to change the climate. If you can change the direction of the wind, then you will be able to change the climate by way of the wind. Until you have such powers, keep on dreaming, as your dreams will not materialize. Mr. President, the real climate change begins with you.

"And God remembered Noah, and every living thing, and all the cattle that was with him in the ark. God made a wind to pass over the earth, and the waters assuaged [became less intense]. The fountains also of the deep and the windows of heaven were stopped and the rain from heaven was restrained. And the waters returned from off the earth continually: and after the end of the hundred and fifty days, the waters were abated" (Genesis 8:1–3). Here we see that the climate of the earth changed gradually after the Flood. Noah did his environmental testing. He sent out the raven, which went back and forth until the waters were dried up from the earth. He sent a dove to test if the waters had receded from the ground; they had not. He waited one week and sent the dove again. This time she came back with evidence of the result he sought, an olive leaf in her mouth. "Noah knew that the waters were abated from off the earth" (Genesis 8:11).

All you must do is strive to please God daily in your activities and your worship. True worship is a sign of your obedience. Your climate is changing, and you are not aware of it. Can't you see what you look like now, compared to what you looked like when you came out of your mother's womb? There is a change taking place, buddy. You are going to die. Your climate will change. Only you can make a change within yourself. You will never be able to do it with the environment.

"The Pharisees also with the Sadducees came and, tempting, desired Him that He would show them a sign from heaven. And He answered and said unto them, 'When it is evening, ye say, "It will be fair weather": for the sky is red. And in the morning, "It will be foul weather today," for the sky is red and lowering. O ye hypocrites, ye can discern the face of the sky; but can ye not discern the signs of the times?'" (Matthew 16:1–3).

You will never be able to put out God's fire. God allows you to control the fires that flare up by themselves in California and across the United States by pouring down water and spewing water up. In this way, the fire is put out for a while, but it starts up again the next year, over and over again.

Have you been able to change the heat in the Nevada desert? Sin's climate can change, for the Word of God is true. Perilous times are here. Evil men, evil women, and seducers are getting worse. Climate change begins with you. If you really want the climate to change, then obey the Word. It is a very sweet feeling to trust in Jesus, to take Him at His Word, to rest upon His promise, "I will be with you even unto the end." Take a good look at the following information, which will help you better understand what I am really saying when I talk to you about real climate change.

THE WIND AND THE SEA OBEY HIM—
THE REAL CLIMATE CHANGE

> And the same day, when the evening was come, He [Jesus] saith unto them [His apostles], "Let us pass over unto the other side." And there arose a great storm of wind, and the waves beat into the ship, so that it was now full. And He was in the hinder part of the ship, asleep on a pillow: and they woke Him, and said unto Him, "Master, carest Thou not that we perish?" And He arose, and rebuked the wind, and said unto the sea, "Peace, be still." And the wind ceased, and there was a great calm.
>
> And He said unto them, "Why are you so fearful? How is it that you have no faith?" And they feared exceedingly, and said to one to another, "What manner of man is this, that even the wind and the sea obey Him?"
>
> —Mark 4:35, 37–41

And straightway Jesus constrained His disciples to get into a ship, and to go before Him unto the other side, while He sent the multitude away. And when He had sent the multitude away, He went up into a mountain apart to pray, and when the even was come, He was there alone. But the ship was now in midst of the sea, tossed with the waves: for the wind was contrary. And in the fourth watch of the night Jesus went unto them, walking on the sea. And when the disciples saw Him walking on the sea, they were troubled, saying, "It is a spirit;" and they cried out for fear. But straightway Jesus spake unto them, saying, "Be of good cheer, it is I; be not afraid."

Simon Peter answered Him and said, "Lord, if it be Thou, bid me come to Thee on the water." And He said, "Come." And when Peter was come down out of the ship, he walked on the water, to go to Jesus.

But when he saw the wind boisterous, he was afraid, and beginning to sink, he cried, saying, "Lord, save me." And immediately Jesus stretched forth His hand and caught him, and said unto him, "O thou of little faith, wherefore didst thou doubt?" And when they were come into the ship, the wind ceased. Then they that were in the ship came and worshipped Him.

—Matthew 14:22–33

God is jealous, and the Lord revengeth; the Lord revengeth, and is furious; the Lord will take vengeance on His adversaries, and He reserveth wrath for His enemies. The Lord is slow to anger, and great in power, and will not always acquit the wicked: the Lord hath His way

in the whirlwind and the storm, and the clouds are the dust of His feet.

He rebuketh the sea, and maketh it dry, and drieth up all the rivers. The mountains quake at Him, and the hills melt, and the earth is burned at His presence, yea, the world and all they that dwell therein. Who can stand before His indignation? Who can abide in the fierceness of His anger? His fury is poured out like fire, and the rocks are thrown by Him. The Lord is good, a stronghold in the day of trouble; and He knoweth them that trust in Him.

—Nahum 1:3–7

If you can prevent yourself from getting old, Joe Biden, then I will go along with your Build Back Better plan. For you are willfully ignorant of the fact that when the Flood came in Noah's day, there was a climate change. God destroyed humans and every living thing having the breath of life in it. But God reserved the heavens. After the Flood, there was a climate change, tested and proven by Noah. Then he came out of the ark safely. The old world had perished. This wicked world today is going to perish. It will be destroyed. And how will you make that change, sir?

For God is not slack concerning His promise, as some men count slackness; but is longsuffering to usward, not willing that any should perish, but that all should come to repentance. But the day of the Lord will come as a thief in the night; in which the heavens shall pass away with a great noise, and the elements shall melt with a fervent heat, the earth also and the works that are therein shall be burnt up. Seeing then that all these things shall be dissolved, what manner of persons ought ye to be in all holy conversation and godliness? (2 Peter 3:9–11)

The Lord God has ensured for all people a safety net in Him for when the climate changes. You had better choose the Lord today. Are you preparing for hell and hellfire, or are you preparing for heaven, a place

where there will be peace, rest, and tranquility? Please make up your mind. You will never, ever be able to change the weather or reverse that which you refer to as "climate change." For seedtime and harvesttime, cold and heat, summer and winter, and day and night shall not cease, for the Lord God said so, and I love it.

CHAPTER 13
DONALD TRUMP'S THREEPEAT

Donald Trump will run for president of the United States again in 2024. This time he will be the threepeat president. It must be done in style. He will win the contest hands down, no doubt about it. To all those who are wondering if he will he again, I say, Oh yes, he will. Mr. Trump will not allow a moment like this to pass him by. He may be keeping you in suspense, but I, a seer, am telling you ahead of time what God put in my spirit as to what will come to pass. In 2024, Donald Trump will win the election in a convincing manner. The Democrats will suffer a humiliating defeat at the hands of the people. The people are currently very, very upset at the attitudes and behaviors of the Democrats, so they will send them a strong message. To date, two years after having lost the election by seventy-four electoral votes and by more than seven million citizen votes, Donald Trump has a better chance than anyone of winning the general election. To be clear, this

means that he has greater than a 70 percent chance of making the most dramatic political comeback in US history.

There is no one, including Joe Biden, who is more likely to win the presidency than Trump in 2024. The math here is quite simple. First, Trump must run, which he certainly will do unless he is locked up (which, despite the liberals' fantasies, is extremely doubtful) or becomes seriously ill. Or he may decide to pull out of the race at the last moment if he realizes his challengers are unafraid of him. Any of these outcomes is highly unlikely. Trump has captivated the Republican Party; more than 90 percent of the party's base are behind him. With Glenn Youngkin's historic win as governor of Virginia, Jason Miyares's as attorney general, and Winsome Sears's, a conservative black Republican, as lieutenant governor, it is game on for Virginia. The Lord God put Trump in my vision.

If events continue in their current direction, given how dismally the current Democrats did on November 2, 2021, then don't look for Joe Biden to win in 2024. If he were to somehow quit and give up his power, the change in the atmosphere of the White House would be dramatic. If Donald Trump decides not to run, there will probably be a contested primary—which could occur given the new rules of "wokeness." It would be deemed racist and sexist to contest an election involving Kamala Harris, as Donald Trump has previously speculated. She will lose anyway, no matter who the Republican candidate is.

This means that whether or not COVID-19 and inflation are solved, and if somehow Mr. Biden continues to hang on in his weakened and sleepy condition, not to mention his dismal first-term record, Mrs. Harris will be his running mate. She will not quit, although it seems she serves no real purpose. But Trump will be there too. He is an extremely popular man. It would be very productive to name Mr. Trump as the Republican nominee. As it stands right now, any Republican candidate vying for political office is hoping to get Trump's endorsement. It is hard to get to the top without it.

As time speeds ahead, the media is trying hard to cause confusion and create a ruckus ahead of the upcoming political races between Brian Kemp and David Perdue, Herschel Walker and Raphael Warnock,

Marjorie Taylor Greene and Marcus Flowers, and others. Kemp will overwhelm Perdue. All this hysteria in the media is designed to create an atmosphere that causes people to become fed up and refuse to do their civic duty and vote. The media are doing this because they all have an agenda. Liberal news outlets are making it seem as if the Democrats have a realistic shot of defeating the Republicans despite the Democrats' injurious behavior and involvement in, and support for, what went on in the streets. Because of the election fix that was orchestrated by the Biden team and his surrogates, in 2020, his and the other Democratic candidates' margins of victory ended up looking very impressive. Commentators and political pundits, never mind how vast the scope of voter fraud, seem not to realize that had it not been for the fraudulent votes in Arizona, Georgia, Nevada, Pennsylvania, and Wisconsin, Trump would have gone all the way. Those who are saying Mr. Trump has hurdles preventing him from getting back into the White House are just hoping and wishing he will give up his quest for the office. It will not happen. You cannot say you have not been warned.

Look Out! Trumpism Is Rising Up

Seven Republicans who were present on January 6, 2021, at the "Stop the Steal" rally won their respective races on November 2, 2021, Election Day. Three of the attendees were elected to state legislative office, whereas four succeeded in their campaigns for local office. Look out, Trumpism is rising up as a well-oiled machine, ready and waiting for the task ahead. More livid citizens will be seeking political office in the coming years. Despite the anarchy and the mayhem that made those who marched to the Capitol Building on January 6 look like domestic terrorists and insurrectionists, many Republicans who attended the rally are holding strong. Rising up to defend Trump, they, the participants and patriots, first passed the word about "Stop the Steal" and then later attended the rally. True and honest people know that the 2020 election was stolen and are saying so, even some Democrats. You must follow

the man with the plan. Mr. Trump has taken advantage of the problems plaguing Joe Biden and his regime to help boost support for the Republicans and shining some light on his time in office.

Trump had some bad officials in his administration. They pretended to be with him, but behind his back, they stacked the deck of election cards against him. Where would he be now were it not for the Lord, who was on his side? Again and again, Mr. Trump has uttered his grievances about the 2020 election, telling those who have the patience to listen to him and empathize with him because they know the truth. The Democrats are currently losing, and will continue losing, ground for having gone too far left. Every step they have taken and continue to take in that direction is one too many. I do not believe that Donald Trump must be at every candidate's rally if they are to be victorious. He just speaks the word and it is done. On the Democratic side, people are disillusioned. They are trying extremely hard to show unity, but discord has taken root within their ranks.

The young progressives are pushing Mr. Biden. He does not resist them but let them have their multimillion-dollar slush fund, hoping that they will fly the blue flag, hoping to inveigle their votes. The voters will not go for it, not at all. This is good news for the rise of Trumpism. Even though the House Speaker, Mrs. Pelosi, is pushing Mr. Biden's Build Back Better agenda, hoping it will take root until the bill passes, the Democrats all have an uphill battle to fight. Mr. Biden and his leftist Democratic socialist progressives, with their heads buried in their books, cannot tell the delusion from reality. Behaving like children, they think the country can be run like an Ivy League school.

Their party is losing as a result. Trumpism began rising the moment Mr. Biden embraced the leftists' ambitions. *Boom*, Biden failed, and Trump's numbers increased. This is good news for Trump, who is waiting on the sidelines. Honestly, Joe Biden is dead weight. He is weighing down his party, making room for Trumpism as the Republicans take complete control. But the Democrats cannot see that the weight is pressing them down because of their bad policies. Trump is on the sidelines, moving ahead rapidly, saying, "I can see clearly now that the weight is

on, weighing them down with their decisions and policies. I can see the Democrats in my way." With all their bad policies hampering the Democrats, it is going to be a bright election for the Republicans in 2022 and 2024, no doubt about it. Wait and see.

Most Americans are still concerned about the coronavirus pandemic, and they are talking about it, the same pandemic Mr. Biden promised to fix when Trump was president and Biden was seeking to be president. People are still being offered COVID-19 booster shots, and they are still getting sick. Mr. Biden returned from his trip to Scotland to a new reality: folks were still concerned about this monstrous disease that originated from China and was unleashed on the world, with enemy number one being the United States and with purpose number one being to hurt Donald Trump and hamper his chances of being reelected. Joe Biden also realized that US citizens are very concerned about the economy and the poor leadership of government officials, failing to solve problems that have proven to be difficult to manage. Things surely must be difficult, hard, and stubborn. Biden made lots of speeches about what would be done, but how to do those things is another story. That must be difficult.

It should not be hard for Mr. Biden to recall the speech he made in 2021 in Delaware where he made mention of a fraudulent organization he had in place. Just as I wrote in my first book about the election, *Make the Vision Plain: The Lord Showed Me Donald Trump—Others*, "The winner will be announced, and it will not be Donald Trump, but Joe Biden, because of the fix." The fix has been going on for more than a year now, so it should not be difficult for Mr. Biden to fix these things as he has promised. His signature legislative proposals are mired in petty party squabbles. His aides want him to speak in such a way as to show to the world that he is on top of things. All that Mr. Biden and his administration has done is to have eliminated Trumpism and all Trump's accomplishments, although when things go wrong, his policy is just blame the situation on Trump.

Biden went to the Eisenhower Executive Office Building to hail the Food and Drug Administration for approving the Pfizer vaccine for children ages five to eleven. "This is a day of relief and celebration,"

he said. When Mr. Biden returned from his trip to Europe, he did not celebrate anything. While he was overseas, he blamed Trump. When he came back, he did the same. When he spoke about the Pfizer vaccine, his celebration was very low-key. Mr. Biden went on a course enabling higher gas prices, higher food prices, and a higher cost of living. For the food prices, this time he did not blame Trump, he blamed the farmers. He wanted to be president, and God gave him his heart's desire. Now, it is up to him: continue to blame somebody, or strive to find solutions to the problems and implement them. If you pull things down, you must be able to build them up.

Donald Trump and Joe Biden are both on a path destining them for greatness. But this greatness they have achieved and are pursuing is temporal. Neither may not live to see one hundred years here on earth. "While we look not at the things which are seen, but at the things that are not seen: for the things which are seen are temporal; but the things which are not seen are eternal" (2 Corinthians 4:18). To accomplish true greatness is to repent and be baptized in water in the name of Jesus Christ, thereby receiving the power of the Holy Ghost, at which time you can honestly say: "I am destined for greatness, 'because greater is He that is in you than he that is in the world" (1 John 4:4)." I am praying for Mr. Biden, hoping that things will work out for him. If he humbles himself, hopefully he will come to know the truth, and that will allow the Lord Jesus Christ to save him from his sins before he dies. For after death comes the judgment. "For we must all appear before the judgment seat of Christ; that everyone may receive the things done in his body, according to that he has done, whether it be good or bad" (2 Corinthians 5:10 KJV).

Donald Trump and Trumpism are rising, with Trump making endorsements, raising funds, holding rallies, creating and re-creating businesses, playing golf, and having lavish parties. Now is his time for these purposes. Yet all these activities will soon come to an end. Donald Trump, you are going to die.

Go thy way, eat thy bread with joy, and drink thy wine with a merry heart; for God accept thy works. ... Live joyfully with the wife whom thou lovest all the days of the life of thy vanity, which He hath given thee under the sun, all the days of thy vanity: for that is thy portion in this life, and in thy labor which thou takest under the sun. whatsoever thy hands findeth to do, do it with all thy might; for there is no work, nor device, nor knowledge, nor wisdom in the grave, whither thou goest. (Ecclesiastes 9:7, 9–10 KJV)

CHAPTER 14
TRUCK DRIVERS ARE RISING UP

Edward Durr, a truck driver from New Jersey, rose up and ran as a Republican for one of his state's Senate seats, against Steve Sweeney, a giant in the party. He was declared the winner of the election on November 4, 2021. This young man is one of many truck drivers who have taken on the responsibility of putting up a patriotic fight against cancel culture, conspiracy theories, and hate. With all the lockdowns, vaccinations, and teaching children how to hate each other, Republicans turned out in droves for this man. They rose up, contributed their time and effort, and got him across the finish line.

Many more giant slayers will be rising up in the coming months and years, with one goal in mind: to take their country back from the Democrats. If you have such an ambition, know that you will never win if you never try. If you try and do not succeed, then try again just as Mr. Durr did. You will come out victorious in the end. You don't need weapons of mass destruction to achieve your goals. Just be honest with the

people you wish to represent, outlining your goals and what programs you would like to see implemented. When you are behaving normally and are up front with the people, they will either gravitate toward your message or ignore you. If your message has any substance at all, you will be their choice, no doubt about it. Just sitting idly by, complaining about everything and doing nothing about anything, will get you nowhere. But when you see an area where you can be effective and you genuinely believe in your heart that you can do all things through Christ, who strengthens you, then go for it. Don't just sit back. Attack! Whatever your hands find to do, do it with all your might and all your strength.

You will be the one who made things happen and did not just sit back and wait for something to take place. When you have achieved the office that you are seeking, do your due diligence as a good steward. For to whom much is given, much is required. You are your brother's keeper. You are your sister's keeper. You should not say, "I'm going in to office to see how much I can get out of it." Instead, say, "I am going in to office to serve the great people of my community, my city, my state, and my country."

Some people believe that if they are dissatisfied with certain conditions and policies that have been in place for some time but that seem not to be working, they just go in on their own power and, without consulting anyone, change things and destroy lives. If you are naive enough to believe, as these people do, that by performing such actions you will be successful, keep on believing it. Think about what you intend to do. Forget about yourself and be mindful of the people whom you wish to represent and the type of representation you wish to give them. Don't just seek the office for selfish, bitter reasons or to be given a discreet way to abuse others. Love does not seek its own advantage. It is always willing to give back in a positive way. Love shines brightly. In the end, if you serve the public with love you will be highly praised.

Say you were in a mess and could not help yourself. But as time passed, God sent people who could help you in our direction. Everyone who came had an agenda. You were down to your last dime, then somebody reached into their chest, pulled some money out, and handed it

to you, which lifted your spirits. Rising from where you were at that moment, your spirit being lifted and enlightened, you rose to another level. For somebody rose up to have influence on you and on your behalf. So, remember, the eyes of God are in every place, beholding both good and evil. Whatever you do, you should do it as unto the Lord, and not unto humankind. You will not always be pleased or satisfied with what someone has done or is doing. But whatever they do, be grateful for it. As someone rose up to help you, you in turn rise to help somebody else that your life may not be in vain. The truck driver who transported mail from New York to Pennsylvania rose up and came forward to testify about the fraudulent ballots that were in his possession. He said that after he had parked the truck in the parking lot, something strange happened. On his return to the truck to fetch the mail, he found that the mail was not there. He looked around but could not find it. It had disappeared.

O the depths of the wickedness of human beings; how prevalent it is and how cunning they are. The truck driver gave his testimony about all the pallets of votes he had seen being swept under the rug or shredded. But God knows who the thieves and the robbers were. God sees the fraudsters who were placed in their positions to carry out their act of thievery. God's Word must be fulfilled in humans. "The wickedness of the wicked shall slay him in that day. The wicked shall be turned into hell, everyone, and none shall escape the fire of God" (Psalms 9:17).

Donald Trump and his patriots have been relentless in their efforts to ensure election integrity in most, if not all, states. Because what happened on November 3, 2020, must not ever be allowed to happen again. We can all hope and wish for the best as we press on, believing better things will come. Just remember this: "As long as the earth remaineth, seedtime and harvest, cold and heat, summer and winter, and day and night will not cease" (Genesis 8:22). And neither will evil cease. Thieves will always find a way to steal, and cheaters will always look for ways to cheat. Then there are those who call evil good, and good evil. No matter the situation, the Word of God is available to help you and guide you concertedly in your quest to do the right thing.

Voting must be made easy. Voting must be made fair and safe, and it must be made harder for culprits to perpetrate voter fraud.

Restoration and Integrity

Thanks be to Lord Jesus Christ for His grace and mercy. He has now given us a chance and some time to get right with God. By repenting of our sins and showing remorse to Him, He will have mercy on us and abundantly pardon us. We have a safety net, that is, grace. Let us use it wisely. For God never came to destroy people's lives, but to save them. Under the law, or rather before the commandments were given to Moses, the Creator was on a death mission.

> King Abimelech had taken Sarah, Abraham's wife. For Abraham had said of Sarah, "She is my sister." So, the king of Gerar sent and took her. But the Lord came to the king in a dream while he slept in the night and said, "Behold, thou art but a dead man, for the woman which thou hast taken; for she is a man's wife."
>
> But Abimelech had not come near her: and he said, "Lord, wilt Thou slay a righteous nation? Said he not unto me, 'She is my sister.' And she, even she herself, said, 'He is my brother.' In the integrity of my heart and innocency of my hands have I done this." And God said unto him in a dream, "Yea, I know that thou didst this in the integrity of thy heart; for I also withheld thee from sinning against Me: therefore, suffered I thee not to touch her. Now therefore restore the man his wife; for he is a prophet, and he shall pray for thee, and thou shall live, and if thou restore her not, know thou that thou shall surely die, thou, and all that is thine." Therefore, Abimelech rose early in the morning, and called his

servants, and told all these things in their ears: and the men were sore afraid. Then Abimelech called Abraham, and said unto him, "What hast thou done unto us? And how have I offended thee, that thou hast brought on me and on my kingdom a great sin? Thou hast done deeds unto me that not ought to be done." And Abimelech said unto Abraham, "What sawest thou, that thou hast done this thing?"

And Abraham said, "Because I thought, surely the fear of God is not in this place; and they will slay me for my wife's sake. And yet indeed she is my sister; she is the daughter of my father, but not the daughter of my mother; and she became my wife. And it came to pass, when God caused me to wander from my father's house, that I said unto her, 'This is the kindness that thou shall show unto me; at every place whether we shall come, say ye of me, "He is my brother."'"

And Abimelech took sheep, and oxen, and menservants, and women servants, and gave them unto Abraham, and restored him Sarah his wife. And Abimelech said, "Behold, my land is before thee: dwell where it pleaseth thee." And unto Sarah he said, "Behold, I have given thy brother a thousand pieces of silver: behold, he is to thee a covering of the eyes, unto all that are with thee, and with all other." Thus she was reproved. So, Abraham prayed unto God: and God healed Abimelech, and his wife, and his maidservants; and they bore children for the Lord had fast closed up all the wombs of the house of Abimelech, because of Sarah, Abraham's wife. (Genesis 20:1–18)

Integrity is the quality of being honest and having strong moral principles. Integrity is the condition of being unified or sound in

construction—the condition or state of being whole and undivided. Why did so many people, trying hard, put forth all that effort to prevent an election audit? They did not want anyone looking into the machines or any other equipment that should be easily accessible when someone requests to inspect it. Some Republicans are very dishonest and have no integrity or morals. They have sided with the Democrats as peas in a pod. They say, "Hear no evil, see no evil, and speak no evil." If there is nothing to hide, then it should be quite easy to be transparent, because you are an honest person. Because you are not honest; you have no integrity at all.

Most people do not fear God, so they keep going their merry way, cheating and scamming people, believing no one sees them. They are sadly mistaken. God revealed to King Abimelech that he had taken a prophet's wife. If he did not restore her, the result would be death. So, the king did the right thing, namely, restored the man his wife. When you do the right things, you get the right results all the time. Joe Biden orchestrated the theft of the election, along with his coconspirators, to secure for himself the win. He is holding on to the win and expects all things to be peaches and cream. But if he is to have success, he must return that which he has stolen to the rightful owner. Only then will he be free and be vindicated, and the prayers made on his behalf will be answered. "Let him know, that he which converteth the sinner from the error of his way shall save a soul from death and shall hide a multitude of sins" (James 5:20). Joe Biden lied about having been arrested marching for civil rights, but in reality he did not participate in any of the marches. How can you believe any of the things this man has spoken when his words are like running water? And running water is not easily stopped, unless you make a ferocious and concerted effort to stop it. Biden is still going. No one has stopped him.

As a Man Thinketh in His Heart, So Is He

Larry Elder, a black conservative, rose up and mounted a challenge when he ran against California governor Gavin Newsom, a progressive

Democrat. Elder came up short, but he lives to try another day. He was mocked as the "black face of white supremacy." When you rise up to make a challenge, you must not be of a doubtful mind. A person who is diligent in his or her heart, though he or she may fall short, if he or she keeps on working hard, he or she will eventually prevail.

There have been many battles fought here on this earth. All of those who have accepted the challenge don't always win. If you arise to a challenge just to show how tough you are, but simultaneously you don't think you will come out the victor, then you will never win. So, if you did not have your ducks lined up, or your troops mounted, ready for the challenge, you will find yourself on the losing end. But if your rising to the challenge has not brought about what you would like, hear the word of the wise. A diligent thought tends to plenteousness. With confidence, a wise person scales the city fence of his or her mighty challenger and casts that challenger down. But if a person is slothful in his or her desire, his or her dreams will be killed, and eventually he or she will give up.

I will not stop trying. I will not bend over for you to ride on my back and keep on riding me as it was back in the Old South, when whites were the oppressors and black people were their victims. Your opponents will not be able to ride on your back all the way to their victory parties unless you bend over and offer them a place to sit. You have the power to rise up and stand firm, refusing to be smeared by either black people or white people, or people of some other color. Tell yourself, *I have truly come a long way with the help of the almighty God. I know a long way is a long way, but it will not be as it was in the 1950s and early 1960s. I am determined to see this through, and I will.*

Your mouth speaks that which comes from your heart. So, while you rise to challenge, seeking the nation's top political office, and you are called a racist, a white supremacist, a nigga or nigger, or some other racial slur, unless you have confessed to someone that you are deserving of any of those appellations, or have demonstrated by your actions that you are deserving of them, then hold you head up high and be true to yourself. The people who says such things speak volumes about themselves, for what they label you as is exactly what they are. Unless you have concrete

proof of what was said, let it go. Continuing to hold on to these things does nothing but cause hurt feelings and, possibly, death. Refusing to allow God to renew your mind, you would rather die in your foolish state. Jesus said, "O generation of vipers, how can ye, being evil, speak good things? For out of the abundance of the heart the mouth speaketh. A good man out of the good treasure of the heart bringeth forth good things: and an evil man out of the evil treasure bringeth forth evil things. But I say unto you that for every idle word that men speak, they shall give account in the day of judgment. For by thy words, thou shall be justified, and by thy words thou shall be condemned" (Matthew 12:34–37 KJV).

CHAPTER 15

SLAMMING

Returning to the topic of the rising up of Donald Trump in the 2016 election contest, I remind you that slamming did take place. An insult-swapping attack between Hillary Clinton and Trump erupted. After all the name-calling and the insults were over, Mrs. Clinton received a shellacking in the election. She had shattered the glass ceiling to no avail. That concerted effort that she so aggressively pushed had so much stigma attached to it. The Russian conspiracy truly was a conspiracy. For Mrs. Clinton to have conjured up such evil in her heart, she had to be in a place of pure desperation. Then suddenly she found herself stuck in the hoax, at the point of no return. So, what next step did she take? To make herself look good, she started painting a picture of a person who would do anything to shatter the ceiling.

So much money was spent and lost, so much time was consumed, and Mrs. Clinton even fainted during the contest. The Lord God, being merciful, is unwilling that any should perish, but all should come to

repentance. God takes no pleasure in the death of the wicked. So, God spared Mrs. Clinton's life and allowed her to live a little longer to see if she would turn from her wicked ways; then He would heal her and save her. There is still a chance while the breath is in her body, but after death, she will be subjected to the judgment. There is no contest in the war of death. When Death shows up, you must go, with no one able to stop you. That is the way it will be for all who have sought or are seeking office in the hopes of gaining worldly possessions, not seeking after the kingdom of God and Christ and His righteousness. Hillary Clinton will reap what she has sown. There is no doubt about it.

Since Trump defeated her in the election, which she was not expecting because of what she had planned, she built up hatred for the man, and now everyone seems to be afraid of him. The Democrats never thought for a moment that Trump would pull it off. His having won the presidency has changed the paradigm of the Republican Party and politics in this country. He and his true patriots have set out on a path and unilaterally called out the media for their hypocrisy. All the Republicans and Democrats, and all other groups, who were hiding in the DC swamp were called out. Trump was on a demolition course, holding no punches, throwing lefts and rights as he went along.

They Became Hostile toward Trump

As Donald Trump kept up his onslaught against the biased media and the RINOs in his party, they became more hostile and pathetic. Both parties, with cheaters within their ranks, were bent on doing everything in their power to prevent Donald Trump from gaining a second term. As they turned up their vicious attack against him, the authorities withheld pertinent information on Joe Biden and his son Hunter Biden. Now we have heard and seen some of the enablers who are still trying their best to show the world how bad Trump is for the United States and its people. Every second word that issued from their lips spoke of the Big Lie. "We have to do everything we can to prevent this man from

winning the 2024 election," they mutter now. God uses whomever He wants to use, so that He can save that person to the utmost, or else allow the individual to destroy himself or herself. My God is not a slouch; He is the only, wise God. You can be a fool if you choose not to believe in your Creator. It is He and not you who has made you. You are a sheep in His pasture. He made you for His glory, you fool. He has the right to do whatever pleases Him. While God is using Trump, He has placed His Words in strategical places for him to hear; if he is willing to listen, God will heal him and save his dying soul, which is on the way to hell unless he repents.

As for Joe Biden, his enablers have painted a picture of him as a god. He is a god?! The only true God, Jesus Christ the Lord, called these rulers gods. "I have said, 'Ye are gods,' and all of you are the children of the Most High. But ye shall die like men and fall like one of the princes" (Psalms 82:6–7). Everyone has a chance to repent and escape the dungeon and the unquenchable fire of hell. People have said Joe Biden is an incredibly good man. They say, head-to-head, that Biden is leading Trump in the polls for the 2024 contest. But they are unaware of the fact that people are tired of Biden's lies. They are tired of the cancel culture he embraces. People are tired of the bullying. Because of the actions of this regime, people are turned off by the Democrats and are turning to the Republicans. The more hostility the Democrats show toward Trump, the more people jump on the Trump train.

Hostile though the Democrats may be toward Donald Trump, he is not in the White House. But he has not given up the fight. He is in that go-get-'em kind of mood. Get up, do not give up the fight. Trump and the Republicans will see a red wave of victory in the upcoming midterm elections. Even with all the efforts the Democrats have made to sink the Trump train, he is still on the move. Trump, with his versatility, will come storming back to the White House in class. The Lord decides who sits in the White House. The people will decide who sits in the White House. Someone with a purpose and a desire to move in the direction they know is best, someone with a clear conscience and strong principles, will win the White House and embark on the intended path.

The people will be turning out in droves for Trump in the next election. We will not tolerate those behind the curtain trying to sneak in as many fraudulent votes as they can, including false votes cast under the same names—even the names of dead people. But real citizens, real patriots, real people who are motivated with one goal in mind: voting for the candidate of their choosing, the man with a plan. The people are angry and sad about what they genuinely believed took place in the 2020 election.

Pledge from Trump to Make America Great Again

"The time for empty talk is over. Now arrives the hour of action. Do not allow anyone to tell you it cannot be done. We will make America wealthy again. We will make America strong again. We will make America safe again. And we will make America great again." These are the resounding words of Donald Trump delivered at rally after rally to his patriotic followers and even his haters. It seems his true patriots are a people with one goal in mind. For their purpose to be achieved, you must not stay at home on voting day and thereby allow the actors and communists to destroy the country you love and live in. "All this I have seen and apply my heart unto every work that is done under the sun. There is a time wherein one man rules over another to his own hurt" (Ecclesiastes 8:9). The Democrats do not rule in fear of the almighty God but for their own gain and so that they will be written about in history books. They will all die without repenting of their sins and being baptized in the name of Jesus Christ, by immersion in water, to receive the Holy Ghost power. All of what they have done will be as though it never happened.

The wars you have fought and won, defeating your enemies and your foes, means nothing to God. You did wonderful things such as feeding the poor and helping to build up other countries, but that means nothing to God. Your name means nothing to God. Your family origin means nothing to Him. The wealth you have amassed means nothing to him.

It is because of Him, who gave you the strength in the first place, that you were able to pile up riches in your chest. But in the end, when you die, you will not take a penny with you. Then to whom will those things belong when you are gone? Did you obey the voice of the almighty God, who specifically gave you direction? "Jesus's mother saith unto the servants, 'Whatsoever He saith unto you, do it'" (John 2:5 KJV).

The next generation of young people will follow in the same way unless they also repent. For my God allows no respecter of persons to dwell with Him. What Jesus says to one, He says to all: "Repent, for the kingdom of heaven is at hand" (Matthew 4:17). "He that believeth and is baptized shall be saved" (Mark 16:16 KJV). "He that believeth on Him is not condemned: but he that believeth not is condemned already, because he hast not believed in the name of the only begotten Son of God" (John 3:18 KJV). In the body of Jesus was the Spirit of Christ, God Almighty. Jesus was born. But God is from everlasting to everlasting.

What makes Jesus God? He did not preach only of repentance: "But we see Jesus who was made a little lower than the angels for the suffering of death, crowned with glory and honor; that He by the grace of God should taste death for every man" (Hebrews 2:9). "And we know that the Son of God is come and has given us an understanding, that we may know him that is true; and we are in Him that is true, even His Son Jesus Christ. This is the true God, and eternal life" (1 John 5:20).

Pledged by the Lord to Make the United States a Great Nation

"Now the Lord had said unto Abram, 'Get thee out of thy country, and from thy kindred, and from thy father's house, unto a land I will shew thee. And I will make of thee a great nation; and I will bless thee and make thy name great; and thou shall be a blessing'" (Genesis 12:1–2).

> And the Lord said unto him, "I am the Lord that brought thee out of Ur of the Chaldees, to give thee

this land to inherit it." And he said, "Lord God, whereby shall I know that I shall inherit it?" And then He said unto him, "Take Me an heifer of three years and a she-goat of three years old, and a ram of three years old, and a turtledove, and a young pigeon." And he took unto Him all these, and divided them, in the midst, and laid each piece one against another: but the birds he divided them not. And when the fowls came down upon the carcasses, Abram drove them away. And when the sun was going down, a deep sleep fell upon Abram; and, lo, and horror of great darkness fell upon him. And He said unto Abram, "Know of a surety that thy seed shall be a stranger in a land that is not theirs and shall serve them; and they shall afflict them four hundred years and also that nation whom they shall serve, will I judge: and afterward, they shall come out with great substance. And thou shall go to thy fathers in peace; thou shall be buried in good old age. But in the fourth generation they shall come hither again, for the iniquity of the Amorites is not yet full." And it came to pass that, when the sun went down and it was dark, behold, a smoking furnace, and a burning lamp that pass between those pieces. In the same day the Lord made a covenant with Abram, saying, "Unto thy seed have I given this land, from the river of Egypt unto the great river, the river Euphrates: The Kenites, and the Kenizzites, and the Kadmonites, and the Hittites, and the Perizzites, and the Rephaims, and the Amorites, and the Canaanites, and the Girgashites, and the Jebushites." (Genesis 15:7–21)

Abram did exactly as God told him to do so that he could receive his blessing.

"Therefore, thou shall keep the commandments of Lord thy God, to walk in His ways, and to fear Him. For the Lord thy God bringeth thee into a good land, a land of brooks of water, of fountains and depths that spring out of valleys and hills; a land of wheat, and barley, and vines and fig trees, and pomegranates; a land of oil olive, and honey; a land wherein thou shall eat bread without scarceness, thou shall not lack anything in it; a land whose stones are iron, and out of whose hill thou shall dig brass. When thou hast eaten and art full, then thou shall bless the Lord thy God for the good land He hath given thee.

"Beware that thou forget not the Lord thy God, in keeping His commandments, and His judgments, and His statutes, which I command thee this day. Lest when thou hast eaten and art full, and hast built goodly houses, and dwell therein, and when thy herds and thy flocks multiply, and thy silver and thy gold is multiplied, and all that thou hast is multiplied, then thine heart be lifted up, and thou forget the Lord thy God, which brought thee forth out of the land of Egypt, from the house of bondage; who led thee through that great and terrible wilderness, wherein were fiery serpents, and scorpions and drought, where there was no water; who brought thee forth water out of the rock of flint ; who fed thee in the wilderness with manner, which thy fathers knew not, that He may humble thee, and that He might prove thee, to do thee good at the latter end.

"And thou shall say in thy heart, 'My power and the might of mine hand has gotten me this wealth.' But thou shall remember the Lord thy God: for it is He that giveth thee power to get wealth that He may establish

His covenant which He sware unto thy fathers, as it is this day. And it shall be, if thou do at all forget the Lord thy God, and walk after other gods, and serve them, and worship them, I testify against you this day that ye shall surely perish. As the nations which the Lord destroyeth before your face, so shall ye perish; because ye would not be obedient unto the voice of the Lord your God." (Deuteronomy 8:6–20)

Understand therefore this day, that the Lord thy God is He which goeth over before thee; as a consuming fire He shall destroy them, and He shall bring them down before thy face: so, shalt thou drive them out, and destroy them quickly, as the Lord hath said unto thee. Speak not thou in thine heart, after that the Lord thy God hath cast them out from before thee, saying, "For my righteousness the Lord hath brought me in to possess the land": but for the wickedness of these nations the Lord doth drive them out from before thee. Not for thy righteousness, or for thy uprightness of thine heart, dost thou go to possess their land: but for the wickedness of these nations the Lord thy God doth drive them out from before thee, and that He may perform the word which He sware unto thy fathers, Abraham, Isaac, and Jacob. Understand therefore, that the Lord thy God giveth thee not this good land to possess it for thy righteousness; for thou art a stiff-necked people. (Deuteronomy 9:3–6)

My God's promises far outshine any promises that any human being has made, some of the latter of which are not kept. But God is not like humankind that He should lie, therefore, all the promises He made, He will fulfill them. My God will never leave you hanging, wondering what the outcome will be. If you will just be obedient to God's Word, He will

stand up for you as a mighty warrior. A warrior is who He is. I am what my Father made me to be: a chosen generation, a holy nation, a peculiar person, a prayer warrior, and a praise warrior. When you know who has chosen you to be great, just be obedient to Him and bless His name. You do not have to flaunt your greatness. Be humble! For "greater is He that is in you, than he that is in the world" (1 John 4:4). Let the God of heaven, Jesus Christ, have His way in your life today.

> Harken unto Me, my people; and give ear unto Me, O My nation. For a law shall proceed from Me. I will make My judgment to rest for a light of the people. My righteousness is near; My salvation is gone forth; Mine arm shall judge the people; the isles shall wait upon Me; on My arm shall they trust. Lift up your eyes to the heavens and look upon the earth beneath. The heaven shall vanish away like smoke; the earth shall wax old like a garment; and they that dwell therein shall die in like manner. But My salvation shall be forever, and My righteousness shall not be abolished. (Isaiah 51:4–6)

Because Abraham obeyed God, He made him a great nation. "For he looked for a city which hath foundations, whose builder and maker is God" (Hebrews 11:10). "By faith he sojourned in the land of promise, as in a strange country, dwelling in tabernacles with Isaac, and Jacob, the heirs with him of the same promise" (Hebrews 11:8). Abraham and his people embraced the promises of God and confessed they were strangers and pilgrims on the earth. They were seeking a better country, that is, a heavenly one, one that God has prepared for them. They were not afraid to call upon the God in Christ. "But ye are a chosen generation, a royal priesthood, a holy nation, a peculiar people; that ye should show forth the praises of Him who hath called you out of darkness into His marvelous light. Which in times past were not a people but are now the people of God: which had not obtained mercy, but now have obtained mercy" (1 Peter 2:9–10).

God Made Known His Mystery to Us

> In whom we have obtained an inheritance, being predestinated according to the purpose of God who works all things after the counsel of His own will. ... Which He wrought in Jesus Christ, when He raised Him up from the dead, and set Him at His own right hand in the heavenly places, far above all principality, and power, and might, and dominion, and every name that is named.
>
> —Ephesians 1:11, 20–21

People from all walks of life are doing everything they possibly can to get into this great country the United States, whose people have many flaws and lusts and are inventors of many evils. Immigration is tight; the rules are strict. To get here legally, an immigrant needs time to be processed, ensuring that once allowed into the country, he or she will not be dependent on the government. Joe Biden has an agenda. He opened the border for people to pour in. Some of these people are secretly flown to different states at the government's expense. They are also placed in communities at the government's expense. Biden is doing this to gain the advantage, hoping that all these people, having received these benefits, will become citizens and then vote for his party. With God, such is not the case. God manifested Himself in the body and flesh of Jesus the Christ, the Anointed One. He did everything for us in order to make us great. He has prepared for us a city, a place with many mansions. He has told this to us in John 14:1.

These are the requirements to get to heaven: you must repent of your sins, and you must be baptized, submerged in water, in the name of Jesus Christ, for your sins to be removed—washed away—and to be given the power of the Holy Ghost, with the evidence of speaking in other tongues as the Spirit gives you utterance. Just as Jesus was raised

up from the dead by the glory of the Father (power), you must rise up to walk in the newness of life.

You must pray and wait to receive the Holy Ghost, who comes with the evidence of speaking in other tongues. And strive daily to live a holy life, for you know not when the Son of man shall appear to call you home. It may be morning; it may be noon; it may be evening or midnight, but He is coming soon. "This same Jesus, which is taken up from you into heaven, shall so come in like manner as you have seen Him go into heaven" (Acts 1:11). You should not bend over so that the devil may ride you. You should not break; let God break you in. You should not turn away from following God. You should not give in to the devices of the enemy. You should not give up, for if you do, you will have given up your birthright. You should surrender to no one but Jesus Christ.

We are on the Master's winning team. We will not bow to adopt any conspiracy theories or cancel culture. In God we put our trust, and we will not be afraid of what humankind will do unto us. For a person has in his or her nostrils the breath of life, and he or she shall die like beast. But we have a hope in Jesus Christ, our Father in heaven. If we do His will, we will rise up again just as the Lord Jesus has shown us. Rising from the grave, He triumphed over His foes with power.

ALL NATIONS BEFORE GOD ARE AS NOTHING

Behold, all nations are as a drop in the bucket and are counted as a small mote of dust. God just take up the isles of this country in His hands as very small things. All the nations of this world before Him are nothing. He counts them as less than nothing but vanity and dust driven by the wind and tossed. Very soon, this beautiful, wonderful country will be destroyed. This great sodomitic United States has got to go. God's stomach is sick with its evil deeds.

> And I will bring destress upon men, that they shall walk
> like blind men, because they have sinned against the

Lord: and their blood shall be poured out as dust, and their flesh as the dung. Neither their silver nor their gold shall be able to deliver them in the day of the Lord's wrath; but the whole land shall be devoured by the fire of His jealousy: for He shall make even a speedy riddance of all them that dwell in the land. (Zephaniah 1:17–18)

Woe to the city of oppressors, rebellious and defiled. She obeys no one, she accepts no correction. She does not trust in the Lord. She does not draw near to her God. Her officials within her are roaring lions; her rulers are evening wolves, who leave nothing for the morning. Her prophets are unprincipled; they are treacherous people. Her priests profane the sanctuary and do violence to the law. The Lord within her is righteous; He does no wrong, Morning by morning He dispenses His justice, and every new day He does not fail, yet the unrighteous knows no shame. (Zephaniah 3:1–5 NIV)

"Arise, go unto Nineveh, that great city, and preach unto it the preaching that I bid thee." So, Jonah arose, and went unto Nineveh according to the word of the Lord. Now Nineveh was an exceeding great city of three days' journey. And Jonah began to enter into the city a day's journey, and he cried, and said, "Yet forty days, and Nineveh shall be destroyed." (Jonah 3:2–4)

The only thing that can save us from catastrophe and destruction is to do as the king of Nineveh did:

When the word from God came to the king about the pending destruction, he arose from his throne, and laid his robe from him, and covered him with sackcloth and sat in ashes. And he caused it to be proclaimed and

published through Nineveh by the decree of the king and his nobles, saying, "Let neither man nor beast, herd nor flock, taste anything: let them not feed, nor drink water: But let man and beast be covered with sackcloth, and cry mightily unto God: yea, let them turn everyone from his evil way, and from the violence that is in their hands. Who can tell if God will turn and repent, and turn away from His fierce anger, that we perish not?" And God saw their works, that they turned from their evil way; and God repented of the evil, that He had said He would do unto them; and He did it not. (Jonah 3:6–10)

The one thing that will save you from destruction is to repent of your sins and be baptized in water in the name of Lord Jesus Christ; then He will fill your heart with the Holy Ghost and fire. All of you, religious Catholics, religious Baptists, religious Methodists, religious Moravians, religious Buddhists, repent and make the change. Jehovah's Witnesses, Southern Baptists, Latter-day Saints, Hindus, Rastafarians, Pentecostals, PAWs, and all others who have embraced one form or other of the Catholic Church's syncretism, repent now! Who can tell if God will turn and forgive you of your sins, which religious fraudsters have inadvertently led you to commit? Rise, make your way out of false-food restaurants, and get on the highway of holiness, where Jesus has a table spread for you. Come and buy, without money: it's free.

Your own wickedness shall correct you, and your stubbornness shall reprove you. You will know that it is a bitter and evil thing to forsake the Lord Jesus Christ, who is God our Savior. He has given direction and has told us His exact way of doing what He has commanded. If you do not obey His Word, you will find yourself going down to hell, where your worm will die not and the fire will not be quenched. Let us all take heed of our ways.

CHAPTER 16
THE ENEMY'S PLAN TO ATTACK

When President Trump realized what had taken place on November 3, 2020, he and some of his true patriots set out to see if the wrong could be made right. As Trump tried to reverse the steal, seeking the help of the courts, he realized there was a lot of wrath out there. People were filled with indignation and mocked him and his followers. Joe Biden and his followers called Trump and his patriots names. They kept saying, "What will Trump and his followers do? Will Trump barricade himself in the White House? Will he call in the military to protect him and keep him in power? Will he put up barricades around the White House?" They said he was a loser and should suck up the loss and just get out of the White House and go somewhere, anywhere, else.

Mr. Trump never sought the help of the Lord; but he sought the help of the judges. They told him he had no standing. Some of Trump's patriots and loyal supporters started holding "Stop the Steal" meetings

and rallies. Finally, January 6 arrived. Trump's loyalists and patriots gathered at the Mall and held prayer sessions. They were not aware that in their midst were infiltrators.

Do not wait until the doors are closed to seek God. When you realize your opponent's motive, you should immediately call on God, for only He has the answers to all your problems. In fact, you should always be calling on the Lord God. You should not wait until you have a problem to vocalize your feelings and your hurt to Him.

In their prayers, the people on the Mall in DC on January 6, 2021, asked God to intervene because they were despised. They asked Him to put an end to the taunting and to turn back the steal. They prayed and asked God not to cover the deeds of the culprits and to let the things they were hiding be exposed. The speakers spoke eloquently that day. They all had their minds ready to work, hoping for an outcome and a quick resolution. Then Trump spoke later that day and said, "The people will march peacefully to the Capitol steps." At the end of his speech, while the people were moving in an orderly manner, suddenly there was a mad dash to the People's House. Officers who were there freely let some of the people go into the building.

The infiltrators started using brute force to break windows, climb up on top of the building, turn over barricades, and perform sacrilegious acts. In that melee, only one person got killed, Ashli Babbitt, a Trump supporter from Texas. Yes, some of his supporters participated in the action. "Monkey see, monkey do" and "The blind leading the blind." Six hundred Trump supporters have fallen into the ditches (i.e., they are in jail) and need someone to lend a helping hand to pull them out of the mire. But the Black Lives Matter participants and the Democratic supporters faced no jail time.

Speaking of what took place then, the Democrats said, "It's Donald Trump's fault"—which they believe to this day. They have not given up their fierce attack on him. In nature, when bears, wild dogs, hyenas, lions, leopards, and tigers taste the blood of prey, they will not give up. They put forth their best effort to secure their kill and eat their fill. Only another who is vicious and able to inflict injury would dare to challenge

a wild beast. The Democrats have blocked Trump from platforms with many millions of his followers to keep him at bay because of the stance he took when questioning the legitimacy of the election results. This they did hoping that Trump's followers would desert him. They were sadly disappointed! Mr. Trump has found a way to gather his scattered followers and regroup. We are talking about his real patriots and supporters who are determined to stand up and do not give up the fight. For where there is a will, there is a way. As Mr. Trump put it, "We will make America great again." While his opponents are seeking blood, Trump has discreetly slipped away and is still hunting. He slipped away because God put a mark upon him and is protecting him.

A Great Cry: "We Love You!"

One side keeps crying, "Loser, loser, loser. Racist! We will make your life a living hell." The other side, consisting of men and their wives, brothers, sisters, daughters, sons, and other kinsfolk, and people of different sexual orientation, raised a great outcry against them, returning the chant. The patriots, and even thousands of Democrats, are now crying because of the direction the administration has taken, with too many things that catch the eyes and are not pleasant to look at. They are offering a lot to chew on and swallow, but the taste is yucky.

Because of the bad taste left in the mouth after the judges dished out the verdict of no standing, Trump supporters have been crying loudly because the outcome is not what they would have preferred. But these same people, although they are sad, keep saying to their leader, "We love you. We love you. We love you." President Trump has returned the favor, saying, "I love you too." Trump now knows that the feeling of love is in the air. He can feel it in the atmosphere as they cry over and over, repeatedly. Let us remember, when people have one goal, one mind, whatever it is, if they put their hands and minds to it, they will succeed because of their perseverance. Until the Mighty One steps in and makes an about-face, we will always see the same results.

All the shouts and the cries from the people, saying, "We love you," plus Trump's strong willpower, will cause Donald Trump to rise to the challenge and continue his quest: "We will make America great again, again." So, get up on your feet. I hope you can see that Donald Trump is ready and waiting; he will not surrender. With your eyes wide open, you will see that he is ready and waiting on a threepeat. On Veterans Day, he paid tribute to those incredible people who served so well in the powerful United States Armed Forces. He told them he could empathize with their feelings when watching what they watch. He told them the country is going through lots of problems, but the country will be back. So, unless God stops Trump, you will see Trump rising again and come storming back to the White House.

Rising Up and Looking Ahead

Speaker of the House Nancy Pelosi took over the January 6 committee and placed Liz Cheney, a disgruntled Republican, on it. Since the inception of the committee, Mrs. Pelosi and the committee members have been hunting for information and spear-fishing in an effort to catch Trump and all those who are associated with him at any cost. Even the totally blind can see what the committee is all about.

On January 6, members of Black Lives Matter (BLM) were at the rally in Washington, DC. More than a hundred well-known Democratic supporters were also at the rally, embedded in the crowd. They made threats while using expletives, saying they were going to drag Trump out of the White House. Yet, for all that was said, the authorities have not arrested one member of Black Lives Matter, or anyone else, for anything. Only those who are known to be associated with Trump have been arrested. One company paid money to these BLM members to disrupt the proceedings held by Trump.

The FBI was caught red-handed in its involvement in the intended coup of the Michigan governorship, which has links to the event on January 6. In questioning, Senator Ted Cruz of Texas drilled Christopher

Wray, the director of the FBI, who found it awfully hard to answer Cruz's questions. If the Democrats have nothing to hide, then why won't Mrs. Pelosi make public all the information that the public is legally entitled to see? These illustrious politicians and high-ranking officials don't seem to understand that a sword cuts more than one way. With all the mudslinging and the calling of Trump officials to testify before the committee, the setup will produce nothing of significance, only the harassment and prosecution of people who support Trump.

The events of January 6 have been called a threat to democracy. The rush on the Capitol has been called a threat to democracy. Donald Trump, at the end of his speech saying to the people, "You will be marching peacefully to Capitol," is a threat to democracy. Before the man was finished speaking, trouble was already brewing at the Capitol steps. Trump's opponents will not be honest and show all the evidence that is available, for it will only serve to make them look very foolish and stupid. If they really want to impress the US public, then they should call all the participants, all the police officers, and anyone else who had anything to do with that day to testify. We will never see that happen in this lifetime.

Questions were raised about the January 6 investigation committee. Nancy Pelosi said, "I have nothing to do with the committee. They are doing what they have to do." She has everything to do with the committee. The Democrats are all liars. They are not seeking for the truth; they are seeking to find as much dirt and trash as they can to throw at Trump and get him out of the way. That has been their goal with all the investigations, the impeachments, and the Russian hoax, but their efforts have been to no avail. Anyone who is searching will always find something in their search. What will that be? Whatever it is that these people, rising up desperately, are trying to find, they just may add something as a pretense instead of finding the real thing. And most of the time, this is what really ends up happening. May the Lord God help us to the utmost.

Sarah Sanders Rising Up

Sarah Sanders, a true patriot for Donald Trump and the Republican Party, is now the governor of Arkansas. Sanders, who was the White House press secretary for President Trump, put herself in the driver's seat for that position. Rising up as a true ardent supporter of Trump, she served him well. She now has his backing and support. She has set Arkansas on fire politically speaking. She is so hot that she burned out the public's confidence in and enthusiasm for State Attorney General Leslie Rutledge for the GOP nomination. Although Rutledge was badly burned by Sarah, after dropping out of the race, she still threw her support behind her. Rising up from the White House, Mrs. Sanders had her eyes set on this governorship, unwilling to just sit back and watch. As soon as she entered into the race, with fire burning, Tim Griffin, lieutenant governor of Arkansas, got out of the race. What is remarkable is the rapidity with which Mrs. Sanders's flame rose and came to dominate.

Sarah Sanders is from Arkansas and is a unique candidate for governor. She is the face of Trump's administration, on the move and hard to stop; is a testament of the strength within the GOP; and is Trump's brand of candidate. She is the daughter of Michael D. Huckabee, a US politician, a Baptist minister, a commentator on politics, and a bassist, who served as the forty-fourth governor of Arkansas from 1996 to 2007. He's a true patriot. Sarah Sanders is following in her father's footsteps while riding the Trump train. Arkansas is hers for the taking.

Those of you in Arkansas who love Sarah, get on board and join her and Trump. In politics today, Trump is more important now than he ever was. He has amassed a treasure trove of cash and will do so again with the help and support of the people. Don't you ever count Trump out, not even for a moment. He is coming back, not forever, but for a while. Watch and you will see! Trump has been busy endorsing his America First candidates, who stand for election integrity and who, he hopes, will make an impact on the upcoming midterm elections. The prospects are outstanding, and things are looking exceptionally good for the Republicans.

"Seek ye out of the book of the Lord and read: not one of these shall fail" (Isaiah 34:16 KJV).

Hear me, all you great leaders of the people. Listen with your ears, all you holders of power. Woe to the president who rises to persecute his or her political rivals. Woe to the nation that rises against God's people! The Lord, Almighty God, will take vengeance on them in the day of His judgment. For their punishment, He will put fire and worms in their flesh; and they will feel this fire and these worms and will weep forever. Just because God gave them power does not mean that they are honest, pure, and trustworthy. For a person will be considerate if he or she accepts godly counsel. But a man or woman who finds an excuse to do things according to his or her own will is a sinful creature and will not be reproved.

You, Mr. Biden, said you were working for the good of the country, and good polices were set in place. The border wall was steadily being built, then suddenly almost everything came to a complete stop. My question is: when one builds something and you pull down all that was built, what does it profit you, except the labor that was used? A person who is void of understanding has false hope. A wise person will instruct the people to do the right things. And how could you consult will someone who suspects you? Such a one has an evil eye. Who will believe and trust a person who doesn't believe his or her own words? God is the Judge of us and our leaders. He will deliver whole cities, states, and the country from injury. Amid all the messy piling up, God will deliver us out of the hands of those injuring us. God is faithful toward us. In times like these, all those who fear the Lord God of heaven will see things go well for them at the last. When leaders rise to positions of power, whether the seats were fairly won or the wins were deceptive and fraudulent, those who fear the Lord shall not be afraid, for He is their hope. But sinners shall be left in their foolishness. Oh yes, a sinner has success in evil things. One thing is for sure: the knowledge of wickedness is not wisdom.

Even though God sets you up and gives you power, or if you cheated your way to get the power, my God, the intellectual who knows all

things, allows things to happen for a purpose. He sets you up, and then He says, "A froward heart shall depart from Me. I will not know a wicked person" (Psalms 101:4). The Lord is truly hoping that the people in and out of power will be able to see the error of their ways. We all were at some point in our lifetimes foolish and lacking in understanding. Nevertheless, God suffers long for us. He allows the sun to rise every morning for our benefit. I will say like King David, "O Lord our Lord, how excellent is Thy name in all the earth! Who hast set Thy glory above the heavens" (Psalms 8:1). So, you holders of power, be instructed to serve the Lord God with fear.

CHAPTER 17
A POLITICAL CATASTROPHE

Ten RINOs decided to defy Donald Trump, revolting against him, voting with the Democrats, and impeaching him. They have spoken against him as if he were the worst political figure in the history of this country. Having all turned away from their oaths of office promising to represent the people of their districts and states, they have pursued only their own causes and concerns and have forgotten the reason they were voted into office in the first place. Now, all ten of them have challengers. Two of these ten Republicans, Liz Cheney and Adam Kinzinger, were censured for their actions by their party, with a vote taken to expel them. Several hundred thousand of their constituents were interviewed and made their voices plain, saying loud and clear, "They all need to go. They are not representing our cause. We will not be voting for them in the midterm elections."

These RINOs will all face a political catastrophe, which is imminent. Just as the Democrats will face defeat for all their actions before

the 2020 election, so will all ten Republicans in Name Only. Some will hold onto their seats; some will lose their seats. Their constituents, displeased with their behavior, are standing with the man whom they say is the greatest president in the history of the United States. Donald Trump has given his endorsement and support to the challengers who will face those RINOs.

Canadian Truck Drivers Are Patriots, Too

Canadian Freedom Convoy truckers rose up against Justin Trudeau and his lockdown policies. They got into their big rig trucks, their cars, and their tractors and formed convoys, stopping on bridges and in major cities. Trudeau was very angry about their actions, so he rose up against them, calling them names unbefitting a man of his stature to say. But he refused to back down, and instead resorted to hiding in a bunker somewhere, still defiant of the truckers and opposed to their actions. The truckers, who were not against the COVID vaccine but against the lockdowns, garnered lots of attention and support from all over the world. They were addressed and endorsed by President Trump for standing up as true patriots for their cause. The truckers were very peaceful in their actions, even though the riot police were given their orders to be very aggressive against them. The truckers did not resort to violence. They remained calm, for violence defeats one's purpose. "Without counsel, purposes are disappointed; but in the multitude of counsellors, they are established" (Proverbs 15:22).

Black Voters Are Leaving Joe Biden

Black voters are rising up and walking away from Joe Biden and the Democrats in droves, and it's hard to see under what conditions they would return. Right now, millions of Democrats do not even want Joe Biden to run in 2024. In one recent poll, Biden's approval rating was at

34 percent. What should be alarming for the Democrats is the sudden erosion of support among black voters, who are increasingly feeling let down and left out. They are rising up and walking off the plantations of Democratic ideology and indoctrination. Pay close attention, there will be a shellacking of the Democrats in the upcoming fall elections in less than a year from now. A few losers will gracefully walk away to continue the activities that had propelled them to push for the top spot in the first place. Rising to the top guarantees a set salary, health coverage, and the ability to create laws for policy making. These individuals will be able to champion programs, legislate, and vote. When you have given power to seekers of power who do not have your best interests at heart, it is not easy to get that power back. You must wait, and then take out those politicians by voting.

THE DURHAM REPORT

John Durham, who was investigating the Russian hoax, released bombshell information. Hillary Clinton and her enablers were the masterminds behind the Russia probe. Durham's filing is astonishing. It shows what Trump had been saying all along, namely, that his campaign was being spied on. He was correct. They infiltrated Trump's servers to link him to Russia. Trump was on *60 Minutes* with Lesley Stahl. During their dialogue, Ms. Stahl, on several occasions, interrupted Trump when he said that his campaign was spied on by the Democrats. She told him that what he was talking about could not be proven. Trump told her it could not be proven because the Democrats were covering for Biden. As I have said before, so say I again: Trump is a political prophet.

Trump was correct in this assertion. Still, with all the Democrats have tried to dump on him, so far it has been to no avail. Trump is still relevant; he is still standing. He was spied on during the campaign and during his time in office. And for all the Democrats' failed efforts to flush him out of the White House, he still finished his term. He won on November 3, 2020, and had the victory stolen from him. All

the wrongdoers in this situation need to be prosecuted. Will that ever happen? Justice has been tainted. One-sided justice is no justice at all.

But Trump is on a mission, carrying on with endorsing candidates and engaging in all the other activities for the fall election. Those in whom he believes will come out on top as winners, which does not mean he has put the right people in place in each case. These legislators will be paving the way for his America First movement, making the United States great again and wealthy again, according to him. Very soon Trump will be announcing that he will be running for president in 2024. He will be the forty-seventh president of the United States; there's no doubt about it. Just watch! Trump will be running, winning, and rising to the top to come storming back to the White House in Washington, DC.

It must be frustrating to all those who have wasted millions of dollars, along with much effort and time, to see that this bigot, as they have called Trump, is still holding firm. When God puts His mark on a person, others can try to pull that person down until they turn blue in the face, but their trying will produce no result. They can mount up as high as an eagle and descend rapidly to catch Trump by surprise. But because God's mark is on him, their eagle's descent will be in vain. All their moonwalking like Michael Jackson, and doing the slide like James Brown did, will profit them little or nothing meaningful at all.

For God is the righteous Judge between Trump and his Republican cronies and all the Democrats who sling mud at him. If God had turned him over and delivered him into the hands of the hoax seekers, it would have been "Good night, Irene." They would have locked him in a box and thrown away the key long, long ago. But it ain't over until God say it is over. It ain't over until God says it is the end. Falling on my knees, I prayed for Trump, his family, and all those in authority (positions of power).

Rising from my knees, I said the very same prayer for all people repeatedly, asking the Lord God to have mercy on all the hypocrites and will make the United States great again. "Because greater is He that is in you than he that is in the world" (1 John 4:4). But the United States

is filled with the lust of the eye, the lust of the flesh, gay pride, nonbinary people, robbers and thieves, and murderers and killers, seemingly all you see today in this great sin-filled country. According to the laws of United States and each authority or jurisdiction, when a person has been accused of breaking a law, a formal accusation or complaint is filed. The person is brought before a judge or is commanded to appear before a judge. On the papers presented to the person are numbers listed along with indictments and charges. These self-righteous, arrogant hypocrites itemize every little detail about the person, ensuring they have all their bases covered to try to nail the individual, even though many times the accusations are false. But they make things up to impress the judge, and then that judge goes along with his or her state's law recommendations (or, if it is a federal case, he or she goes along with the guidelines set by Congress.

The Lord God has His eyes on the United States, a country on the decline. The Lord looks out into the deep heart filled with whores and their crafty devices. For the Lord knows all that may be known. He knows the signs of the world. People of the United States, you had better rise. Lift up your heads, for the time of your redemption draws near.

The Books of God Are Written Indictments

All the nations are under the indictment of our great God of heaven and earth, Jesus Christ. We are all sentenced to death. We are dead in our trespasses and sins as we have walked according to the course set by this world. The courses that the United States and the world at large are teaching is what they have adapted to according to their ignorance and knowledge, and the spirit of death that now works in them because of their disobedience. The Lord God has given His unrighteous wicked servant the devil, who is a thief, authority, saying, "The thief cometh not, but to steal, and to kill, and to destroy you. I am come that they might have life, and that they may have it more abundantly" (John 10:10).

You are already dead under the indictments and the sentence that

you have received, that is, spiritual death. Soon, you will die the second death, dust returning to dust. And in hell you will lift up your eyes, "where their worm dieth not, and the fire is not quenched" (Mark 9:48). "And as it is appointed unto men once to die, but after this the judgment" (Hebrews 9:27).

Rise Up, United States of America, You Great Sin-Filled Nation, and Repent

In the days of Moses, when he was leading the children of Israel from Egypt, a great, sinful, demon-possessed, idol-worshipping nation, to the land of Canaan, on his way the Lord spoke to him, saying, "Speak thou to the children of Israel, saying, 'Verily, My sabbaths ye shall keep; for it's a sign between Me and you throughout your generations; that ye may know that I am the Lord that doth sanctify you'" (Exodus 31:13). While Moses was having fellowship with the Lord, the people committed a great sin. "And when Joshua heard the noise of the people as they shouted, he said unto Moses, 'There is a noise of war in the camp. It is not the voice of them that shout for mastery, neither is it the voice of them that cry for being overcome but the noise of them that sing I hear'" (Exodus 32:17–18).

Hear, arise, all you people of the United States and its territories. Repent of your sins; turn and fear the Lord God, and truly exercise justice and judgment. For the sins of the people of the United States are great and many. How can you justify two men living together as lovers? How can you justify marrying two men? How can you justify two women living together as lovers? How can you justify marrying two women? You do these things because your bulging blind eyes are filled with sin. You have been living in darkness for far too long, and it seems all right to you. Your deeds are unfruitful. You will suffer the consequences of the almighty God for your behavior. Leave your filth and your vomit; you are wallowing in filthy juices and mud. Ask the almighty God, Jesus Christ the Lord, to open your eyes and cause you to

decide not be partakers with them and supporters of them. It is a shame to speak of the things that are done by churchgoing hypocrites. You are being reproved for your evil ways, that you may know and understand that the wrath of God is upon you. How can you escape the vengeance of God's wrath?

Jesus Christ says: "Awake thou that sleepest, and arise from the dead. And Christ shall give thee light" (Ephesians 5:14 KJV). Stop acting as fools; try your best to get spiritual wisdom in order to be wise.

If you can just lie in your bed or sit in your rocking chair and do these wicked and sadistic acts of violence, killing people and committing crimes against others, then your heart is in the gall of bitterness. With your early rising from your position of comfort or your position of disgust, and with your desire for greed, power, and gain, you go on a rampage, destroying other people's hopes and dreams. For this you deserve the wrath of God the Mighty One, who gives life and takes it away. Now, if you give yourself as alms (a sacrifice) to the Lord Jesus Christ, you will be delivered from death, and all your sins shall be purged and washed away. When you have rightfully exercised your alms (yourself), you will be filled with life everlasting. They who sin and remain in their sin, refusing to stop, are enemies of their own lives. In hellfire they will lift up their eyes to see the flames.

What Really Makes a Nation Great?

What really makes a nation great is the fear of the great God of heaven, Jesus Christ the Lord. The earth, the land, the seas, the rivers, and the trees all do their magnificent work of obeying God and praising Him day and night. You want to have a great country? So do I. We are living in a great country where most of the people are filled with their own ideas about religion and are bent on doing things their own way; they really do not know right from wrong. They call the good evil. They call evil good. "Righteousness exalteth a nation, but sin is a reproach to any people" (Proverbs 14:34). Do you not know, Mr. and

Mrs. Self-Righteous, that your soul (person) that sins shall die unless you repent? Mr. President, the Lord Jesus Christ has been very good to you, showing you His mercy morning after morning, day after day, and night after night, giving you your heart's desire, yet you fail to repent. In hell you will lift up your eyes, where the devil will welcome you. Under no circumstances will the devil set you free. Turn to Jesus Christ now; He will set you free and you shall live.

You shall die in your sins unless you repent. You will end up in hell, rising up amid the vehement heat that will never be quenched. All of you wicked judges who don't know the difference between a man and a woman, creating anarchy and confusion in the land, you exact justice according to your own ability and your own wisdom. All you silly men and women of Congress, you know the difference between male and female! Take a good look at yourself in the mirror. I am now talking about you, who goes to the moneymaking fanatics and ignorant doctors who cut you up and patch you up with other body parts, just as they replace parts in cars and houses, just as they graft limbs onto trees. That sort of surgery does not change who God made you to be.

You are just a fool waiting to die, unless you repent. In hell you will lift up your eyes, "where [your] worm dieth not, and the fire is not quenched" (Mark 9:46). You have seen many taking that road time after time. The next may just be you! My God loves you the way He made you, but He hates the sins you have committed and are committing. I love what my Father, Jesus Christ the Lord, loves, and I hate what He hates. I am striving in my daily walk with God. I rose and did what the Lord told me to do to escape hellfire and torment. I want to go with Him when He returns to take back with Him those who are counted worthy. Rising up, Jesus Christ is coming back again. He will not change His Word to please me. Neither will He change His Word to please you. If you really want to make the United States great again, then repent and be a friendly son or daughter and servant of the Lord Jesus Christ.

You do everything to please humankind and everything to disobey God. Do you really believe that you will get away with your foolishness and sins? You cross-dressers, you gay fools, you lesbians, all of you are hell

bound. Repent, or in hell you will lift up your eyes, where your worm never dies and the fire is not quenched. "Cast away from you all your transgressions, whereby you have transgressed; and make you a new heart and a new spirit: for why will ye die, O house of Israel? For I have no pleasure in the death of him that dieth, saith the Lord God: wherefore turn yourselves and live" (Ezekiel 18:31–32).

The Policies of Condemnation, Damnation, and Death

I rose up to tell you about your condition in this life. You had better read this carefully; it will do you good. "But we had the sentence of death in ourselves, that we should not trust in ourselves, but in the living God. Who delivered us from so great a death, and doth deliver? In whom we trusted that He will yet deliver us" (2 Corinthians 1:9–10). "But he that believeth not is condemned already, because he hath not believed in the name of the only begotten Son of God. This is condemnation, that light is come into the world, and men love darkness rather than light, because their deeds were evil. … The Father loveth the Son and hath given all things into His hand. He that believeth on the Son hath everlasting life: and he that believeth not the Son shall not see life; but the wrath of God abideth on him" (John 3:18–19, 35–36). "Then said Jesus again unto them [the Pharisees, the Jews, and the apostles], 'I go My way, and you shall seek Me, and shall die in your sins: whither I go, ye cannot come'" (John 8:21). "I said therefore unto you, that ye shall die in your sins: for if ye believe not that I am He, ye shall die in your sins" (John 8:24). "Verily, verily, I say unto you, if a man keeps My saying, ye shall never see death" (John 8:51). "And ye shall know the truth, and the truth shall make you free" (John 8:32).

In the body of Jesus was Christ, the Anointed One, God. Therefore, if "thou believest that there is one God, thou doest well; the devils also believe and tremble" (James 3:19).

"And Thomas answered and said unto Jesus, 'My Lord and my God'" (John 20:28).

The following is your guaranteed payment of eternal condemnation, damnation, and death for your failure to believe that Jesus Christ is God, that He alone can save you from the seeds you have sown continually. If you will repent and be baptized in water in the name of Jesus Christ, being filled with the Holy Ghost, which was promised unto you, then all your sins will be washed away. Jesus's transparent blood saturated in the water will cleanse you from all your sins. If you fail to believe, then you have a death insurance policy and are destined for hellfire. Consider the following scriptures:

- "Let not sin therefore reign in your mortal body, that ye should obey in the lust thereof" (Romans 6:12).
- "But she that liveth in pleasure is dead while she liveth" (1 Timothy 5:6).
- "Know ye not, to whom ye yield yourselves servants to obey, his servants ye are to whom ye obey, whether of sin unto death, or of obedience unto righteousness?" (Romans 6:16).
- "For he that soweth to his flesh shall of the flesh reap corruption" (Galatians 6:8).
- "For the wages of sin is death" (Romans 6:23).
- "For if ye live after the flesh ye shall die" (Romans 8:13).

Ashli Babbitt, who lost her life on January 6, 2021, never knew her life would end on that day. She was not prepared to leave so soon. When death comes and calls your name, whether you are ready or not, you must leave. The rising up of the COVID pandemic, which statistics show has destroyed millions of lives around the world, came with no warning. You have the ability and the right to change your life. Get this insurance policy changed and make your life great again in Jesus before it is too late.

CHAPTER 18

YOU CAN HAVE YOUR DEATH SENTENCE OVERTURNED AND BE GRANTED ETERNAL LIFE INSTEAD

Jonah cried, and said, "Yet forty days, and Nineveh shall be overthrown." So, the people of Nineveh believed God, and proclaimed a fast, and put on sackcloth, from the greatest of them to the least of them. For word came unto the king of Nineveh, and he arose from his throne, and he laid his robe from him, and covered him with sackcloth, and sat in ashes. And he caused it to be proclaimed and published through Nineveh by the decree of the king and his nobles, saying, "Let neither man nor beast, herd nor flock, taste anything: let them not feed, nor drink water: but let man and beast be covered with sackcloth, and cry mightily unto God, yea, let them turn everyone from

his evil way, and from the violence that is in their hands. Who can tell if God will turn and repent, and turn away from His fierce anger, that we perish not? And God saw their works, that they turned from their evil way; and God repented of the evil, that He has said that He would do unto them; and He did it not.

—Jonah 3:4–10

And behold, one came and said unto him, "Good Master, what good thing shall I do, that I may have eternal life?" And He said unto him, "If thou will enter into life, keep the commandments." He saith unto Him, "Which?" Jesus said unto him, "Thou shall do no murder, thou shall not commit adultery, thou shall not steal, thou shall not bear false witness, honor thy father and thy mother: and thou shall love thy neighbor as thyself." And the young man said unto Him, "All these things have I kept from my youth up: what lack I yet?"

—Matthew 19:16–20

This young man came and asked Jesus, the Master, "What shall I do to have my sentence overturned?" Jesus told him, "If thou will be perfect, go and sell that thou hast, and give to the poor, and thou shall have treasure in heaven, and come and follow Me." When the young man heard these sayings, he went away sorrowful, for he had great possessions."

—Matthew 19:21–22

And we know that the Son of God is come, and has given us an understanding, that we may know Him

that is true; and we are in Him that is true; even in His Son Jesus Christ. This is the true God, and eternal life.

—1 John 5:20

Father, the hour is come; glorify Thy Son, that the Son may glorify Thee. As Thou hast given Him power over all flesh, that He should give eternal life to as many as Thou hast given Him. And this is life eternal, that they might know Thee the only true God, and Jesus Christ whom Thou hast sent. ... For I have given unto them the words Thou gavest Me; and they received them and have known surely that I came out from Thee, and they have believed that Thou didst sent Me.

—John 17:1–3, 8

And you hath He quickened, who were dead in trespasses and sins; wherein in time pass ye walked according to the course of this world, according to the prince of the power of the air, the spirit that now worketh in the children of disobedience. ... Among whom also we all had our conversation in times past in the lust of the flesh, fulfilling the desires of the flesh of the mind; and you were by nature the children of wrath, even as others, even when we were dead in sins.

—Ephesians 2:1–3, 5

Therefore, we are to give the more earnest heed to the things which we have heard, lest at any time you make them slip. For if the word spoken by angels were steadfast, and every transgression and disobedience received a just recompence of reward, how shall we escape, if we

neglect so great a salvation; which at the first began to be spoken by the Lord and was confirmed unto us by them that heard Him? God bearing them witness, both with sign and wonders, and with diverse miracles, and gifts of the Holy Ghost, according to His own will.

—Hebrews 2:2–4

But we see Jesus, who was made a little lower than the angels for the sufferings of death, crowned with glory and honor; that He by the grace of God should taste death for every man. ... For it became Him, for whom are all things, for both He that sanctifieth and they who are sanctified are all of one: for which cause, He is not ashamed to call them brethren.

—Hebrews 2:9, 11

Forasmuch then as the children are partakers of flesh and blood, He also Himself took part of the same; that through death He might destroy him that had the power of death, that is, the devil; and deliver them who through fear of death were all their lifetime subject to bondage.

—Hebrews 2:14–15

My New Assurance and Insurance Policy Sealed

But Christ as a Son over His own house [you], whose house are we, if we hold fast the confidence and the rejoicing of the hope firm unto the end. Take heed, brethren, lest there be in any of you an evil heart of unbelief in departing from the living God. For we are

made partakers of Christ, if we hold the beginning of our confidence steadfast unto the end.

—Hebrews 3:6, 12, 14

My formal accusation was real; my sins were many and were dragging me down. For I had once believed in the Trinity death panorama. I quickly turned away from that way of believing. But I, Julius Williams, had my sentence overturned in the year 1968. I asked God to forgive me of my sins, as I did not want to go to hell and die. He pleaded my case. Jesus immediately dropped my charges and saved me by His grace. I stepped in the water and was baptized in the name of Jesus Christ for the remission (removal) of my sins. I sought God for the promise of the Father, which, saith He, "Ye have heard of Me." Then, in the space of a week, Jesus Christ filled me with the Holy Ghost and fire, along with the ability to speak in other tongues.

> In whom ye also trusted after that ye heard the word of truth, the gospel of your salvation: in whom also after that ye believed, ye were sealed with the Holy Spirit, which is the earnest of your inheritance until the redemption of the purchased possession, unto the praise of His glory.
>
> —Ephesians 1:13–14
>
> In whom also we have obtained an inheritance, being predestinated according to the purpose of Him who worketh all things after the counsel of His own will. That we should be the praise of His glory, who first trusted in Christ.
>
> —Ephesians 1:11–12

> For he that will love life, and see good days, let him refrain his tongue from evil, and his lips from speaking no guile. Let him eschew evil, and do good; let him seek peace, and ensure it.
>
> —1 Peter 3:10–11

Thanks be to God; I know who Jesus is. He is residing in my body. I have the Father and the Son living in me—not two persons, nor two Spirits, nor three Spirits, but the One Holy Ghost, which is God in Christ, who reconciled me unto Himself. Rising from my dead works, I am now focused on those things that are above, where Christ sitteth on the right hand of God. I am wrapped up, sealed up, tied up, and tangled up in Jesus Christ. My policy cost Jesus Christ His life, and I am so glad He paid that price. I am the temple of the living God.

> Therefore, if any man be in Christ, he is a new creature: old things are passed away; behold, all things are become new.
>
> —2 Corinthians 6:17

> For the law of the spirit of life in Christ Jesus has made me free from the law of sin and death.
>
> —Romans 8:2

> Let not you heart be troubled: ye believe in God, believe also in Me, [Jesus] God. In my Father's house are many mansions: if it were not so, I would have told you. I go to prepare a place for you. And if I go and prepare a place for you, I will come again, and receive you unto Myself;

that where I am, there ye may be also. And whither I go ye know, and the way ye know.

—John 14:1–4

I am covered by the blood of Jesus, hallelujah. My sins are washed away! My iniquity is purged; I rose up from my dead works, and I am bound for higher ground. For I have found the way of holiness, and the true religion that Jesus builds, and is building, me and you. If any man defile the temple of God [i.e., his body], him shall God destroy. For the temple of God is holy, which temple ye are.

—1 Corinthians 3:17

I am so grateful to God for having chosen to make that call to give me everlasting assurance of security in my life if I would forsake my ways and abandon my unrighteous thoughts. Rising from my seat on a bench in a small church building, I came to this Son of man, Christ Jesus. I had no money to buy my way into eternity, so He immediately sealed the agreement He had made with us before the foundation of the world, namely that we should be holy and serve Him in truth, knowing the love that He has for us is eternal. He delivered to me the Holy Ghost (Holy Spirit), signed and sealed. It is my will that He gave me in this earthen vessel. He told me to love Him and keep His commandments. For if I walk about telling everybody that I am saved and I love the Lord, but if I refuse to keep His commandments, I am a liar, and the truth is not in me. For you are the light of the world. You are a city that is set on a hill that cannot be hid.

He told me that if I abide in Him, I should also walk in Him. The devil, the father of lies and deception, tricked me several times and caused me to lose focus. I got myself engaged in some things in the old man's house. I lied. I committed fornication. I committed adultery and

did several other little things in this man's house I found myself resorting to. But one thing was for sure: this man Christ Jesus has a love for me that is more than a tongue can tell of. I cannot express my gratitude. He kept reminding me of the policy He purchased for me. When I told a lie, my heart was always condemning me, saying, "He that telleth lies shall not tarry in My sight" (Psalms 101:7).

He kept reminding me of what He did for me at the cross, where I first received Him by faith. He made me cry and He made laugh, but He set my soul on fire, a fire that is always burning within me. I realized that all the trying to have things go my own way was to no avail. He lets me know I am just wasting my time seeking to have things my way, showing me that my way is only right in my own eyes.

He kept on reminding me that I was raised up by the glory of the Father to walk in the newness of life. He kept telling me, "You have the hope of My guarantee in you, and anyone who has this hope purifies himself even as I, Jesus, am pure." He would not for a moment let me forget about this new policy He had taken out on my life. It would only lapse if I were to blaspheme the Holy Ghost or if I turn away from Him and refuse to repent and seek His face. He told me I would die in my sins and my policy would be revoked. Being cognizant of the abuse, the mocking, and the pain He suffered, along with the scourging and the nailing of His body on a cross to die, although I was not there, I was just as guilty as those who inflicted these things upon Him. I humbled myself and fell on my knees for trouble was rising in me. I boldly told Him of all my sins; He told me, "You are forgiven, and you have obtained more mercy and found the grace to help in your need."

He held me very close to Himself, promising never to let me go. He just keeps blessing me and blessing me, reassuring me I am well guarded and protected by His holy angels. He kept reminding me to have no fear, for He walks with me and He talks with me, telling me I am His own, saying that the joys we share will always be seen and people will know whose I am. He kept on reminding me, saying, "I know you can make it if you try hard enough. Just place your hand in My hands. I will never let it go. Though storms rage and winds blow, I will hold you

with My hands." I realized I have a precious Friend. O how he loves me. So, I slapped myself with my hand, *bam* upside my head, saying, "What are you doing, Julius? You know better than to do those crazy things."

Jesus kept reminding me how God raised Him up from the dead. He reminded me that I had been raised to walk always in the newness of life. He said, "Know ye not that ye are the temple of God, and that the Spirit of God dwelleth in you? If any man defile the temple of God, him shall God destroy; for the temple of God is holy, which temple ye are" (1 Corinthians 3:16–17).

He just would not give me a break, simply wanting me to be reminded that I have an advocate with the Father, Jesus Christ, the one true God. He brought the scripture to light, saying, "If we confess our sins, He is faithful and just to forgive us our sins, and to cleanse us from all unrighteousness. If we say we have not sinned, we make Him a liar, and His Word is not in us" (1 John 1:9–10). I figured I must have been dreaming about a love like this. He paid the whole debt off for me, and I owe Him everything. The stain that sin left in me, He washed until I was whiter than snow. This man has an unfeigned love for me and refuses to give me up to the devil, who wants to kill me, steal from me, and destroy my life. He presented me this scripture: "Know ye not that your bodies are the members of Christ?" (1 Corinthians 6:15).

"'I know the thoughts that I think toward you,' saith the Lord, 'thoughts of peace, and not of evil, to give you an expected end. Then shall ye call upon Me, and ye shall go and pray unto Me, and I will hearken unto you. And ye shall seek Me, and find Me, when ye shall search for Me with all your heart'" (Jeremiah 29:11–13).

"And in that day, thou shall say, 'O Lord, I will praise Thee: though Thou was angry with me, Thine anger is turned away, and Thou comfortedst me. Behold, God is my salvation, I will trust, and not be afraid: for the Lord Jehovah is my strength and my song; He also is become my salvation.' And in that day ye shall say, 'Praise the Lord, call upon His name, declare His doings among the people, make mention that His name is exalted. Sing unto the Lord; for He hath done excellent things: this is known in all the earth'" (Isaiah 12:1–5).

Finally, I am reassured by the saying, "And you hath He quickened, who were dead in trespasses and sins: wherein in times past ye walked according to the course of this world, according to the prince of the power of the air, the spirit that now worketh in the children of disobedience; among whom also we all had our conversation in times past in the lust of the flesh, fulfilling the desires of the flesh and of the mind; and were by nature the children of wrath, even as others. But God, who is rich in mercy, for His great love wherewith He loved us, even when we were dead in sins, hath He quickened us together with Christ [by grace are ye saved]" (Ephesians 2:1–5). So, my friend, "Love not the world, neither the things that are in the world. If any man love the world, the love of the Father is not in him. For all that is in the world, the lust of the flesh, the lust of the eyes, and the pride of life, it is not of the Father, but is of the world. And the world passeth away, and the lust thereof: but he that doeth the will of God abideth forever" (1 John 2:15–17). Thank You, God, for Your amazing grace.

CHAPTER 19
THE RISEN TRUTH SHOWING GOD'S GREATNESS

If it impossible for God to lie, and it is so, then let God be the Truth. There is not another way for you to be saved than being totally immersed in water in the name of Jesus Christ. The reason Jesus commanded you to do this is that when you go down into Jesus Christ, you put on Christ. You are buried with Him by baptism unto His death. Jesus Himself was immersed by John the Baptist, and He came up straight out of the water. The dove, in the form of the Holy Spirit's power, sat on His head. When He was buried, He went down into the grave, but He was raised up by the glory of the Father. You must do the same. This is the only way to have your sins removed, washed away. If you refuse and rebel, be it known unto you that you will die in you sins.

Jesus's name is very important. He is a great King. Therefore, whatsoever you do in word, or in your outward expressions, you must do it

in the name of the King, Christ Jesus. When you see "Christ Jesus," it means the eternal God in the flesh with an anointing. When you see "Jesus Christ," it means the Man representing God in the flesh as the Son of man. Jesus carried a dual nature. He is the Son of God, who taketh away your sins when you submit yourself to be immersed in His name. To do it another way is to set yourself up for disaster. For there is no other name given in the Bible under which you may be saved but the name of Jesus Christ or Christ Jesus.

The truth of God is great, and the truth is, you are going to die. For the Truth has appointed unto every person a time to die, and after death the judgment comes. Where you are from is important, but not as important as where you are going. You will be spending your life in eternity somewhere, heaven or hell: it's up to you.

The Lord God gave a promise to our father Abraham and his descendants. And his outward covenant seal of expression was as follows:

> This is My covenant, which ye shall keep, between Me and you and thy seed after thee; every man-child among you shall be circumcised. And ye shall circumcised the flesh of your foreskin; and it shall be a token of the covenant betwixt Me and you. And he that is eight days old shall be circumcised among you, every male child in your generations, he that is born in the house, or bought with money of any stranger, which is not of thy seed. He that is born in thy house, and he that is bought with thy money, must needs be circumcised: and My covenant shall be in your flesh for an everlasting covenant. And the uncircumcised man-child whose flesh of his foreskin is not circumcised, that soul shall be cut off from his people; he has broken My covenant. (Genesis 17:10–14 KJV)

God's covenant seal must be delivered precisely as God has said. For He told Abraham, "And the uncircumcised man-child whose flesh

of his foreskin is not circumcised, that soul shall be cut off from his people; he has broken My covenant." Abraham followed God's Word by doing exactly as he was told so that he would gain the promise, because he believed the promise of the Preacher, the Teacher, and the Truth. Abraham was ninety-nine years old when he was circumcised. After this, he confessed that he and his people were pilgrims and strangers in that land. He went on and on with Isaac and Jacob, his heirs, in the same promise. "For he looked for a city which hath foundations, whose builder and maker is God" (Hebrews 11:10).

The Holy Ghost is a witness to as many of us as have received Him.

> "This is the covenant that I will make with them after those days," saith the Lord. "I will put My laws into their hearts, and in their minds will I write them; and their sins and iniquities will I remember no more." … Having therefore, brethren, boldness to enter into the holiest by the blood of Jesus, by a new and living way, which He has consecrated for us, through the veil, that is to say, His flesh, and having an High Priest over the house of God; let us draw near with a true heart in full assurance of faith, having our hearts sprinkled from an evil conscience, and our bodies washed with pure water. … For if we sin willfully after that we have received the knowledge of the truth, there remaineth no more sacrifice for sins. (Hebrews 10:16–17, 19–22, 26)

Jesus is risen from the dead. He will not die (i.e., sacrifice Himself) again.

The Truth about Death

> He that despised Moses's law died without mercy under two or three witnesses. … For we know him that

hath said, "Vengeance belongeth unto Me, I will recompense," saith the Lord. It is a fearful thing to fall into the hands of the living God.

—Hebrews 10:28, 30–31

Where you are going, or where you are heading, is very important. You must obey the order if you are to receive the blessing, as you were directed. "And He said unto them, 'Go, into all the world, and preach the gospel to every creature. He that believeth and is baptized shall be saved; but he that believeth not shall be damned'" (Mark 16:15–16).

Damn you for not believing and coming forward to be baptized in water in the name of Jesus Christ, for your sins to be removed and for you to receive the Holy Ghost as you were promised. Be it known unto you that when you refused to be baptized in the name of Jesus Christ for the remission of your sins, you broke the covenant made with us by our great God. You are still dead in your sins. Be it known unto you, Mr. and Mrs. Smarty-Pants, that Abraham was told if that man-child was uncircumcised, he had broken the promise (covenant) and should be cut off from his people.

Be it known unto you, longtime churchgoers and worshippers, that if you refuse to be baptized in water in the name of Jesus Christ, you have broken the covenant that God made with us through Jesus Christ. The truth of God is great, and the Truth has spoken: "For as many of you as have been baptized into Christ have put on Christ" (Galatians 3:27). If you refuse to be submerged in water in Jesus's name and remain in your Father, Son, and Holy Ghost baptism, you have broken the covenant (promise) of God, which you will need to have received if you are to be allowed into the place where the mansions have been prepared for those who are obedient to God. If you refuse to be submerged in water in the name Jesus Christ, you are walking around as naked as could be, and your nakedness will be clearly seen. Moses almost lost his son, having failed to circumcise him, having not followed the instruction. So, to prevent God from killing his son for breaking the covenant, Moses's

wife, Zipporah, used a share stone to cut off the foreskin and cast it at Moses's feet, thereby saving the child.

I am warning you not to seek death in error because of the way you live your life. And bring not upon yourself destruction by the works of your hands. For God made not death: neither hath He any pleasure in the destruction of the living. For He created all things that they might have their being, and the generations of the world were healthy in their time. There was no poisonous venom of destruction in them until humankind decided to bring death upon themselves because of their disobedience. Adam argued with God and blamed Him for giving him a woman. "The woman whom thou gavest to be with me, she gave me of the tree, and I did eat" (Genesis 3:12).

That day when Adam ate the fruit, he died a spiritual death. He quickly created his own righteousness. He and his wife sewed fig leaves together and used them to clothe themselves. Truthfully, God Almighty was not pleased; He killed an animal and made clothing for them. They refused to admit or confess they were wrong and then submit themselves to Truth, Almighty God. Eve blamed the serpent.

Who will you blame for your disobedience, for not submitting yourself to the order of the almighty God? Yet when a person from the court who has the breath of life in his or her nostrils sends you a letter or a postcard saying, "You are hereby commanded to appear as a defendant at the following court proceeding," you do not hesitate to show up. For you know the consequences you will face for your disobedience. A bench warrant will be issued for your arrest. At this point, who can you blame but yourself? You shall know the truth, that the day when you refuse to obey the gospel of Truth, which is the power of the Lord God unto salvation, the sentence of death and sin that is on your life will not be removed. You are guilty, and you shall die in your sins unless you repent.

With the power that is vested in me, Mr. President; Mrs. Vice President; Mrs. Speaker of the House; all the members of Congress, the House of Representatives, and the Supreme Court; governors, mayors, doctors, lawyers, and all people, I say this: "Then said Peter unto them, 'Repent, and be baptized every one of you in the name of Jesus Christ

for the remission of sins, and ye shall receive the gift of the Holy Ghost. For the promise is unto you, and your children, and to all that are afar off, even as many as the Lord our God shall call.' And with many other words did he testify, saying, 'Save yourselves from this untoward generation'" (Acts 2:38–40).

Rising, I came to Jesus as I was, young, weary, wounded by sin, and sad. I came to Jesus kneeling, repenting of my sins, and admitting them to the Truth, Jesus Christ. I was baptized in the name of Jesus Christ, which washed away my sins, and now I am singing "Glory, hallelujah!" Don't make death your friend, even though it doesn't mind sticking around as bees keep close to the honeycomb. Righteousness is immortal, but ungodly men and women, the two genders of humans that the Truth, God Almighty, created, decided to have their own way, keeping death alive within themselves, making death their friend. Because you decided to make death your partner in friendship, you are consumed to naught, for you have made a covenant with death because of your willingness to continue taking part in it.

The ungodly reason with themselves, saying, "God is good. I thank Him for life; I thank Him for blessing my family; He's been so good to me." But they refuse to submit themselves according to the command and order of the great Truth, Jesus Christ. I say to these people: "Be it known unto you, your life is short and tedious. You are under the sentence of death. O man and woman, there is no other remedy for your sins; neither was anyone who died before known to return from the grave to make things right with God. You were born to all adventures, and you shall hereafter be as though you had never been born. For the breath that is in your nostrils is as smoke, and smoke vanishes.

"In your heart you have a little moving spark. When it is extinguished by the command of Truth, your body shall return to ashes (dust), and your breath (spirit) shall vanish as soft air, and your name shall be forgotten in time. For your time here is as shadow that passes away, and you will not return, for your life is sealed. No person can come back from the dead."

To anyone who refuses to be baptized in the name of Jesus Christ,

Truth says, "You have professed yourself to be a child of God, and you have the knowledge of God." Truth, rising, comes storming back to you stare you in the face, reproving your thoughts and your mind, convicting you. Yet still you decide to hold on to being a Catholic, a Seventh-day Adventist, or a Jehovah's Witness, or an adherent to some other false religion, and refuse to submit to being submerged in water baptism in Jesus's name. Because of this, in hell you will lift up your eyes."

Go ahead, keep enjoying yourself and partaking of the good things currently available to you. Keep behaving as a child, being involved in different sports. Go ahead, fill yourself with costly wine and ointments: let no flower of the spring pass you by. Go ahead, fill yourself with your precious seafood, your high-priced beef, chicken, mutton, venison, and turkey. Don't go without your voluptuous lifestyle, leaving a token of the lust of your joyfulness in every place you go. This is your portion and your token in this life. Go ahead, oppress the poor righteous people, oppress the people in general, and show no mercy to the widows or those who are gray-headed.

Go ahead, you gunslingers, commit your murders selfishly, showing no mercy. The time is coming, and soon you shall die. Unless you repent and turn from your gunslinging ways and from committing murder, your death will come soon, and your sentence will not be overturned. You foolish and ignorant son of the devil, your father the devil will soon take the life you love to live and separate you from your pleasures. Go ahead, you fool, who is using the law of justice that you have skillfully created for the feeble, whom you found to be worth nothing to you. Do not allow your sins to pile up; you will have to answer for all of them on the day of trial. Death is coming soon. Don't wait to turn to the Lord Jesus when you hear His call. Don't keep on shirking it and putting it off from day to day, for God's wrath will come upon you quickly, and you will have no one to protect you or give you security, for Truth is a consuming fire, and you will perish on the day of His vengeance.

Go ahead, lie in wait for the righteous people who are doing right. You with your wicked works and ways are trying to force your homosexual lifestyle upon the righteous people, calling it pride. You and your

proud self will lift your eyes up in the lake of fire unless you repent and turn away from your foolishness. Go ahead, Mr. Homosexual, shooting your sperm in another man's rear end, or you sodomite, shooting your semen in a woman's rear end. You know the Truth. The Lord God made the female and brought her unto the man, and after some time had passed, the man had sexual relations with his wife and they produced children. But you are self-willed, ignorant, and stubborn like your father the devil.

The devil knows that they who do such things are worthy of death, yet he has you engaged in a homosexual or lesbian lifestyle. Truth said, "Be fruitful and multiply and replenish the earth." You refused to do it Truth's way, being filled with your own wicked ways; you shall die in your sins. Now that I have told you the truth from the Truth Himself, are you going to kill me? Will you try to kill me before my time? You fool! Unless you repent, you will die in your sin.

When you put your trust in the Lord, you will know and understand the Truth. They who are faithful in their love for God shall abide with Him: for Truth loves His saints because He cares for them. But the ungodly will be punished according to their deeds, their lusts, and their passions according to their own imaginations, and for rejecting the righteous truth of God. Whosoever despises Truth, which gives wisdom, is miserable, and their hope is in vain. Your homosexual and lesbian lifestyles are unfruitful, and your works are unprofitable. Your children, whom you received from another, in your unlawful and sin-filled beds, will be witnesses of their parents' wickedness in their trial before none other but the Truth, the Judge, Jesus Christ the Lord. He is Master of all.

Go ahead, weary yourself in the ways of wickedness and destruction. You have traveled so far through the wicked deserts of your sins. What has it profited you? The riches you have amassed, what will they profit you? Your riches and your wealth will pass away like a shadow, or you will pass away like a shadow. I have written very much in these pages about Joe Biden and Donald Trump, men of renown. From their youth, these men were given to evil. Their ways are ever before the Lord and is not hid from Truth's eyes. None of your sinfulness or unrighteousness

is hidden from God. But because the Lord is merciful and filled with compassion, He has spared other people's lives as He will spare yours. Very soon the Truth will revolt against Biden and Trump, and you, who are good but are not doing right, will see Truth render recompence upon your head. You will never be able to say to God, "As president, I am exempt from doing the things you required." You are eager to have swearing-in ceremonies filled with iniquity, but unless you repent, the plague shall never depart from your house.

You need to have the foreskin of your heart cut off, along with your false baptism and your false worship. Jesus made us a promise, saying, "In My Father's house are many mansions: if it were not so, I would have told you. I go to prepare a place for you, and if I go and prepare a place you, I will come again, and receive you unto Myself, that where I am, there ye may be also. And whither I go ye know, and the way ye know" (John 14:2–4).

You must know that the place where you are planning on going to spend eternity is very, very important. "Thomas saith unto Him, 'Lord, we know not whether Thou goest, and how can we know the way?' Jesus quickly corrected Thomas, saying, 'I am the way, the truth, and the life: no man cometh unto the Father but by Me. If ye had known Me, ye should have known My Father also, and from henceforth you know Him, and have seen Him'" (John 14:5–7).

CHAPTER 20
THE TRUTH ABOUT THE CITY AND THE MANSIONS

While on your way to a place you are heading, you make inquiries and make every effort to get all the details and have them handy. Jesus told us, "In My Father's house are many mansions. I go to prepare a place for you. I will come again and receive you unto Myself, that where I am, there ye may be also. And whither I go ye know, and the way ye know" (John 14:3).

Here are the dimensions of this place (city), found in Revelation 21:16–22:

> The city lieth foursquare. The length is as large as the breadth. The length, breadth, and height of it is equal. The measured wall is a hundred and forty cubits, that is of the angle. The wall is built of jasper stones. The city

is pure gold of clear glass. This building is exclusive and a sight to behold. These mansions are decked with all different types of transparent precious stones. And the streets of the city are pure gold as transparent glass, as white as snow. The city has no temple therein. The Lord God Almighty and the Lamb are the temple of it.

"And the nations of them which are saved shall walk in the light of it: and the kings of the earth do bring their glory and honor into it. And the gate of it shall not be shut at all by day: for there shall be no night there. ... And there shall in no wise enter therein anything that defileth, neither whatsoever worketh abominations or maketh a lie, but they that are written in the Lamb's book of life" (Revelation 21:24–25, 27).

Mount Zion, the City of a Great King

This great Truth is our God. He will guard us and guide us through death and until death. He is greatly to be praised and will be praised in this city of our God, the high mountain of His holiness. It is the beauty and envy of the powers of darkness. It is beautiful for the eyes to behold, for where it is situated, it is the joy of the whole world. This city is Mount Zion; it is located north of heaven and is the city of the great Truth-teller, the city of the great King of kings and Lord of lords, none other than Jesus Christ. Do you know Him today? Please don't turn Him away, or you will be sorry in the end because you refused to be risen from your stubborn and dark ways. Rising from slumber in your religiousness and blindness of heart, you have made a calculated decision to be buried with Him in baptism.

Now, you will be witnessed rising to walk in the newness of life. You are being watched because you came storming back to the Truth. Once you have done this, you continue to live in holiness, pleasing God in everything, being faithful to the end, until you die. You have made the preparation and are now waiting for the Truth, Jesus Christ Himself, to

come in the clouds, to the sounding of trumpet, and with the voice of the archangel. Then you, the righteous, shall be changed into your new body, to be caught up with those who rose from the dead in the clouds with the Lord in the air, to be with the Truth, Jesus Christ, forever in Mount Zion, the great city, the holy Jerusalem, the city of the great King Jesus.

This city will be well guarded and protected by the army of angelic forces in heaven. The general overseer is the Lamb of God, who takes away the sins of all those who came out of the world admitting that they have sinned. They are submitting to Jesus, knowing that He is God; they are baptized in water only in the name of Jesus Christ. Then they commit themselves to grow in grace and in the knowledge of our Lord and Savior Christ Jesus, taught by those who have been placed in the fivefold ministry. "For the perfecting of the saints, for the work of the ministry, for the edifying of the body of Christ: Till we all come in the unity of the faith, and of the knowledge of the Son of God, unto a perfect man unto the measure of the stature of the fullness of Christ. That we henceforth be no more children, tossed to and fro, and carried about with every wind of doctrine by the sleight of men, and cunning craftiness, whereby they lie in wait to deceive. But speaking the truth in love" (Ephesians 4:12–15).

"But the fearful, and unbelieving, and the abominable, and murderers, and whoremongers, and sorcerers, and idolaters, and all liars, shall have their part in the lake which burneth with fire and brimstone: which is the second death" (Revelation 20:8).

Great is Truth, and mighty above all things. "Pontius Pilate saith unto Him [Jesus], 'What is truth?'" (John 8:38). All the earth calls upon the Truth, for He is great who makes all things that are in the heavens and on the earth. Truth made the things that are visible and the things that are invisible. Truth is the head of the body, the church. The Truth has a place laid up for us in heaven. You probably have heard before in the preaching of the gospel, or perhaps now reading in *Rising Up*, of the truth of the gospel. Truth invigorates you and compels you to walk in a way that is worthy of the Lord, being filled with the wisdom of God and fruitful in every good work.

Truth Invigorates Your Strength

Truth strengthens you with all might, according to His glorious power, to help you in your long-suffering, striving to please God and everyone with joyfulness. Giving thanks to Truth, Jesus Christ has brought us to the light of the hope, which is laid up for us in heaven, whereof we have heard before in the Word of truth—the gospel. This truth of the gospel is come unto you, as it is in all the world, and it is producing fruit, as it is doing in you and will do in you since the day you heard it or read it in *Rising Up*. You now know for sure that the grace of God is Truth. This is the reason God is using me to write, to inspire you, so that you will be filled with the knowledge of wisdom in His will, and gain spiritual understanding, so that you might talk and walk in a worthy way, striving to please God, being fruitful in every good work, ever increasing in the knowledge and wisdom of the Truth.

All of us were foolish sometime in our lives, being sedated by darkness's stigma; we were alienated from God, the Truth, by our wicked works and our wicked minds. We are our own worst enemies. Truth makes us come clean and be honest.

For instance, if you are concentrating only on where you are from and what you have attained or achieved, for example, education, fame, or wealth, but you are still carrying heavy baggage, when Truth reveals Himself to you, you had better gravitate toward Him quickly if your intent is to spend your eternity with Him in the new city, holy Jerusalem. Don't be so caught up in where you have come from and what you have achieved. When you have lost sight of His glory, if you return to seek Him and you start thinking about coming clean and being honest with Him, you will see things differently.

When Truth invigorates your strength and you realize that you divorced your first wife or first husband in the wrath and blindness of your ignorance, as soon as you put your former spouse away, you go and marry someone else. Truth steps in and condemns you, for you are snared by the words of your own mouth. You stood before Truth, God, the faithful witness, and all the other witnesses, big or small, men and

women, and said: "I now take this woman [or man[to be my lawful wife [or husband], to have and to hold; to love and to cherish, in sickness, and in health; for richer or poor, and forsaking all others, I, cleave only to her [or him]."

How is it, then, after two years, or five years, or maybe even ten years or more, after you made such a vow to the Truth, God Himself, you return to this man or a woman, and a person in authority or a pastor allows you to marry someone else. You now have a new agreement, called a vow. Truth, rising, comes storming back at you, reminding you of your initial vow, saying, "While your first wife [or husband] is alive and not yet dead, and while you are married to this other individual, you shall be called an adulteress, and your second spouse is also an adulterer." Let Truth speak now, or forever let God hold His piece. But Truth can't be silent, because you must know the Truth if you are to be set free. For Truth (God) said, "The woman who has a husband is bound by the law of God as long as he is alive and not dead." The man who has a wife who is alive and not yet dead, and who is married to another woman, is an adulterer, living in an adulterous affair, and you know that no adulterer or adulteress has eternal life abiding in him or her or can gain eternal life until he or she admits he or she is living in adultery or in an adulterous affair.

You submit to the Truth of God and dissolve (get out) that marriage. Now, you make a commitment to obey God and stand with the Truth and for the Truth. How can you have two covenants (agreements) in force at the same time? Death alone is what can bring an end to the first covenant (agreement), before the second can be established. Although some people claim they do not know of this law of God's, they are straight-faced liars, having broken the covenant (agreement) instituted by God saying, "Therefore shall a man leave his father and his mother, and shall cleave unto his wife: and they shall be one flesh" (Genesis 2:24).

> And every man that hath this hope in Him [Jesus] purifieth himself, even as He is pure. Whosoever committeth sin transgresseth also the law: for sin is the transgression of the law. And you know that He was

manifested to take away our sins; and in Him is no sin. Whosoever abideth in Him sinneth not: whosoever sinneth hath not seen Him, neither known Him. ... He that committeth sin is of the devil; for the devil sinneth from the beginning. For this purpose, the Son of God was manifested, that He might destroy the works of the devil. Whosoever is born of God doth not commit sin; for His seed remaineth in him: and he cannot sin, because he is born of God. ... Whosoever hateth his brother is a murderer: and you know that no murderer hath eternal life abiding in him. (1 John 3:3–6, 8–9, 15)

So, go ahead and hate me for saying so, stupid, but if you have divorced and remarried, then you are adding sin upon sin.

"For whosoever shall keep the whole law, and yet offend in one point, he is guilty of all. For He that said, 'Do not commit adultery,' said also, 'Do not kill.' Now, if thou commit no adultery, yet if thou kill, thou art become a transgressor of the law. So, speak ye, and so do, as they shall be judged by the law of liberty. For you shall have judgment without mercy" (James 2:10–13). The Lord (Truth) said, "Let not the wife depart from her husband. But and if she departs, let her remain unmarried, or be reconciled to her husband. And let not the husband put away his wife" (1 Corinthians 7:10–11). "The wife is bound by the law as long as her husband liveth, but if her husband be dead, she is at liberty to be married to whom she will. But she is happier if she remains unmarried" (1 Corinthians 7:39).

The Truth about Breaking Covenants (Agreements)

If you have ever signed a marriage agreement, or an agreement to purchase a car, a boat, a ship, a truck, or a house and some land, then you know that if you break the agreement, the consequences will be severe.

You will be given time to rectify any violation of the agreement you signed. If you fail to respond by the set time, then you will lose. If you break a marriage agreement, you may end up losing all your possessions in the divorce settlement. With all the other sorts of things mentioned above, if you do not remedy the problem in a timely manner, then you will lose your down payment, and the item or property will be repossessed. When you have signed an agreement with the government to pay your taxes and you fail to follow through, the IRS will notify you that you are in tax arrears. If you do not immediately rectify the problem, they will charge you hefty fines and credibly threaten to confiscate any property you own as payment toward whatever you owe.

> A man that breaketh wedlock, saying thus in his heart, "Who seeth me? I am compassed about with darkness, the walls cover me, and nobody seeth me; what need I to fear? The Most High will not remember my sins." Such a man only feareth the eyes of men, and knoweth not that the eyes of the Lord are ten thousand times brighter than the sun, beholding all the ways of men, and considereth the most secret parts. He knew all things ere ever they were created; so, also after they were perfected, He looked upon them all. This man shall be punished in the streets of the city, and when he suspecteth not he shall be taken.

> Thus, shall it go also with the wife that leaveth her husband, and bringeth in an heir by another. For first, she has disobeyed the law of the Most High; and second, she hath trespassed against her own husband; and thirdly, she hath played the whore in adultery, and brought children by another man. She shall be brought out into the congregation, and inquisition shall be made of her children. Her children shall not take root, and her branches shall bring forth no fruit. She shall leave

her memory to be cursed, and her reproach shall not be blotted out. And they that remain shall know that there is nothing better than the fear of the Lord, and that there is nothing sweeter than to take heed unto the commandment of the Lord. It is great glory to follow the Lord, and to be received of Him is long life.

—Ecclesiasticus 23:18–28

He that obeyeth Me shall not be confounded, and they that work by Me shall not do amiss. All these things are the book of covenant of the Most High God, even the law which Moses commanded for an heritage unto the congregation of Jacob.

—Ecclesiasticus 24:22–23

For the Lord, the God of Israel, saith, "He hateth putting away. For one covereth violence with his garment. Therefore, take heed to your spirit, that you deal not treacherously." You have wearied the Lord with your words.

—Malachi 2:16–17

CHAPTER 21
THE END OF ALL THINGS IS AT HAND

In the first chapter of *Rising Up*, I stated that I came from Jamaica, the third-most populous Anglophone country in the Americas (after the United States and Canada). Most of the 330 million people in this country came from somewhere else or were born of an immigrant. The almighty God put all of us in our fathers' loins. Then our fathers put us into our mothers' wombs through sperm. Then after nine months of gestation, we came out of the womb. And little by little, we kept growing according to God's purpose to attain the ages we are today. We all are privileged to live upon the earth that the great God, Christ in Jesus, has given unto us to enjoy for a period (season) of time.

Many have lost their lives before their time because of their disobedience, failing to surrender to the Lord Jesus Christ. Because you refuse to humble yourself, He turns you over into the hands of the executioner.

Let us hear the conclusion of the whole matter: "Fear God and keep His commandment: for this if the whole duty of man. For God shall bring every evil work into judgment, with every secret thing, whether it be good or evil" (Ecclesiastes 12:13–14).

Next, we are to love one another and to be our brother's keeper. The Lord requires us to do justice, and righteous judgment, and walk humbly with God. "The God of Israel said, the Rock of Israel spake to me, 'He that ruleth over man must be just, ruling in the fear of God. And he shall be as the light of the morning, when the sun riseth, even a morning without clouds; as the tender grass springing out of the earth by clear shining after the rain.' Although my house be not so with God, He hath made with me an everlasting covenant, ordered in all things, and sure: for this is all my salvation and all my desire" (2 Samuel 23:3–5). With the same judgment you rendered, it will be rendered back to you by God. You are going to die soon, then the judgment will come. Where I am from is important, but much more important is my eternal destination.

Mr. President, you are going to die. Congresspeople, you are all going to die. All you who judge, you are going to die. All you doctors, your medicine will not help you: you are going to die. And you (liars) lawyers, you are going to die. All those who are crippled or lame, dumb or deaf, you are going to die. All people who rise daily to do wrong and engage in all wicked activities, you are going to die. You who have lots of money, to the poor you have given nothing, but you have willed your estate to someone you care for. Even if your heir is not of your family, you are still going to die. Your social status will not prevent you from dying on that day when death calls you to go. You will go! You are not invincible at all.

Your dust will return to the dust. You can finish out your life on earth in health and mercy if you submit yourself to God and call upon His name, saying, "I will extol Truth, the God of heaven; my mouth shall praise Thee, Lord. I will rejoice in Thy greatness. The God who lives forever and ever must be feared. It is good to praise You, Lord, and magnify Your great name, and honorably speak of Thy mighty works.

Truth, my God, You have not let that which I suspected come upon me; You are to be praised. You are holy."

To be obedient to the Truth (God) is to fear Him, albeit not be afraid of Him. For I am convinced if I fear the Lord and turn away from my wrongdoings (evil), it will go well with me at the last, and I will find favor in the day of my death. If you believe God and are trusting in His Word, you don't have to be fearful of death.

All the people who had been before died, and everyone who is now in existence will die, as will those who will come after. But, "Precious in the sight of the Lord is the death of His saints" (Psalms 116:15). "Blessed are the dead which die in the Lord from henceforth: Yea, saith the Spirit, that they may rest from their labors; and their works do follow" (Revelation 14:13).

Many of my family members where I am from have all died. And many of my peers and people in the community have all died. When I got to the United States, many people died, as they continue to do. Fast-forward to 2020–21: millions of people worldwide have died unprepared to meet the Lord God. Preparation was made for the 2020 election for people to vote, but preparation was not made for the eventful outcome on the Republican side. The crafty, skillful Democrats are the ones who have honed their craft. All you seekers of power, you are looking to the people for your help. And you are seeking help from the people to get you into power. You are always looking to the wrong source. You must know this as a fact: only God gives power to whom He wills.

God sets you up in power, then He takes you down, out of office. In the same way that He kills, He alone gives life or can save you. In my making, I was baptized in water in the name of Jesus Christ for the removal of my sins. One week later, God filled me with the gift of the Holy Ghost with the evidence of speaking in tongues. Ever since then, I have been preparing to leave this earth and this life, in this world of separation where there is so much chaos, madness, killing, and stealing. I will be going to sleep (i.e., dying) for a while.

Then when the Lord Jesus Himself, the Truth, descends from heaven with a shout, with the voice of the archangel, and with the trumpet of

God, and calls, the dead who obeyed God's Word will rise up first. The living saints will also be changed, and all will be caught up in the clouds, together with the saints from their graves, to meet the Lord in the air. And so shall we ever be with the Lord. Then all sinners and all those who hate God will be preparing for their tasks and doing business as usual as if nothing happened. They will be unaware of what has taken place. Then after some time has passed, reality will kick in: *The people are gone. The rapture has taken place.* Then they have nothing to do but wait for their fiasco to come.

Then all the wicked dead will wait their turns for their everlasting contempt, which will take place soon. I am very sure I will rise up again. There is no power on earth that is able to hold me down. Watch out! I shall arise to meet the Lord Jesus in the sky. Jesus gave us a guarantee. Whosoever fears and respects the Lord, it shall go well with them at the last. They shall find favor in the day of their death. Behold, God Himself is the Judge. You had better humble yourself before Him today. Cease committing your sins, and meddle no more with them forever. Woe is me! Who will deliver me and you on that horrible and terrible day of death's wrath? Rise, stand up on your feet, and move so that the Lord will lead you forward and deliver you from all your troubles and you shall find rest for your soul. The people, the whole house of worshippers, are very, very dry. They are dead and need to be revived.

Hear the Word of the Lord. You Are Guaranteed to Live

> The hand of the Lord was upon me, and He carried me out in the Spirit of the Lord and set me down in the midst of the valley which was full of bones. And caused me to pass by them round about: and behold, there were very many in the open valley; and, lo, they were very dry. And He said unto me, "Son of man, can

these bones live?" And I answered, "O Lord God, Thou knowest."

Again, He said unto me, "Prophesy upon these bones, and say unto them, 'O ye dry bones, hear the word of the Lord. Thus saith the Lord God unto these bones, "Behold I will cause breath to enter into you, and ye shall live. And I will lay sinews upon you, and bring up flesh upon you, and cover you with skin, and put breath in you, and ye shall live; and you shall know that I am the Lord."' So, I prophesied as I was commanded: and as I prophesied, there was a noise, and behold a shaking, and the bones came together, bone to bone. And when I beheld, lo, the sinews and the flesh came upon them, and the skin covered them above: but there was breath in them.

Then He saith unto me, "Prophesy unto the wind, prophesy, son of man, and say to the wind, 'Thus saith the Lord God; "Come from the four winds, O breath, and breathe upon these slain, that they may live."' So, I prophesied as He commanded me; and the breath came into them, and they lived, and stood up upon their feet, an exceeding great army.

Then He saith unto me, "Son of man, these bones are the whole house of Israel: behold, they say, 'Our bones are dried, and our hope is lost; we are cut off for our parts.' Therefore, prophesy and say unto them, 'Thus saith the Lord God, "Behold, O My people, I will open your graves, and cause you to come up out of your graves and bring you into the land of Israel. And you shall know that I am the Lord, when I have opened your graves, O My people, and brought you up out of your

graves; and shall put My Spirit in you, and ye shall live; and I will place you in your own land; then shall ye know that I the Lord have spoken it and performed it."'"

—Ezekiel 37:1–14

The devil and his legions are truly angry because For in every city and place, there will be a great insurrection upon those who fear the Lord and trust in His mercies. Like raging lions, and ravenous hyenas, and sly serpents, men and women will rise up against the truth of God. Boiling in their heat and their lust, they will try to pervert and prevent the way of Truth. Acting like madmen and madwomen in their rage, they will subtly waste and take away the people's goods and cast them out of their houses and their homes.

"'Be not afraid, neither doubt; for God is your guide, and the guide of them that keep His commandments and precepts,' saith the Lord: 'Let not your sins weigh you down and let not your iniquities lift-up themselves. Woe be unto them that are bound with their sins and are covered with their iniquities like as a field is covered with bushes, and the path thereof covered with thorns, that no man may travel through. It is left undressed and is cast into the fire to be consumed therewith'" (2 Esdras 16:75–78). "'Hear, O ye, My beloved,' saith the Lord: 'The days of trouble are at hand, but I will deliver you from the same'" (2 Esdras 16:74). Death has no power over the ones washed in His blood.

Resurrected to Come Storming Back

Just as Jesus rose up from the dead and came storming back to declare, "I am alive forevermore," we will do the same when the trumpet of God sounds at His coming. We will quickly come storming back to meet the Lord amid the clouds in the sky.

Now, if Christ be preached that He rose from the dead, how say some among you that there is no resurrection of the dead? But if there be no resurrection of the dead, then is Christ not risen: and if Christ be not risen, then is our preaching vain, and your faith is also vain. Yea, and we are found false witnesses of God; because we have testified of God that He raised Christ: whom He raised not up, if so be that the dead rise not. For if the dead rise not, then Christ is not raised: and if Christ be not raised, your faith is vain; ye are yet in your sins. Then they also which are fallen asleep in Christ are perished.

If in this life only we have hope in Christ, we are of all men most miserable. But now is Christ risen from the dead and become the first fruits of them that slept. For since by man came death, by man came also the resurrection of the dead. For as in Adam all die, even so in Christ shall all be made alive. But every man in his own order: Christ the first fruits; afterward they that are Christ's at His coming. Then cometh the end, when He shall have delivered up the kingdom to God, even the Father, when He shall have put down all rule and all authority and power. For He must reign, till He hath put all enemies under His feet. The last enemy that shall be destroyed is death. (1 Corinthians 15:12–26)

You'd Better Watch Out, or You Will Be Destroyed

The Lord God gave Himself a body known as Jesus as it has pleased Him, just as He did to the man Adam. Adam was made from dust, a living soul; and in the end, Adam returned to dust as a dead soul. God

gave Himself a body, became a man from heaven, to die for the world (to be destroyed), and was called the second Adam; He was made a quickening Spirit. When He was on the cross to perform His supernatural act, the Spirit came out of the body, for Jesus had to die. "Before He died, about the ninth hour Jesus cried with a loud voice, saying, 'Eli, Eli, Lama, Sabachthani?' (That is to say, 'My God, My God, why hast Thou forsaken Me?')" (Matthew 27:46 KJV). Out of His side came blood and water for the saving of the world. He went to the grave and returned with His new resurrected body. Mary wanted to touch Him after He arose from the dead, but Jesus objected, saying, "Touch Me not; for I am not yet ascended to My Father: but go to my brethren, and say unto them, I ascended unto My Father, and your Father, and to My God, and your God" (John 20:17).

Jesus had a sinless body that could not die, yet when He was pierced, out came blood and water. You have a sin-sick, dead body that needs resurrection. If you are not resurrected, then your sin-sickened body will be destroyed. For the soul that sins shall die. Therefore, that soul must possess the nutrients of God's Holy Ghost to take up residence within and give it power. And as Jesus Christ rose from the dead and came storming back, if you obey God, after you die you will rise like a storm and be caught up in the clouds with Him in the air. But if you choose to rebel and remain in your sin, be it known that you will be destroyed. Just as the last enemy to be destroyed is death, so will you be destroyed just as death. Death is a law. Jesus stuck to the law and promised to save us from the law of sin and death. He kept the law. Will you keep the law?

Hear, therefore, all you rulers of the people, President Biden and Donald Trump, please get an understanding. All you judges of the earth, give a listening ear. All you governors, mayors, military members, senators, and congresspeople, your power is given to you of the Lord God, who will try your works. He has searched out your counsels. Being his ministers, you have not judged right, nor have you kept the law, nor walked after the counsel of God. Do you not know that the law is good if you use it lawfully? Just as you were ushered into office speedily, God

shall hurry up and speedily come upon you in your high places and kill some of you and remove the rest of you from power.

God gives power to the faint, and for he or she who has no might, He renews his or her strength. But mighty men and women will be mightily tormented by the one who raised them up to their positions of power. Such people will never escape His wrath unless they repent. He, who is Lord over all, fears no person, neither will He back down from any person's greatness. For it is He, God, who made the great and small, and cares for all the same. He only counsels with Himself.

A swift trial shall come upon you mighty men and women in possession of power. Unto you, therefore, holders of power, do I speak, that you may learn wisdom, and get an understanding of the Word of God and not destroy yourselves. The great God, Jesus Christ, says, "Set your house in order; for you shall die and not live" (2 Kings 20:1 KJV). "Set your affections on things above" (Colossians 3:2 KJV). "Now ye are clean through the Word which I have spoken unto you" (John 15:3 KJV). "Desire them, and you shall be instructed out of them. Wisdom is glorious, and never fadeth away" (Song of Solomon 6:12). "I love them that love Me, and those that seek Me early shall find Me" (Proverbs 8:17 KJV). Your earthly wisdom is corrupt, devilish, and sensual, and your house, which is filled with envy, confusion, strife, wickedness, and every evil work, will not stand. "This wisdom descendeth not from above, but is earthly, sensual, devilish" (James 3:15 KJV). One-sided justice in no justice at all. "For whatsoever a man soweth, that shall he also reap" (Galatians 6:7 KJV).

Because of the botched election, we have the January 6 commission. Because of the botched election, food prices have doubled and sometimes tripled. Gas prices are way up, and the prices for major commodities have all risen. Some supermarkets are only allowing mothers and shoppers to get five cans of baby formula at one time. But in a little while, there will be relief. The rule of power is in the hands of the Lord. In due time, Truth will set over the country and over the presidency a person who is profitable, for in His hand is the prosperity of humankind. And the Truth (God) will bring Donald Trump back into the White House

despite all the traps his opponents are setting and all the raids of his proprieties and his minister's properties. Just as the January 6 uprising took place, in which one soul was lost, there will be many more lives lost from every area of this nation before things turn for the better.

From morning till evening, all the things that are done are before the Lord. Every man and woman of understanding has some form of earthly wisdom. Let us hope we will all garner as much gentleness, mercy, peacefulness, and righteousness as we can, without partiality. These make up the wisdom that is from above. These will assist you to evaluate the time because the days are evil. For the hearts of the people are filled with excess madness, and evil is surfeiting.

Lucifer (Satan), also called the devil, was kicked out of heaven for rebelling against God Almighty. He lost his place in the kingdom of God. He was cast out onto the earth, and his angels were cast out with him (Revelation 12:9). Cain rose up and killed his brother and hid the body in the earth. When he was questioned by God Almighty about his brother's whereabouts, he said, "I know not: Am I my brother's keeper?" (Genesis 4:9 KJV). Lamech killed a man who wounded him (Genesis 4:23). "Be not hasty in thy spirit to be angry: for anger resteth in the bosoms of fools" (Ecclesiastes 7:9 KJV). There was an uprising against some of the prophets who prophesied in the name of the Lord. They lost their lives for Jesus's sake. "Which of the prophets have not your fathers persecuted? And have slain them which showed before the coming of the Just One; of whom ye have been now the betrayers and murderers. Who have received the law by the disposition of angels and have not kept it" (Acts 7:52–53 KJV).

John the Baptist lost his life because of his boldness in telling the truth. "For John has said unto Herod, 'It is not lawful for thee to have your brother's wife.' Therefore, Herodias had a quarrel against him, and would have killed him; but she could not. For Herod himself had sent forth and laid hold upon John and bound him in prison for Herodias' sake, his brother Phillip wife: for he had married her" (Mark 6:18–19 KJV).

"Now, Herod the tetrarch heard of all that was done by Him: and he was perplexed, because it was said of some, that John was risen from

the dead; and of some, Elias had appeared; and of others, that one of the prophets was risen again. And Herod said, 'John have I beheaded: but who is this, of whom I hear such things?' And he desired to see him" (Luke 9:7–9). Judas Iscariot rose up against the Lord Jesus Christ, selling Him out for thirty pieces of silver. "Then one of the twelve, called Judas Iscariot, went unto the chief priest, and said unto them, 'What will ye give me, and I will deliver Him unto you?' And they covenanted with him for thirty pieces of silver" (Matthew 26:14–15 KJV). For his greed, he lost his life.

Then, the Romans, on behalf of the Jewish leaders, killed the body of Jesus, and they thought it was all over for Him. But the Lord Jesus rose from the grave by the power of the Almighty and came storming back to save us and set us free from our sins, which He will do if only we believe. "I am He that liveth, and was dead; and behold, I am alive forever more, amen; and have the keys of hell and death" (Revelation 1:18 KJV). The people revolted against Stephen and stoned him to death while he called on the name of the Lord. "And Saul, yet breathing out threatening and slaughter against the disciples of the Lord, went unto the high priest" (Acts 9:1). "Now, about that time Herod the king stretched forth his hands to vex certain of the church. And he killed James the brother of John with the sword" (Acts 12:1–2).

The devil, called Satan, if he does not control you, will rise up against you. For he comes to destroy you and kill you, stealing your goods and your livelihood.

> Take heed that no man deceives you. For many will come in My name, saying, "I am Christ," and shall deceive many. And ye shall hear of wars, and rumors of wars: see that ye be not troubled: for all these things shall come to pass, but the end is not yet. For nation shall rise against nation, and kingdom against kingdom. And there shall be famines, pestilences, and earthquakes, in diverse places. All these are beginning of sorrows. They shall deliver you up to be afflicted and kill you: and you

shall be hated of all nations for My name's sake. ... For there shall arise false Christs, and false prophets, and shall show great signs and wonders; insomuch that if it were possible, they shall deceive the very elect. ... But he that shall endure unto the end, the same shall be saved. And this gospel of the kingdom shall be preached in all the world for a witness unto all nations; and then shall the end come. Behold, I have told you before. (Matthew 24:4–9, 11–14, 24–25)

Thanks be to God for Apostle Gino Jennings and the worldwide ministry of the churches that the great God of heaven and earth has privileged him to oversee. In all the church locations of the saints, you hear the same things. There are no variations and no deviations from the truth. For God has raised up true men, humble and bold, to preach the truth of His Word to save a dying world. When you hear the Word of God, rise, get up on your feet, and move urgently toward Jesus; He will save you now. Backslider, rise, run, come storming back to Him. Jesus will save you now. We will not sprinkle you with water, but we will immerse you in the name of Jesus.

We will not baptize you in the name of the Father, the Son, and the Holy Ghost as those liars and deceivers are doing. If you will arise and come to Jesus Christ, we will baptize you in the name of Jesus Christ for the remission of your sins. Mr. President, Mr. Trump, all congresspeople, everyone in the House of Representatives, all the other offices of power, doctors, and lawyers: repent and be baptized in the name of Jesus Christ for the remission of your sins and you shall receive the gift of the Holy Ghost, which Jesus promised to you and to your children.

Unless you repent of your wickedness and believe the gospel of Jesus Christ, you shall likewise perish. For more wickedness shall arise from the wicked. When this happens, the wicked build up a great wicked community, city, and nation. God's Word remains firm; it will not pass away. How great is our God! How great is His name! He is the Greatest One, the only one who remains the same. He will forgive you

of your sins. He will raise you up and make you great for His glory. We are standing on the Word of God and will not bend or break. We have confidence in the Word of God; we will never back down or give up. So, you are being told once more, worm man or woman, you are going to die. Prepare to meet your God. He will come and He will not tarry. What is hindering you from being baptized in the name of the Lord Jesus Christ? Only if you would believe that the Son of God has come and has given you an understanding, so that you, and all of us, may know Him who is true. And we are in Him who is true, even in his Son Jesus Christ. This is the true God and eternal life.

CHAPTER 22
WE WILL RISE TO BE LIKE AND BE EQUAL TO ANGELS

A dying world needs to be resuscitated from its dead works and returned to life if anyone wishes to meet with the Lord Jesus in the clouds. God revealed Himself to Moses in the burning bush. Moses was filled with amazement looking at the fire, but the bush was not burned. God called out to him from the flames. God is not dead; He is alive. He is the living God of Abraham, Isaac, and Jacob. Where we are going, we must have life in us if we are to get there. Donald Trump always speaks about somebody up there in heaven looking down. Steve Harvey is also famous for saying what he would like when he gets to heaven. He is also concerned about who he will meet up there. Let me give you the sad news: in order to go to heaven, you will have to have the new birth to make it to the first resurrection.

So, let the blind lead the blind; they all will end up in hell. The same

is true for you unless you repent of your sins and are born again, being submerged in water in the name of Jesus Christ, being filled with the Spirit, and speaking in tongues as the Spirit gives you utterance. If you do not, you will not be able to even see the kingdom, much less to enter therein. In heaven, we will not know any man or woman in the flesh as we now know them. The former things will be over. But if you have the Spirit of God, you will know others better.

> And Jesus, answering, said unto them, "Do ye not therefore err, because you know not the scriptures, neither the power of God? For when they shall rise from the dead, they neither marry, nor are given into marriage. But are as the angels in heaven. And as touching the dead, that they rise, have ye not read in the book of Moses, how in the bush, God spake unto Moses, saying, 'I am the God of Abraham, and the God of Isaac, and the God of Jacob'? He is not the God of the dead, but the God of the living: you do greatly err." (Mark 12:24–27)

When a person is sleeping naturally, that person is either lying down, sitting down, or standing up. In any of these three cases, the person needs to be awakened from sleep to be engaged in anything productive. That person who has not been born again by way of water baptism, in the name of Jesus Christ and receiving the Holy Ghost, is dead in sin and still sleeping. The person whose life has been changed by being submerged in the name of Jesus Christ for the removal of his or her sins and who is filled with the Holy Ghost and fire is walking in the newness of life in Jesus Christ. This person is walking in the light of God, preparing to meet Him.

Sin is a law that keeps you in its dead works, determined to hold you captive as a slave. If your intent is to return to Jesus when He returns to call the church (His chosen people) home, then you must be crucified with Christ, submitting to water baptism and being filled with the Holy Ghost. And the new life that you now have, walking about doing your

everyday business, you will be living it by Jesus Christ, who lives in you. You are not your own. Jesus shed His blood and gave you new life in Him. Why not awake from your sinful, sleeping ways and all your dead works and walk in the newness of life? You do not want to frustrate the grace of God, for Jesus did not die in vain for you. If your claims of a new life are valid, you must walk by the same rule, receive the same baptism, and receive the same Spirit as others who have been baptized. We all speak the same thing.

Jesus was told that His friend Lazarus was sick. When He heard of this, He told His apostles, "This sickness is not unto death, but for the glory of God, that the Son of God might be glorified by his death." He lingered for an extra two days in the same place. After some activities and making some statements, Jesus said to His disciples, "Our friend Lazarus sleepeth; but I go, that I may awake him out of sleep" (John 11:11). The disciples, who never truly understood what Jesus meant, said to Jesus, "If Lazarus is sleeping, he is really doing well with his rest."

> Then said Jesus unto them plainly, "Lazarus is dead. And I am glad for your sakes I was not there, to the intent you may believe; nevertheless, let us go unto him." ...
>
> Jesus came to Mary and Martha's house. He found that Lazarus had been laid in the grave four days already. ... As soon as Martha heard that Jesus was there, she went and met Him and said, "Lord, if Thou hadst been here, my brother would not have died. But I know even now, whatsoever Thou will ask of God, God will give it Thee." Jesus saith unto her, "Thy brother shall rise again." Martha saith unto Him, "I know he shall rise again in the resurrection at the last day." Jesus said unto her, "I am the resurrection, and the life: He that believeth in Me, though he were dead, yet shall he live: And whosoever liveth and believeth in Me shall never die. Do you believe this?" She saith unto Him, "Yea,

Lord: I believe that Thou art the Christ, the Son of God, which should come into the world." (John 11:12–15, 17, 20–27)

Rising Up to Be Part of the Resurrection

"And when she [Martha] had so said, she went her way, and called Mary her sister secretly, saying, 'The Master is come and calleth for thee.' As soon as she heard that, she arose quickly, and came unto Him" (John 11:28–29). People do things out of their ignorance and their unbelief, simply because they refuse to believe the truth of God's Word. Whether or not you believe it, your unbelief will not void the perfect law of God. It is the law that converts the soul, binds up your broken heart, and drives away all your fears and your tears, the law that gives you a new perspective on the life you are now living. "Being confident of this thing, that He which hath begun a good work in you will perform it until the day of Jesus Christ" (Philippians 1:6 KJV).

> The Jews then which were in the house, comforted her, when they saw Mary, that she rose hastily and went out, followed her, saying, "She goeth to the grave to weep there." Then when Mary was come to where Jesus was, and saw Him, she fell down at His feet, saying, "Lord, if Thou hadst been here, my brother would not have died." When Jesus therefore saw her weeping, and the Jews also weeping which came with her, He groaned in the Spirit, and was troubled, and said, "Where have ye laid him?" They saith unto Him, "Lord, come and see." And some of them said, "Could not this man, which opened the eyes of the blind, have caused that even this man should not have died?" Jesus, again groaning in Himself, cometh to the grave. …

It was a cave, and a stone lay upon it. Jesus said, "Take ye away the stone." Martha, the sister of him that was dead, saith unto Him, "Lord, by this time he stinketh: for he hath been dead four days." Jesus saith unto her, "Saith I not unto thee, that, if thou wouldest believe, thou shouldest see the glory of God?" Then they took away the stone from the place where the dead was laid. ...

And Jesus lifted His eyes and said, "Father, I thank Thee that Thou hast heard Me. And I know that Thou heardest Me always: but because of the people which stand by I said it, that they may believe that Thou hast sent Me." And when He had spoken, He cried with a loud voice, "Lazarus, come forth." And he that was dead came forth, bound hand and foot with graveclothes: and his face was bound with a napkin. Jesus saith unto them, "Loose him, and let him go." (John 11:31–32, 34–35, 37–44 KJV)

You likely want to be resurrected and go back with Jesus, but you are having this problem. You are bound and can't see because you have a napkin filled with faked things covering your face. Jesus commanded those at the grave to loose Lazarus and let him go. You need to be loosed from the fake hair you bought at CVS, Walgreens, or Walmart. You need to be loosed from your fake eyelashes and your fake long multicolored fingernails. You need to remove the napkin of your lipstick and your various face painting, and also remove your graveclothes. That which you call beautiful is an abomination in the sight of God.

You are telling God, "I really want to go home with You," and He tells you in His Word, "In like manner also, that women adorn themselves in modest apparel, with shamefacedness, and sobriety; not with braided hair, or gold, or costly array; but (which becometh women professing godliness) with good works" (1 Timothy 2:9 KJV). You are saying to God, "Not so!" God wants you to be holy. For the scripture saith:

"What? Know ye not that your body is the temple of the Holy Ghost which is in you, which you have of God, and you are not your own? For you are bought with a price: therefore, glorify God in body, and in your spirit, which are God's" (1 Corinthians 6:19–20 KJV)?

"I beseech you therefore, brethren, by the mercies of God, that ye present your bodies a living sacrifice, holy, acceptable unto God, which is your reasonable service. And be not conformed to this world: but be ye transformed by the renewing of your mind, that you may prove what is that good, and acceptable, and perfect, will of God" (Romans 12:1–2 KJV). You want to rise to go back with God when He comes, right? You are here walking around with the body you claim to be yours, and nobody will tell you what to do with it. But God said, "What? Know ye that your body is the temple of the Holy Ghost, which is in you, which ye have of God, and ye are not your own?" (1 Corinthians 6:19 KJV). How can you take the temple that belongs to God and deck it out with chains, hanging them around your neck like an animal?

You have chains, and bangles, and bracelets on your hands as dead weights. You have chains on your feet as do the people who are incarcerated, and you have a problem walking. Maybe you are incarcerated; you just may be. If you are, come accept the truth in God's divine Word and be made clean. The vessel that belongs to God is you, your body, which must be presented to God as your reasonable sacrifice. For if God has called you out of the world, why are you still looking like the world? "Jesus called out to Lazarus, and said, 'Come forth.' He came forth hand and foot bound, with graveclothes on, and a napkin on his face. Jesus commanded, 'Loose him, and let him go'" (John 11:44 KJV).

You need to be loosed from all your dead works and get rid of your graveclothes, which are weighing you down. You are blind because you have an invisible napkin on your face and you just can't see yourself. God wants you to clean yourself up and present to Him a glorious church without spot or wrinkle or any such thing. "If ye then be risen with Christ, seek those things which are above, where Christ is sitting on the right hand of God. … For you are dead, and your life is hid with Christ

in God. When Christ, who is our life, shall appear, then shall ye also appear with Him in glory" (Colossians 3:1, 3–4 KJV).

I have risen stronger in the Lord and in the power of His might. As an ambassador and steward of the one and only God, who carries the name Jesus Christ, I declare that there is no other God besides Him. I am troubled on every side because of Him. I was persecuted because of Him, but not forsaken. My body was taken by force, my hands were cuffed, my feet were shackled, and a chain was placed around my waist by the enemy's cohorts. They thought they had taken everything that I possessed, but they were sadly mistaken. For Jesus said, "I have given unto them eternal life; and they shall never perish, neither any man pluck them out of My hand. My Father, which gave them to Me, is greater than all; and no man is able to pluck them out of My hand" (John 10:28–29 KJV).

Because I have this guaranteed protection, my storming back is accompanied by the Bible, which tells you, "Search the scriptures; for in them ye think ye have eternal life, and they are they which testify of Me" (John 5:39 KJV). Rising up in my Father's name, I am very bold, but very humble to bring you the truth of the revelation of Jesus Christ. Will you kill me as your forebears killed the prophets of old who prophesied in the Lord's name? You have a choice. I've come this far by faith, trusting in the Lord. He has not failed me yet. So, if you wish not to hear what God has to say through me, don't read *Rising Up*, and don't listen to me. But I will not be silent, for there is a storm rising. In this storm, there are three weapons I possess: first, a hammer, to break up things; second, an ax, to root out things from my heart; and third, a two-edged sword that is the Word of God, which cuts you both ways to set you right, preparing you for the coming of the great day of our God. How do you love me now? Whatever you intend to do to me, I am still determined to cry aloud, and spare not, for this wicked nation must hear the truth and decide if they want to be free and go back with the Lord when He comes. It won't be long; we will be leaving here. Mark my words!

O you foolish people, walking about and talking about how you are going back with Jesus our God when He comes, but the one body that He has given to you to maintain, a male body, you have changed you it

into that of a woman. Or you, being a woman, changing yourself into a man only to fulfill your lustful desires and your fantasies. Your body will fall apart very soon.

Nothing is more important than the gospel of salvation, which will make the people of the United States great. A great boy and great girl will come and taste and see that the Lord is good. A great man and a great woman will come taste and see that the Lord Jesus is good. He is with us, and He will see us through. So, come, rise up from your grave of dead works, remove the napkin that has blinded you, and be loosed in the name of Jesus Christ. Let the world see that you are a pilgrim passing through this great devilish and wicked world. You are to rise up, loose yourself, and free yourself, storming back to Jesus our great God. For where we are going is far more important than where we are coming from. Prepare yourself for a great flight. You are going to forever be with the Lord in the New Jerusalem. If not, prepare yourself for the deluge of fire and brimstone. Farewell! Peace be unto you.

ABOUT THE AUTHOR

Julius Williams was brought up in the Shiloh Apostolic Church in Manchester, Jamaica. He developed a love for the Lord and accepted Him as his personal Savior. He was baptized in water in the name of Jesus Christ and received the Holy Ghost, along with the evidence of speaking in other tongues as the Spirit gives him utterance. The Word of God is richly dwelling within him in all wisdom. He hopes that all people will come to the knowledge of the truth that there is only one God. He got into the body of Jesus as Christ, the Anointed, to save us from our sins.

He knows that the Son of God has come and has given us an understanding so that we may know Him. Julius is in Him, that is true, and even in His Son, Jesus Christ. This is the true God and eternal life. Julius Williams is not afraid to let the truth be known. Rising up, saying, "Just watch Me come storming back," was what Jesus did when He rose from the dead more than two thousand years ago. Julius shares his thoughts about what he knows, testifies to what he sees, and shares the mind of God with a dying world through the Word of God and the visions that God has given him.

Julius has been encouraging the people, preaching, teaching, exhorting, and testifying to the Word of God constantly to all who will listen. The Word of God has made him wise unto salvation. He is now a member of his local First Church of Our Lord Jesus Christ, located at 3441 Milledgeville Rd., Augusta, GA 30906. The church pastor is Bishop Morris Williams. You can reach the church by phone at (706) 736-3200 or (706) 414-7003.

First Church is a worldwide organization. It offer the *Truth of God* broadcast, which you can tune in and listen to. The leader, pastor, and teacher who will guide you through the Word is none other than the apostle and general overseer Gino Jennings.

Headquarters temple location:

First Church of Our Lord Jesus Christ
5105 N. Fifth St.
Philadelphia, PA 19120

Toll-free telephone number: (888) 231-2201
Local phone number: (215) 739-8103

truthofgod@erols.com
www.truthofgod.com

CPSIA information can be obtained
at www.ICGtesting.com
Printed in the USA
BVHW041426200123
656716BV00020B/1017/J